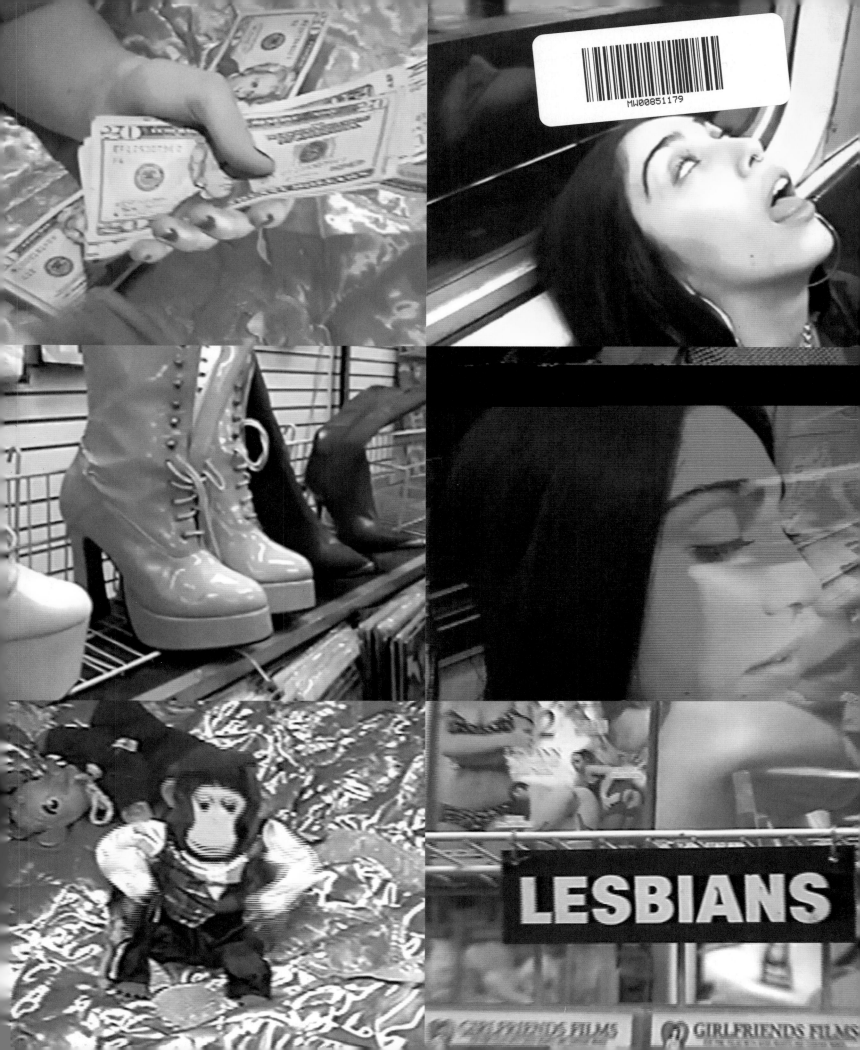

LESBIANS

GIRLFRIENDS FILMS

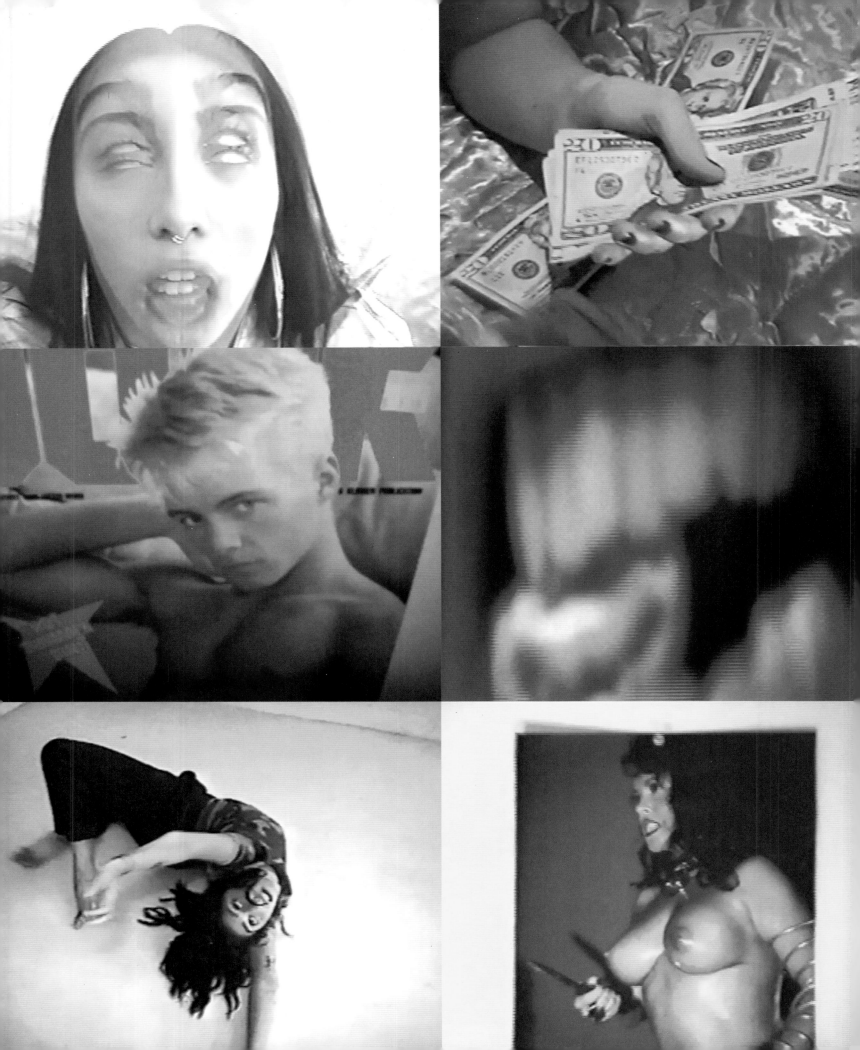

mademe®

Erin Magee

RIZZOLI
NEW YORK

New York Paris London Milan

Brenda Carole Magee
April 7, 1948–January 27, 2024

Mom, you taught me a lot of things, but most of
all you taught me it's OK to be different. We never
really spoke about it. I just learned by watching
you, and I learned by how you treated me. A true
nonconformist, you carved your own path in the
bravest and most fearless way. The exact same way
you handled your illness later in life.

You embarrassed me so many times when I was a kid.
Your leather suits, your various hair colors, your
healing magnets, your love for weeds, your study of
Chinese medicine, your jewelry-sourcing trips to
Nepal, your vintage Mercedes convertible. When I was
younger, I wished you could just be like everyone
else's mom — normal. But you weren't. You were
yourself; you were never afraid to live your truth.
You loved and supported my weirdness the same way
you nurtured your own.

I didn't realize this until after you passed away,
but it turns out I was so inspired by it that I
based my entire personal creative practice on you.
A woman who does whatever she wants to do, and
doesn't care what other people think. The coolest
girl in the room. It took me until a few days after
your passing to realize this: you were my only
inspiration. I love you, Mom.

Contents

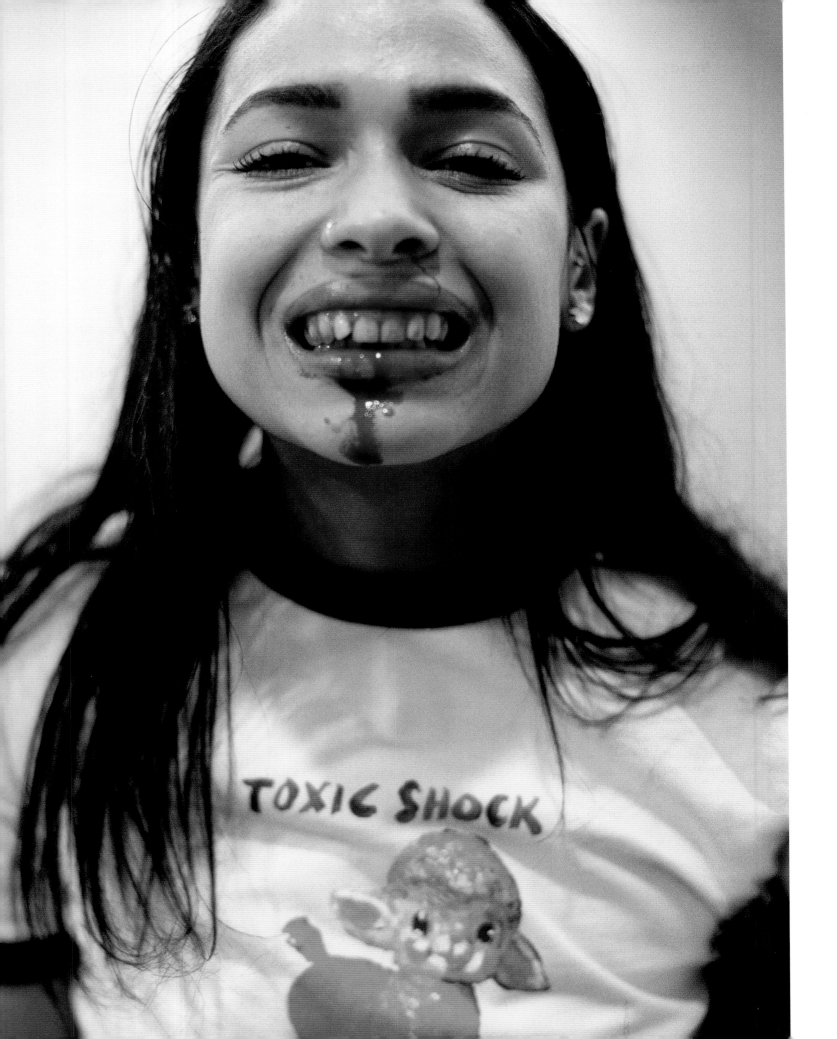

Foreword
Chioma Nnadi

With her bloody mouth, maniacal grin, and the words "Toxic Shock" written across her baby tee, Princess Nokia appeared like a girl possessed in MadeMe's Fall 2017 campaign. Shot by photographer Mayan Toledano at a seedy short-stay hotel in Pennsylvania, the image struck like a gut punch when it dropped in October of that year, circulating on social media at a rate of knots. Yes it was transgressive, some might even say ghoulish, but more than that, the campaign captured the unbridled rage of adolescent girls, a rally cry for womanhood breaking out of its shell. Once you saw its power — and I remember clearly the moment I did — it was almost impossible to unsee.

As the story goes, MadeMe's Erin Magee and Princess Nokia, born Destiny Frasqueri, had met at a fashion show some months prior. Magee was a fan of the Nuyorican rapper, who was in the midst of promoting *1992 Deluxe*, her critically acclaimed sophomore album. For the designer, Princess Nokia embodied the raw, riotous spirit that had informed MadeMe since she started the label in 2007. The single "Tomboy" in particular became something of an unofficial soundtrack for the brand. With her take-no-prisoners attitude and free-spirited verve, Nokia was quickly building a name for herself. When a young man in the crowd at an Ivy League school hurled sexist abuse her way, she reportedly stopped the performance to punch him in the face. The rapper was, in short, the quintessential MadeMe poster girl.

The admiration was mutual: Nokia was, quite serendipitously, wearing a MadeMe tee the day they met. Inspired by a Riot Grrrl flier from the '90s, the "Slutz" shirt was a cheeky riff on the Utz potato chips logo and had recently gone viral after Rihanna wore it a couple of weeks earlier. As Magee recalled, it proved to be the perfect icebreaker. "You made that shirt, didn't you?" Nokia asked the designer gingerly. And so when Magee approached Nokia about starring in her Fall campaign a few weeks later, the rapper agreed without much hesitation.

It was around this same time that I was introduced to Magee by a mutual friend over burgers in the East Village. I was working as the style director for *The Fader* and was always on the hunt for new streetwear brands. What's more, there was something about MadeMe that resonated with me on a more personal level. For starters, the tongue-in-cheek '90s references spoke to my angsty inner teenager, even as someone who'd grown up outside the States. In a largely male-dominated downtown New York fashion scene, MadeMe represented something fresh and exciting. Magee made it look easy, but it couldn't have been. Holding one's own in that world took grit and guts. For that reason, I was more than a little intrigued to meet her.

Shy, soft-spoken, and unassuming, Magee didn't exactly match the image of rabble-rouser that I had in my head. Even still, there was a steeliness about her, a determination and a sense of purpose that revealed itself over the course of our conversation. I quickly understood that, for her, it wasn't just about making great clothes — and as someone who has worn many of her pieces over the years, including bombers, biker jackets, and her coveted shoulder bags, I can attest that she's really good at it — it was about community above and beyond anything else.

Magee's circle is wide and far-reaching, full of talented and creative young women like Princess Nokia. There's Paloma Elsesser, whom Magee met in 2015, first appearing in the brand's Fall 2018 campaign season — long before she'd risen to supermodel stardom. As soon as she was old enough to model, Lourdes (Lola) Leon became part of the crew as well. She famously turned down campaigns with several renowned European fashion houses, lending her support to a select crop of downtown New York labels instead, and MadeMe was first in line. Leon was about 17 or 18 when Magee suggested she become the face of her collaboration with Kim Gordon's cult '90s label X-girl. After being introduced by a mutual friend on Instagram, the

Princess Nokia photographed by Mayan Toledano. Lakeville, Pennsylvania, 2017.

pair met for coffee to see if the chemistry was right (of course, it was). And so began their now decade-long friendship.

Some designers might call them brand ambassadors, but Magee would for sure cringe at the thought. The relationships she's established over the years are hardly transactional, built instead on mutual respect and a sense of kinship. Warm and generous to a fault, Magee is always around to lend a sympathetic ear. Her loyalty is unwavering, her advice sage. Before the rest of the world really understood who they were, she championed these young women. They, in turn, show up when she needs them the most, buoying her spirits and urging her to push ahead whenever she thinks about giving up on MadeMe. Do it for *us*, they tell her.

Shortly after the book project was up and running, Magee messaged me with sad news: her mother had died quite suddenly. Bereft and heartbroken, she knew she needed to take a pause. When we got on the phone a couple of months later, she was clearly in a deeply reflective state. We'd talked about her path toward motherhood in the past, about raising her two wonderful daughters with her wife, Nicole, but much less about her own childhood. Now her earliest memories of growing up in suburban Toronto were coming into focus.

She explained that, over the years, she'd never quite slowed down enough to process just how much her mother had shaped the way she saw the world and the woman she would become. In some ways, Brenda Magee was the original MadeMe muse. "She was a mom in the suburbs, but she always went against the grain. She was a nonconformist in her politics, in her interests, in her clothing, in the way she decorated the house. When I asked to shave my head aged five, she was like, 'Of course. I'm going to take you.' It was she who bought me the suits and ties I would wear all the time. She didn't care what anyone thought. She was just completely sponsoring the individual that I was," she said.

"I learned a lot after her passing. I realized that I had made a whole creative practice about being obsessed with this type of woman, and it was actually her. When I was a teen, I was embarrassed by these things that she did — wearing three-piece leather suits, constantly changing hair colors, her love for garden weeds, and jewelry-sourcing trips to Nepal — because she wasn't like anybody else. But as an adult and a mother myself, I realized that she was just the coolest person I knew. When I moved to New York and lived without her, I seemed to be constantly chasing that spirit, creating a world around women who just did what they wanted, these cool rebellious women just like my mother."

Much like her mother, Magee has always led by example, guiding those who seek her counsel with a steadfast tenderness and sense of purpose. Cool rebellious women like Princess Nokia, whose bloodied image has a spellbinding power on the cover of this book, are drawn to the designer for the same reason she is to them. They see something special in Magee — something vibrant and truly vital — that perhaps she's too modest to claim for herself.

Introduction
Lola Leon

My first thought when I saw Erin: "Is that Jean Paul Gaultier?"

I mean, it was just a photoshoot really. I didn't have any eye bags to conceal at that age and the hatred hadn't wrecked my heart yet. I remember sitting by some stained glass and hearing "Oh no, you're better than stained glass"...

Immediately there was an understanding that we were all stupid and from there came a very natural ease. We got eachother's references, we got eachothers' humor. There was an attitude of caring so deeply but also not giving a fuck.

Since that first experience some of us lost weight, some of us lost brain cells, we all lost our minds!

I feel theres a lot of strength in Madelle but in a very unassuming way. Its never pushed down anyone's throat, its never trying to get anything from you.

There's a timeless, classic quality to MadeMe that will keep it relevant for hundreds of years. Erin's never trying to do the most, she picks the people she fucks with, she likes the people she likes, and she likes to showcase them. She likes the cool girls, rebellious, protective, fearless. She genuinely gives a fuck about women but doesn't care about any crybaby bullshit.

Its a boy eat boy world but I'm like — I can do everything you do and I can do it better. We're taught to move in these gender coded ways—"move like a man", "move like a woman". MadeMe is moving in a parallel way to men and somehow that becomes offensive. But we're actually just doing what you're doing so fuck you.

Being a girl in New York you got two eyeballs and you have to use them in two different ways. You have to be constantly looking at everyone thats around you and protecting yourself at the same time you have to be looking within yourself.

Mind your business but be aware of all thats going on at the same time. As soon as you walk out the house you have to be in that mode - doing you but peripherals on, paying attention.

Theres a ~~very~~ way to be mean, thats also kind. A sharp, protective, fierce mean. A hot knife cutting a pan of butter.

It's gratifying to be recognized by Erin and her crew because they very much are the tea.

I look up to Erin because she reminds us all how <u>lit</u> we are. A Madelle girl wants people to suceed, she's humble but shes also a judgmental cunt about the right things. We started working together when I was basically a teenager, full of attitude, but not that much maturity, and here we are almost ten years later, the same but with more focus.
Mademe is for the girls of any age, any stage, from when you're still all bratty rebellion to when you finally become the most distinguished <u>idiot</u>.

♡ LOLA

Iconography

Alana Derksen "Baby Head" photographed by Natalia Mantini. Fort Lee, New Jersey, 2016.

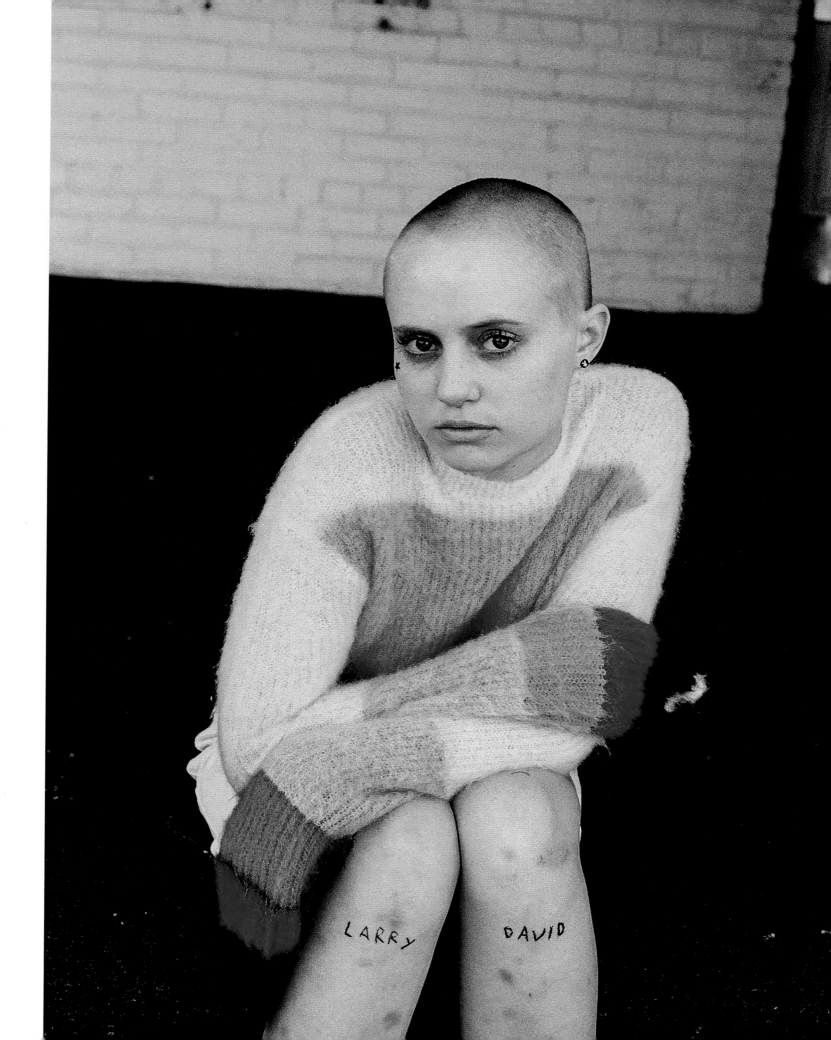

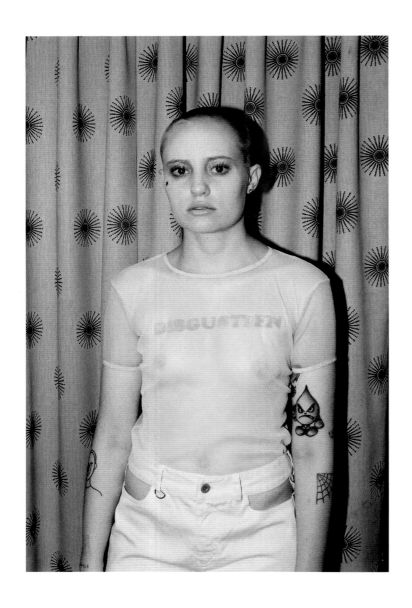

I found Alana on the internet;
her name online was Baby Head.
She happened to be from Toronto,
and I'm from there too. One time
I was flying home to see my
family, so I asked if we could
meet up to see if she'd work in
the clothes. We met in a random
park outside this Starbucks
in downtown Toronto. I decided
she was cool. We exchanged
information and I flew her to
New York to do the shoot. I had
no money at the time, so she
had to stay in my apartment.
The night before the shoot I
was like, "Listen, maybe you
shouldn't go out — or be home
early — because we're leaving at
like eight in the morning."

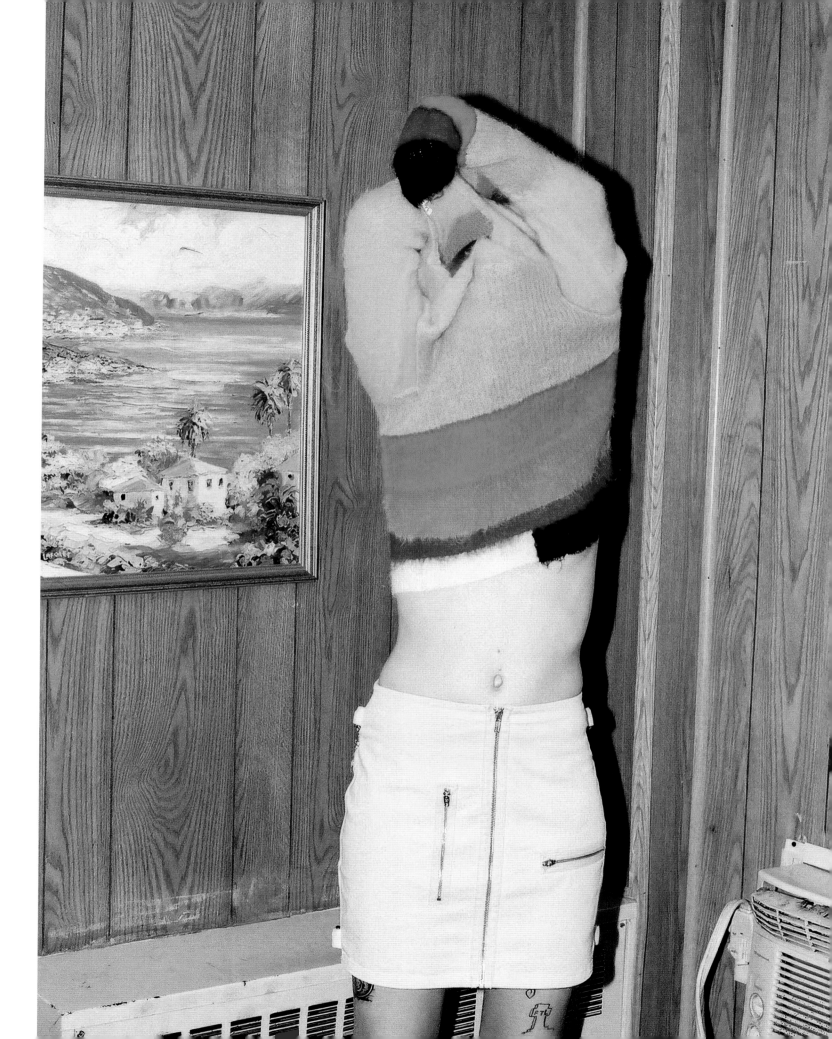

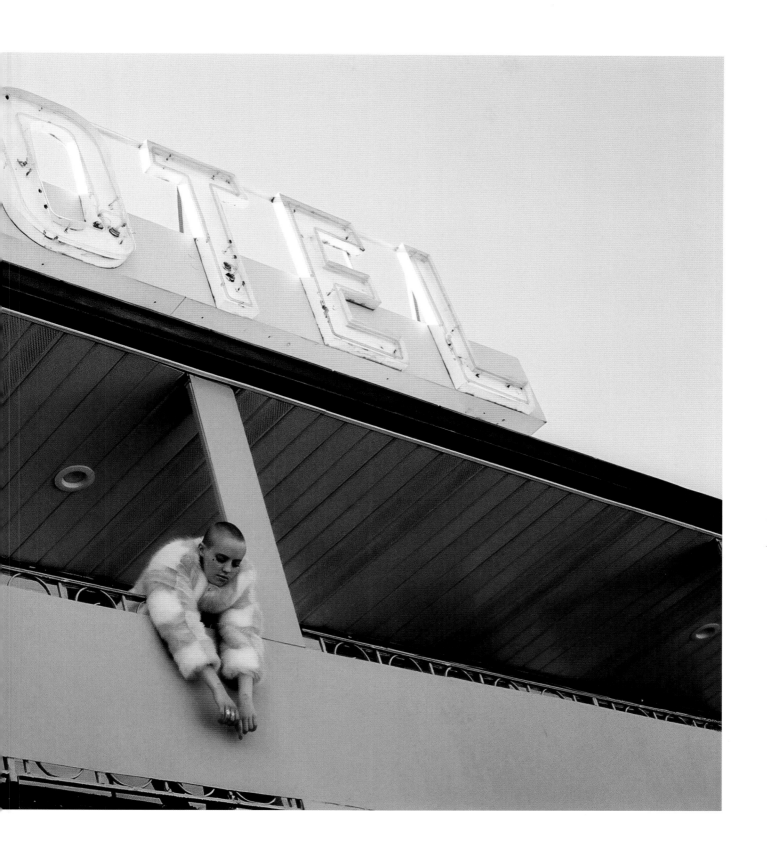

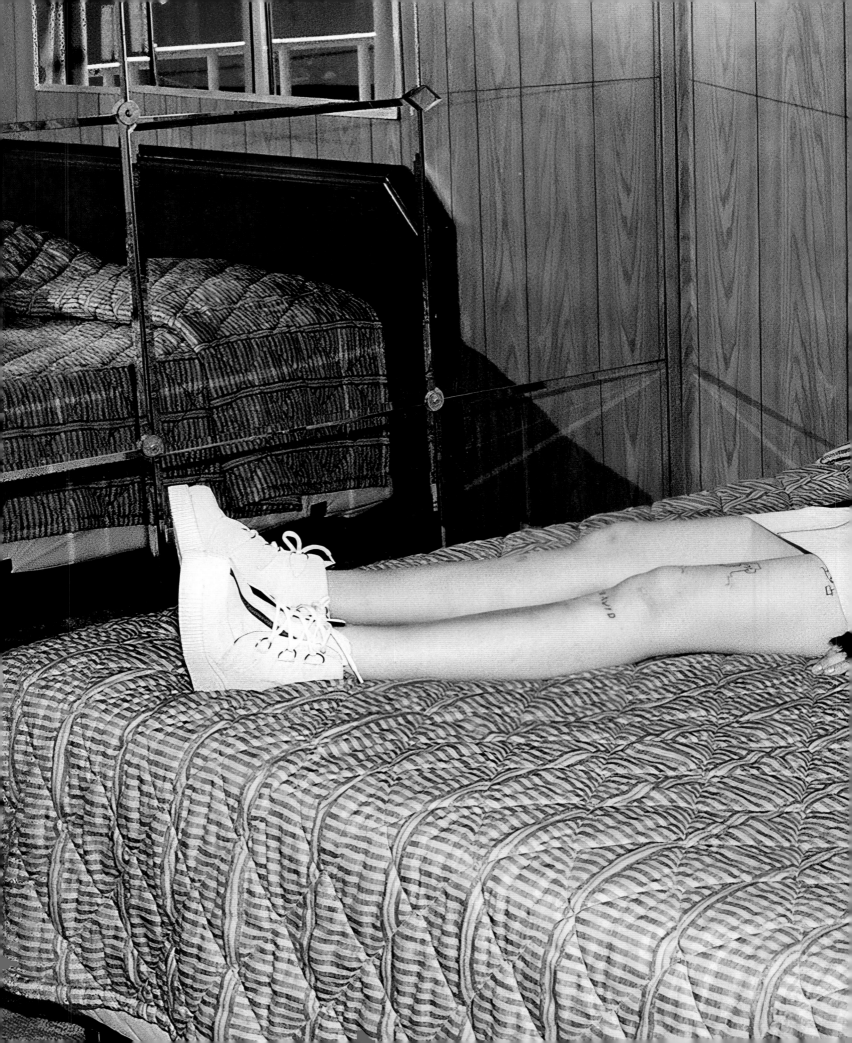

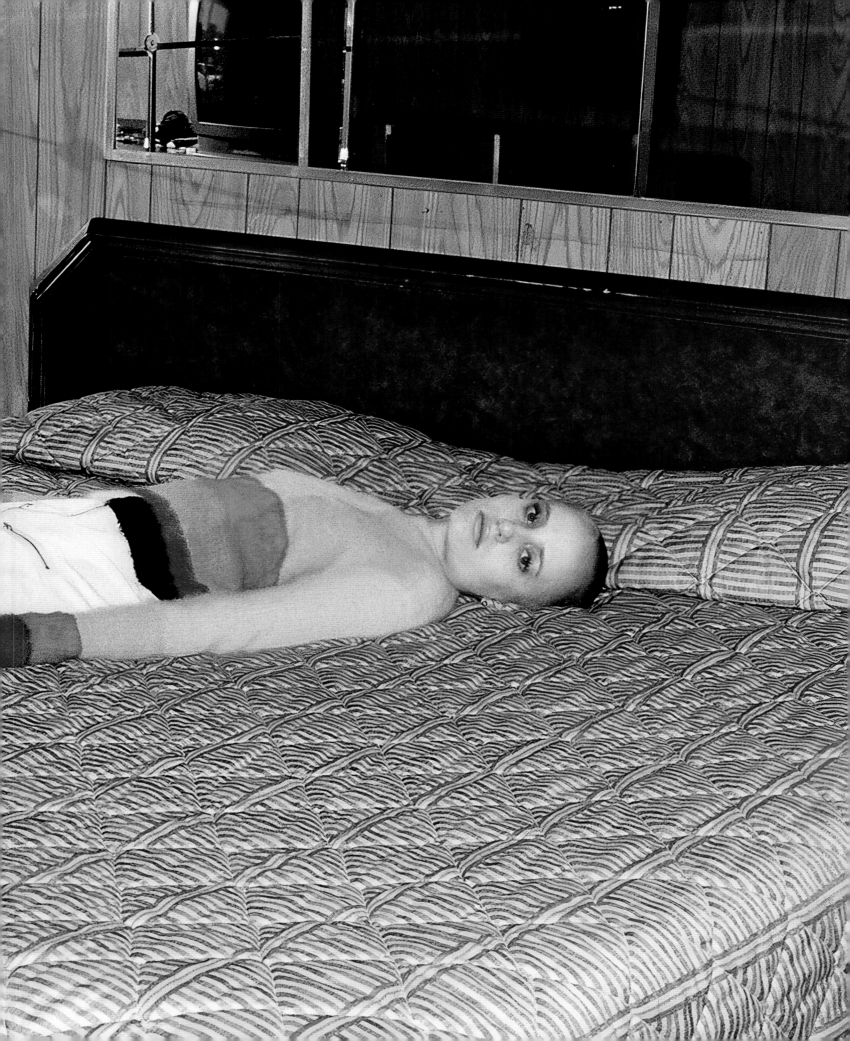

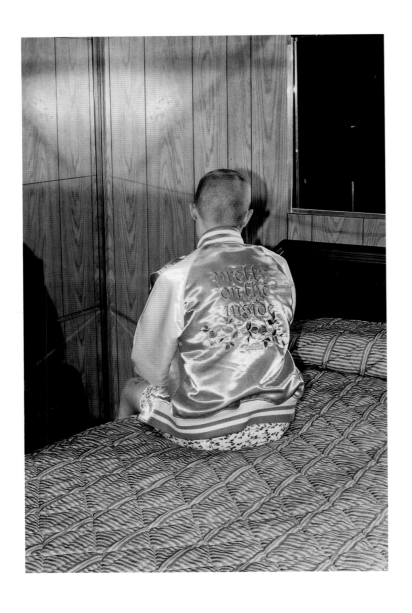

Eight in the morning rolls around, and she's nowhere to be found. She hadn't called me. She wasn't answering my texts. The photographer, the equipment, the stylist, the assistants — everybody is waiting at my apartment for her. She shows up and she's fucking wasted, hadn't slept. I was furious. We get to set, a cracked-out motel in New Jersey somewhere over the George Washington Bridge; it was perfect because she looked like she was going to die. I have a bunch of photos where she's barfing. Eight years later she was like, "That incident inspired my sobriety. You scared the shit out of me."

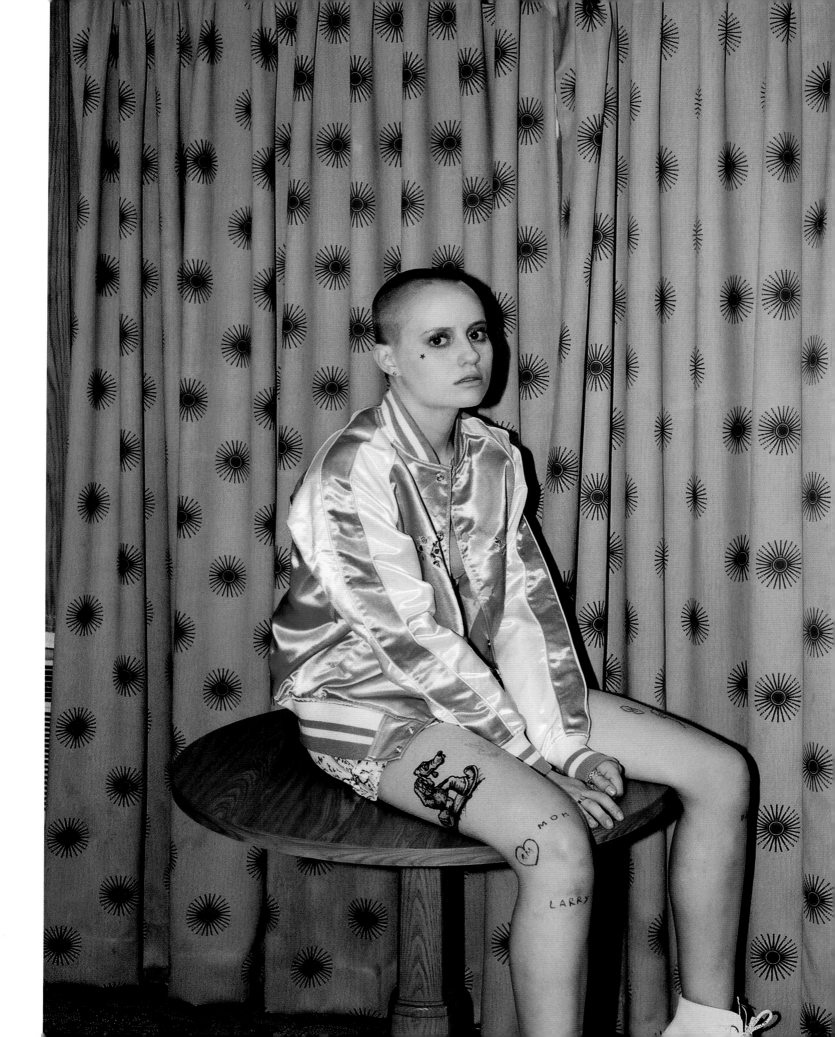

Princess Nokia photographed by Mayan Toledano. New York, New York, 2022.

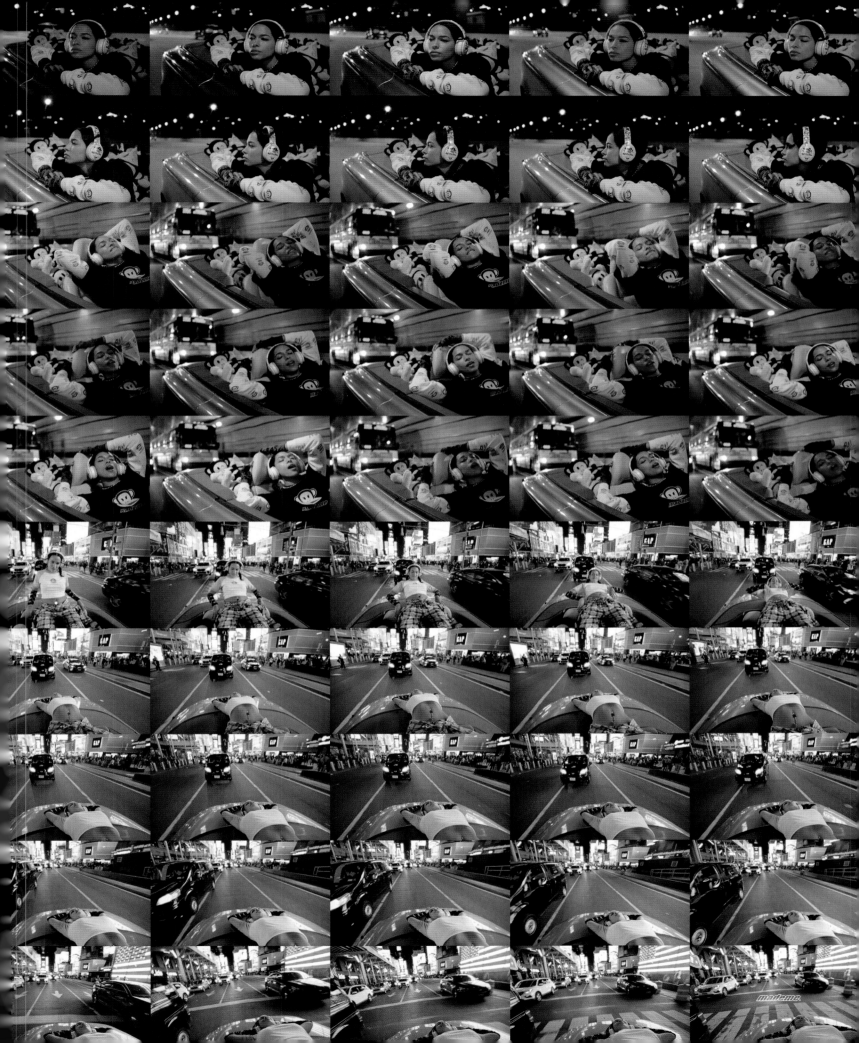

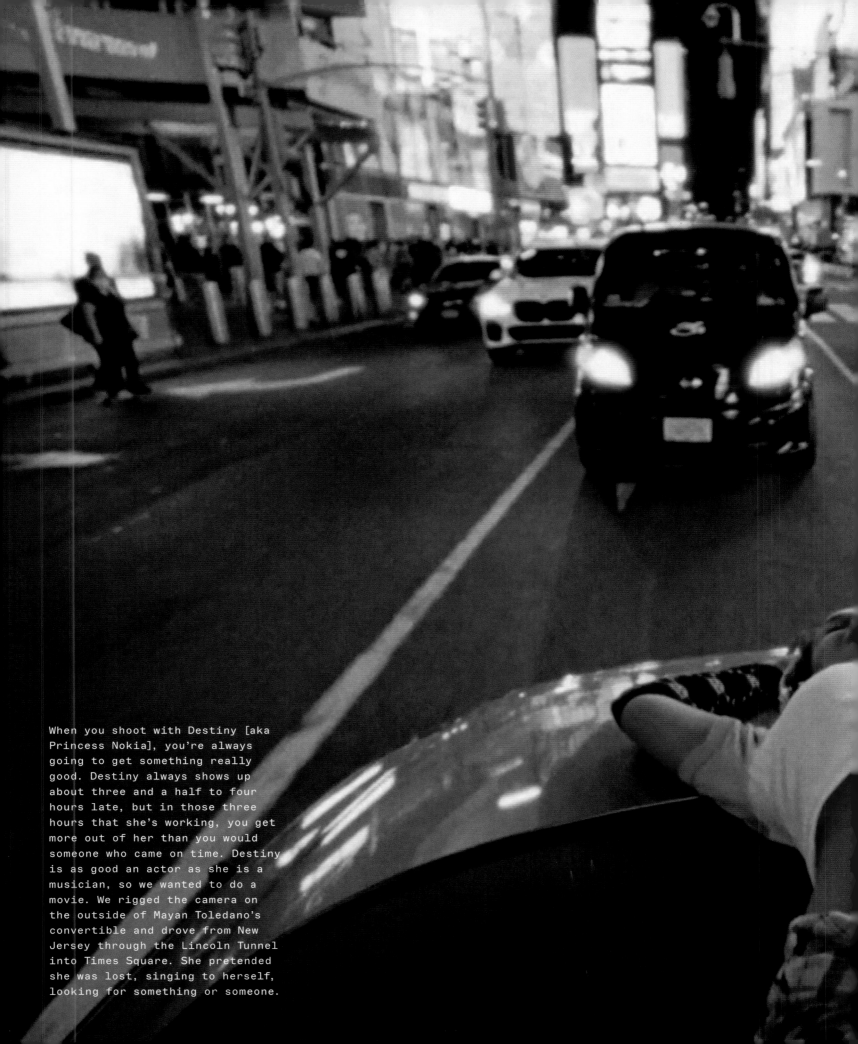

When you shoot with Destiny [aka Princess Nokia], you're always going to get something really good. Destiny always shows up about three and a half to four hours late, but in those three hours that she's working, you get more out of her than you would someone who came on time. Destiny is as good an actor as she is a musician, so we wanted to do a movie. We rigged the camera on the outside of Mayan Toledano's convertible and drove from New Jersey through the Lincoln Tunnel into Times Square. She pretended she was lost, singing to herself, looking for something or someone.

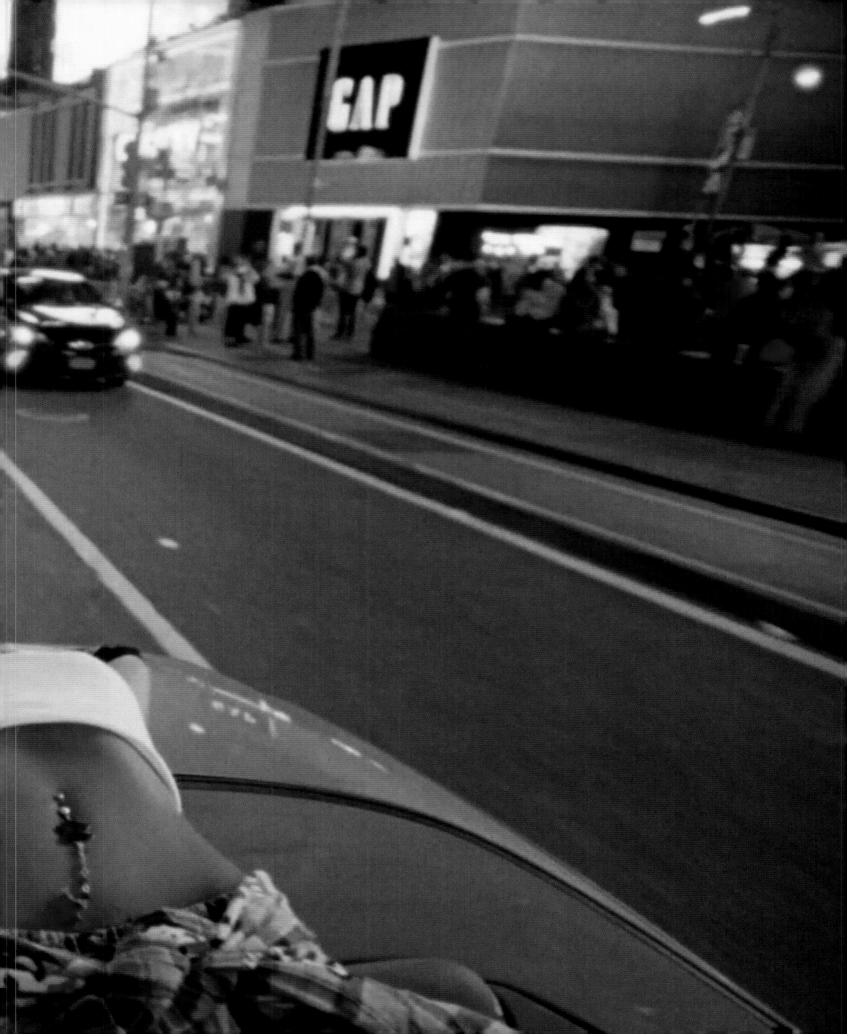

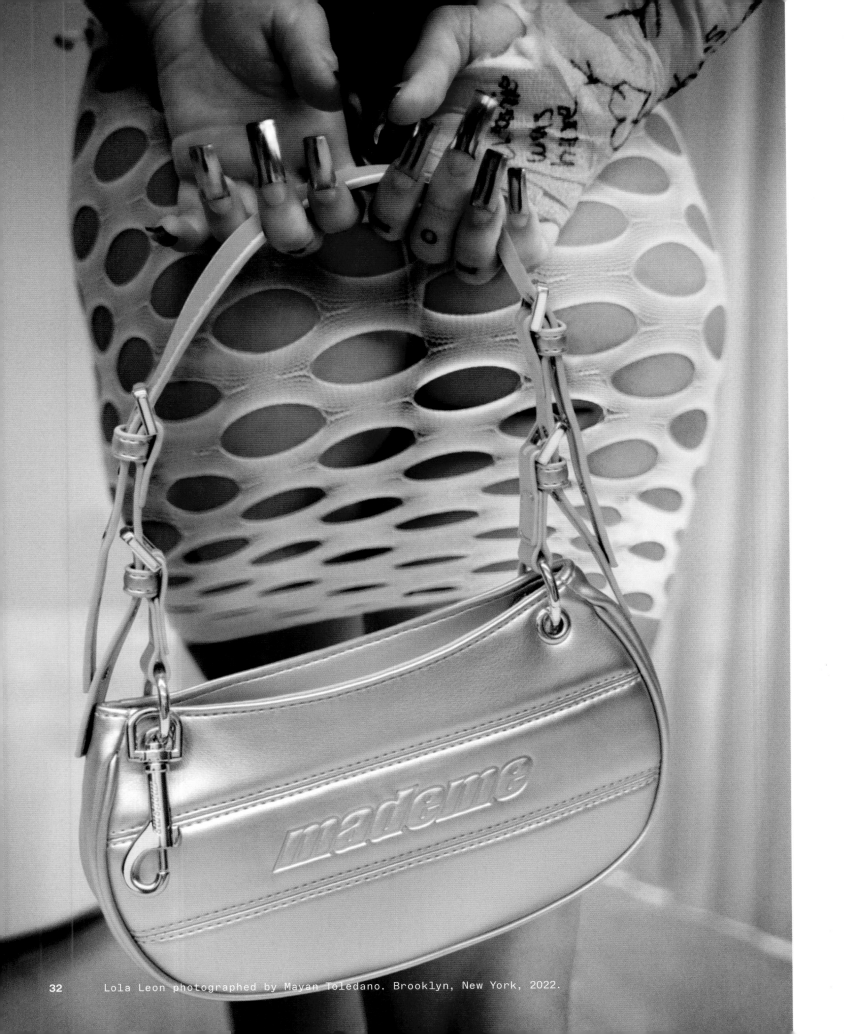

Lola Leon photographed by Mayan Toledano. Brooklyn, New York, 2022.

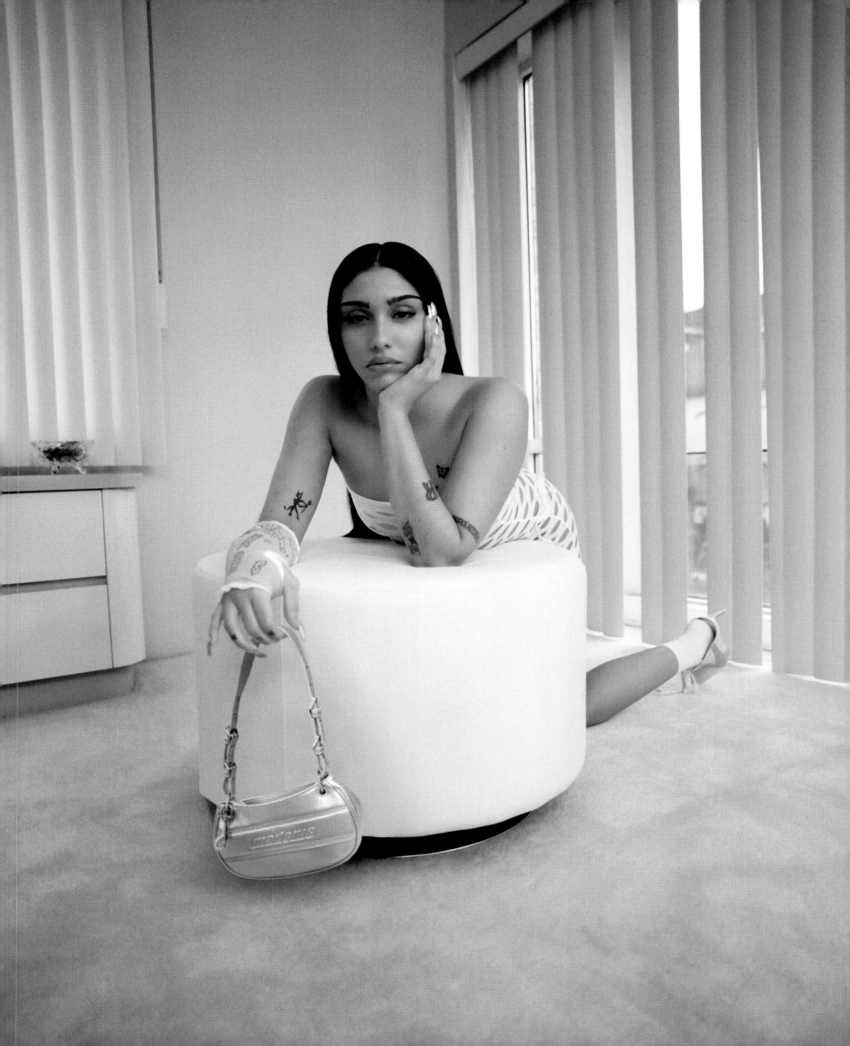

Lola and I first got together
around ten years ago. I saw on
people's Instagram stories that
she was at the clubs with my
friends. Like, what the hell?
That's Madonna's daughter! I
asked this guy to introduce
me because I was working on
an X-girl collaboration, and
I wanted her to star in the
campaign. I was pretty sure
she'd say no. At the time, she
hadn't done anything except
Material Girl, her Macy's
collection with her mom. She
agreed to go out for coffee with
me. She was so young then; it
was very awkward. I told her
what I was doing with X-girl,
and she said yes right away. She
said everyone had already asked
her to do things — serious
fashion houses, big things! —
which she'd said no to. But this
felt like more of her own thing,
so she said yes. I couldn't
believe it. She's been part of
the family ever since.

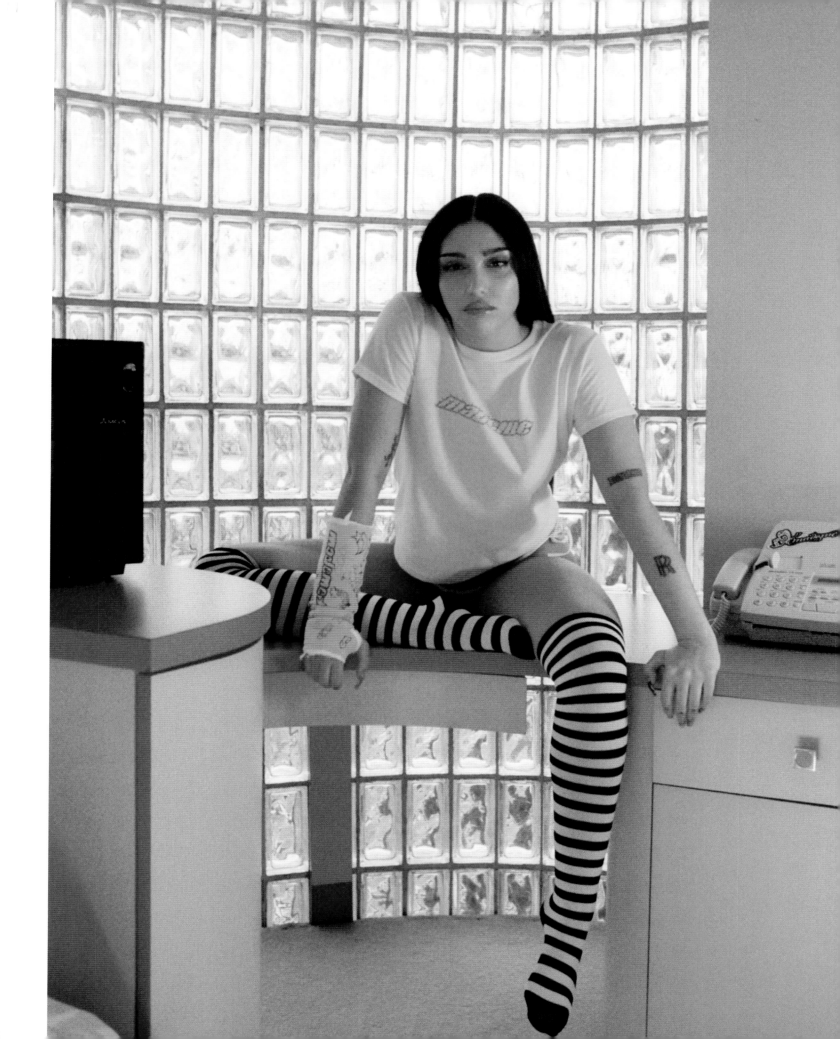

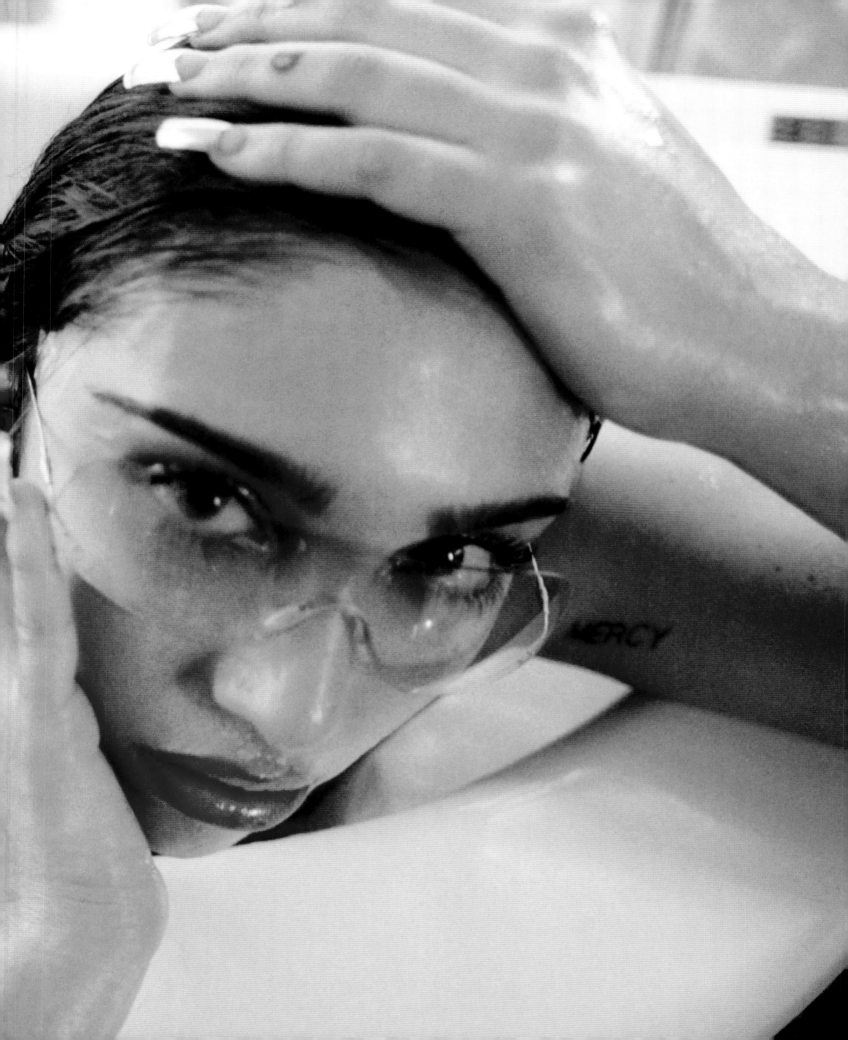

There's something about these photos that feel like, if you could squeeze them, juice would come out. Mayan found this Barbie house in Bensonhurst, Brooklyn, and we had to get Lola [Leon], queen Barbie, Barbie bitch in the Barbie house, for the shoot. Lola's like, "I can only do it if there's three bottles of rosé on set, pay me cash, and what am I wearing?" I was like, "I know the gig, Lola!"

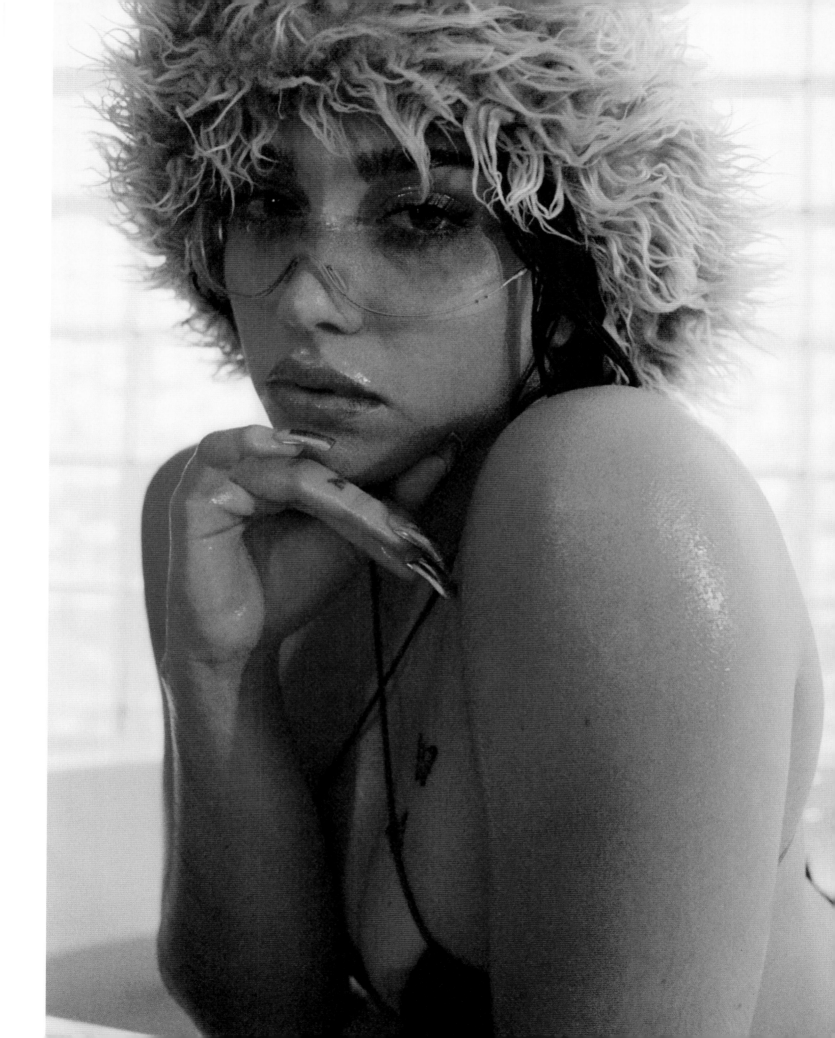

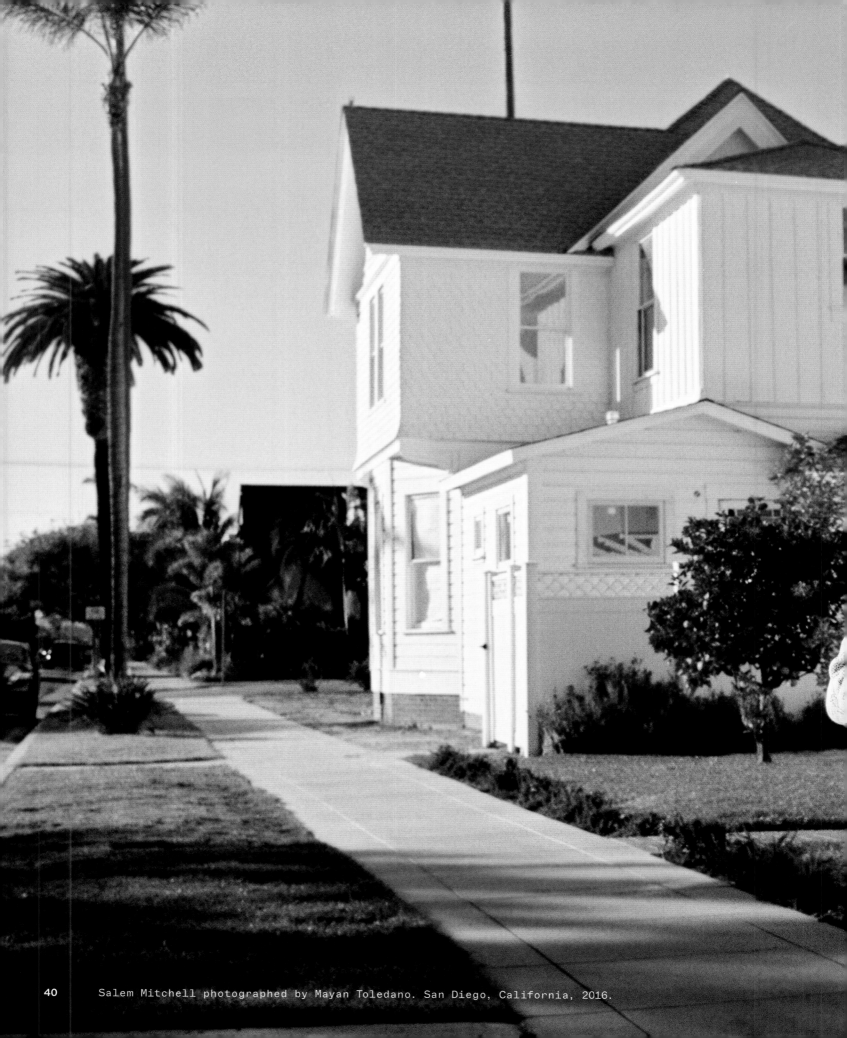

Salem Mitchell photographed by Mayan Toledano. San Diego, California, 2016.

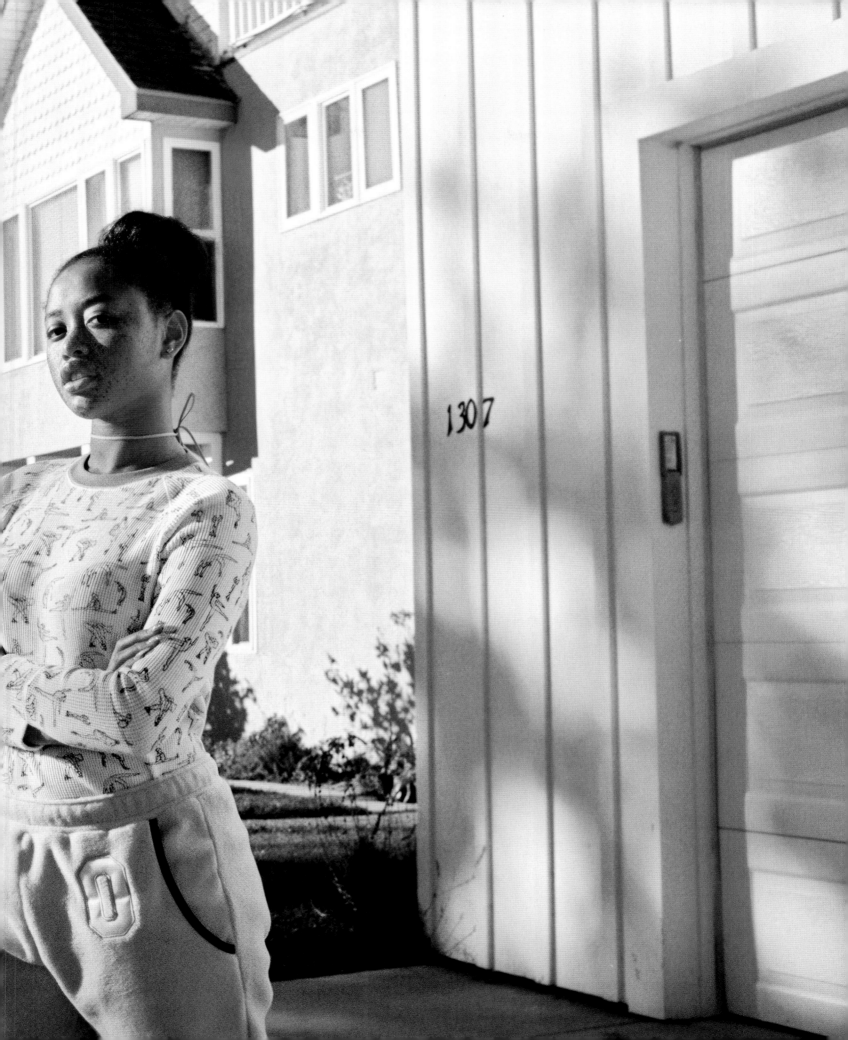

This is the first shoot Mayan
Toledano did for MadeMe. Mayan
discovered Salem Mitchell on the
internet. Mayan used to have her
own line called Me and You, so we
made a small collection together.
She even drew the ballet dancers
that are printed on the thermals.
Salem lived in the suburbs in
San Diego with her mom, so Mayan
flew out from New York for this
shoot. She must have been sixteen
or something here. I think these
are also some of the first photos
that Salem ever took. I walked
down Fifth Avenue the other day,
and Salem is everywhere now.
Billboards, stores — everywhere.

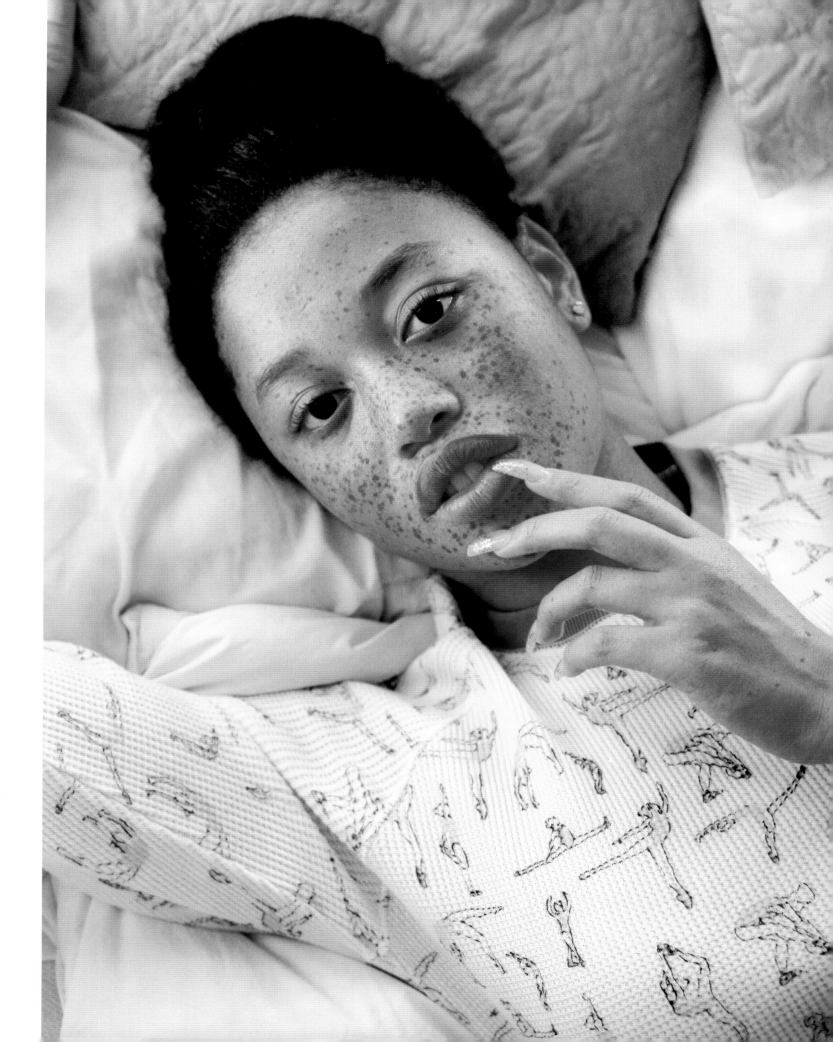

I'm obsessed with Akobi Williams.
I'm like her biggest fan. She's an
insane athlete, skater, model, and
she's so underrated. So kind.

Akobi Williams photographed by Mayan Toledano. South Amboy, New Jersey, 2023.

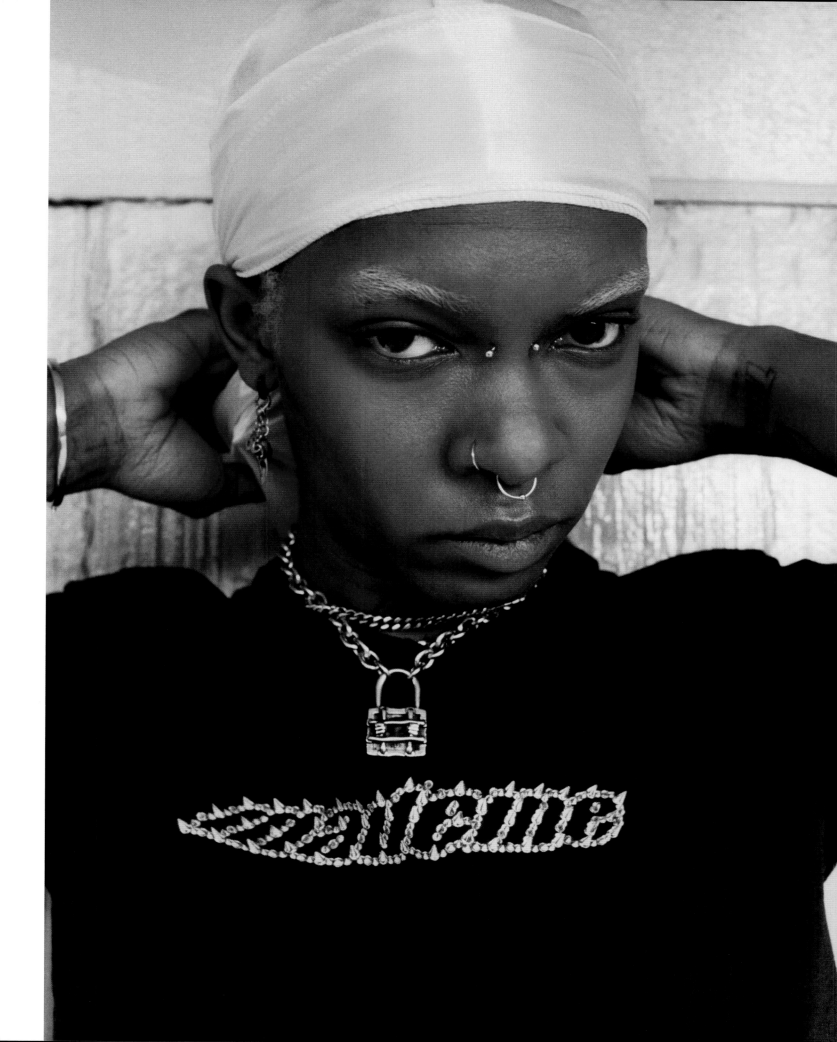

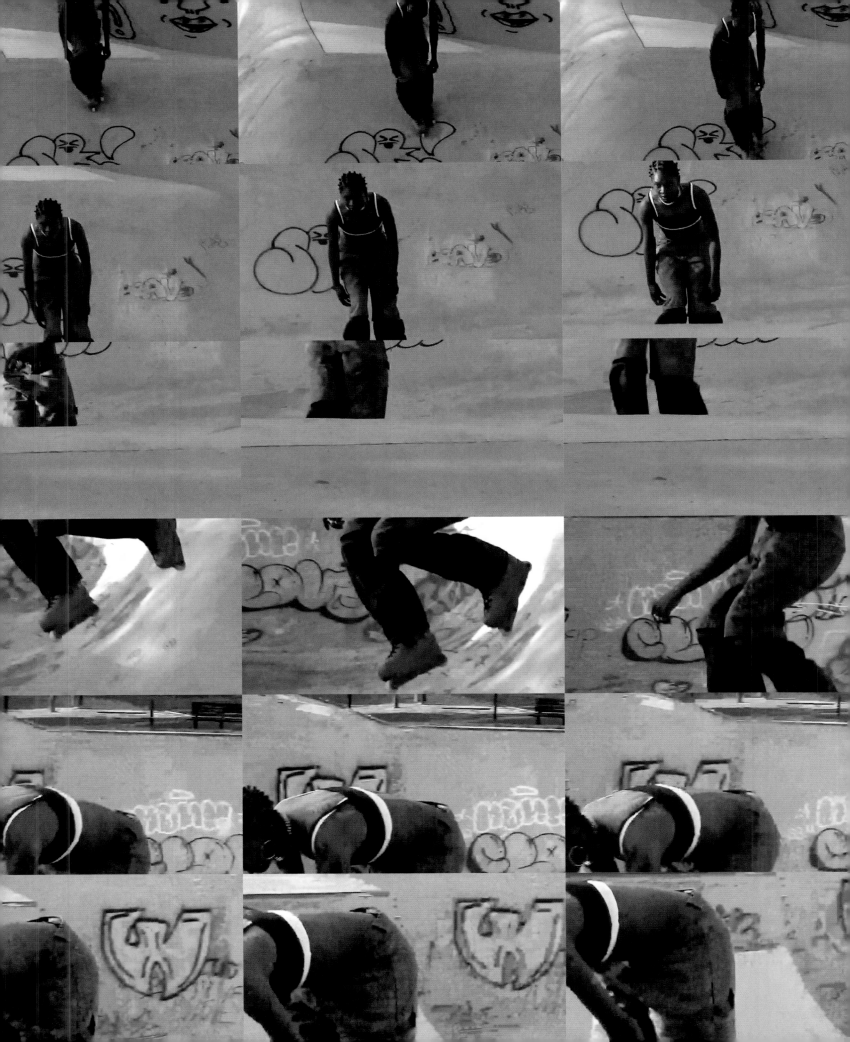

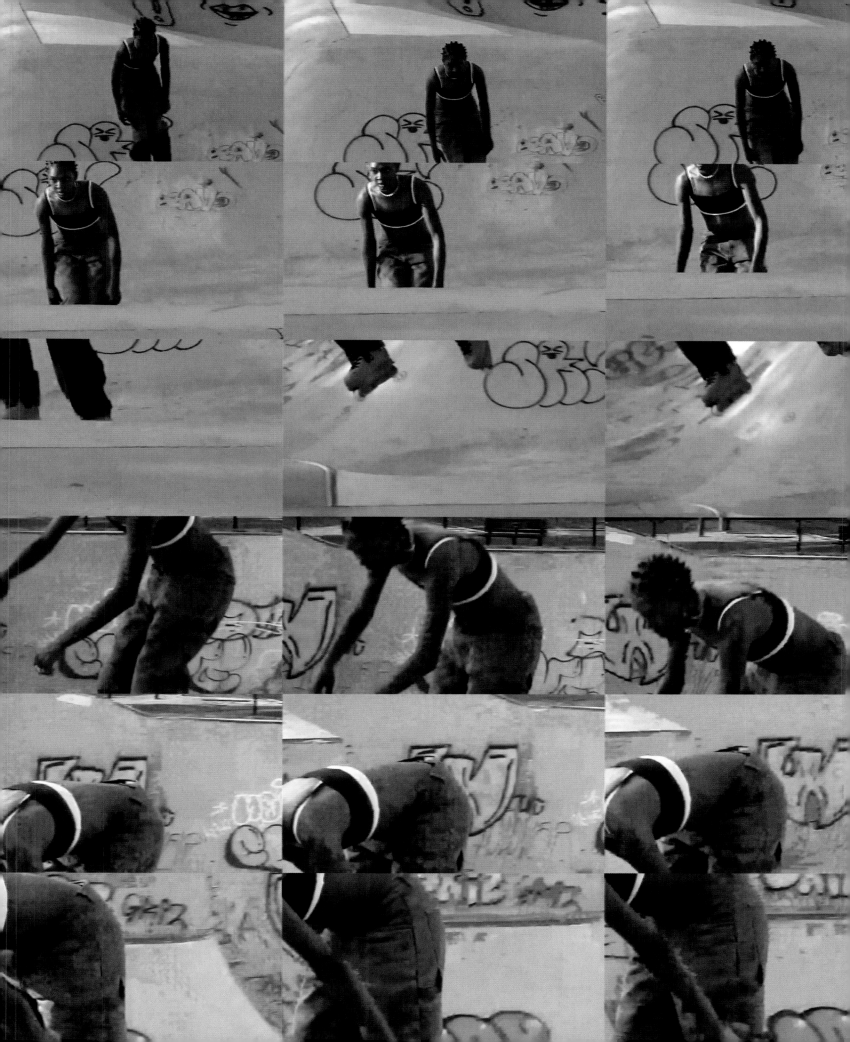

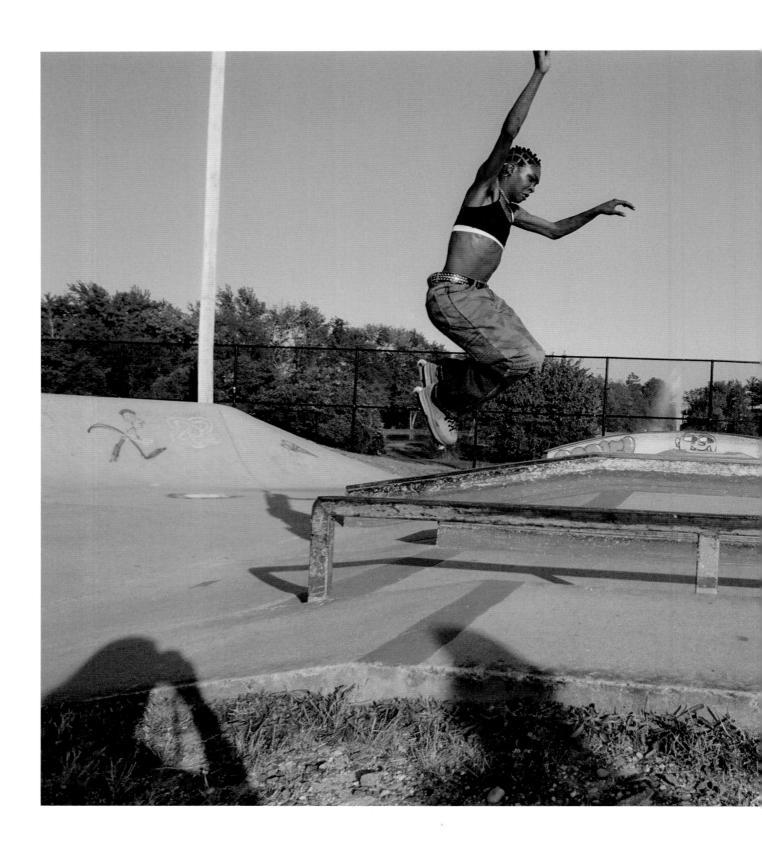

This was shot far out in Jersey.
I wanted to do rollerblading to
break away from the skate thing.
There was a baby snapping turtle
in the park, and the only one who
was brave enough to pick it up
was, of course, Akobi.

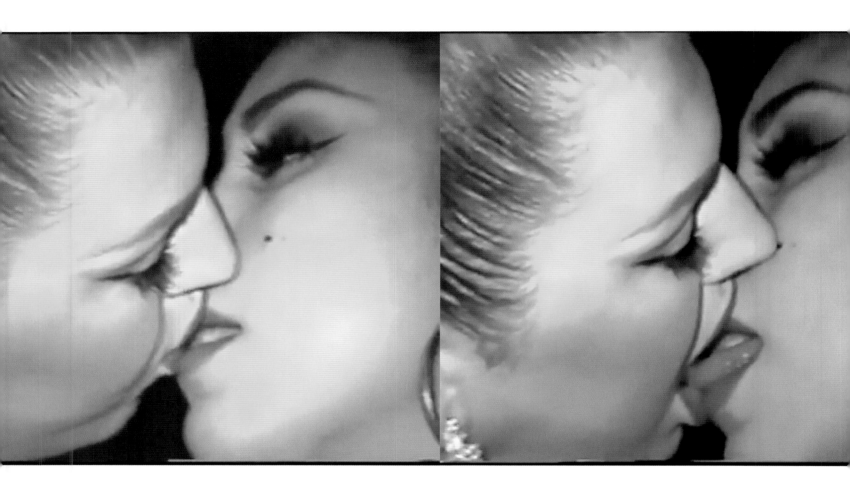

Sateen "Queenie & Ruby" photographed by Sam Puglia. Brooklyn, New York, 2017.

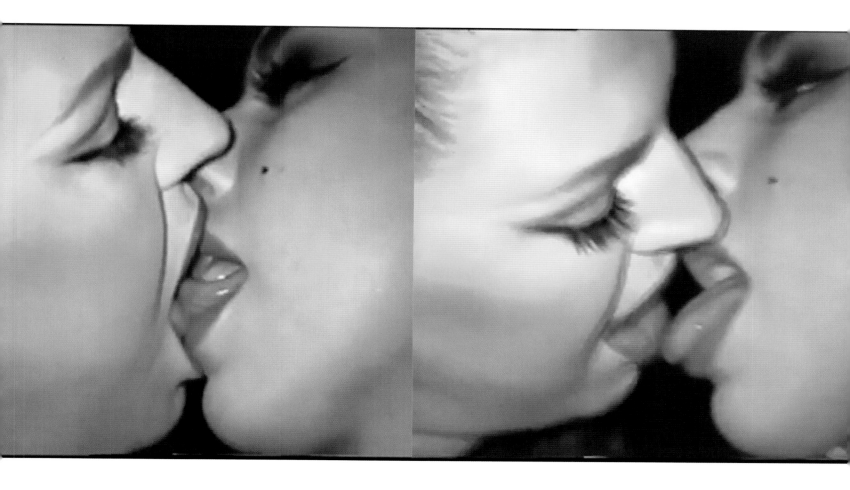

I love Sateen, and at this time
they were a couple: Queenie and
Ruby. I was eight months pregnant
when we did this campaign. I went
to their townhouse in Brooklyn
to shoot a video with Sam Puglia,
Lola's best friend. The T-shirt
said "For Vaginal Use Only." After
the shoot, Sam went out with them
to the Boom Boom Room, and my
pregnant ass went home.

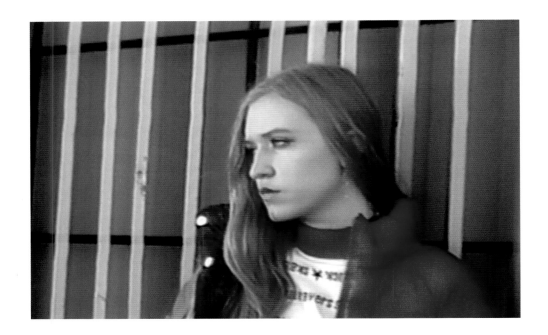

This was my first X-girl collection. No one had done anything with X-girl yet; I was the first person to do it. I wanted to pay homage to a brand that was important to women's involvement in culture. I wanted people to care and pay attention. Kim Gordon was the founder of X-girl and, of course, the frontwoman of Sonic Youth. I read Kim's autobiography; in the late '90s, when she was pregnant, she sold the brand partly because she wanted to spend time with her baby. So I thought, *Let's find that baby!* Coco was going to school in Massachusetts, and I had to find my way to her. I asked Chloë Sevigny to connect me to Kim, and it worked out.

Coco Gordon Moore photographed by Ricky Saiz for MadeMe / X-girl. Los Angeles, California, 2016.

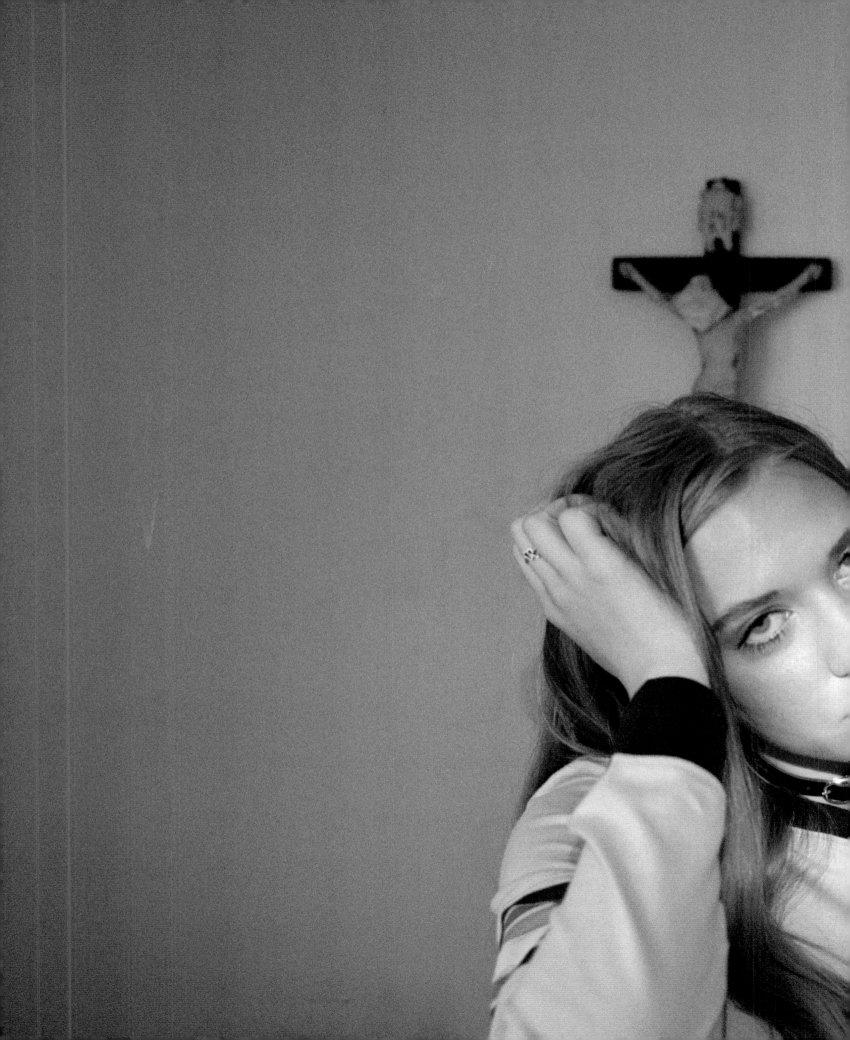

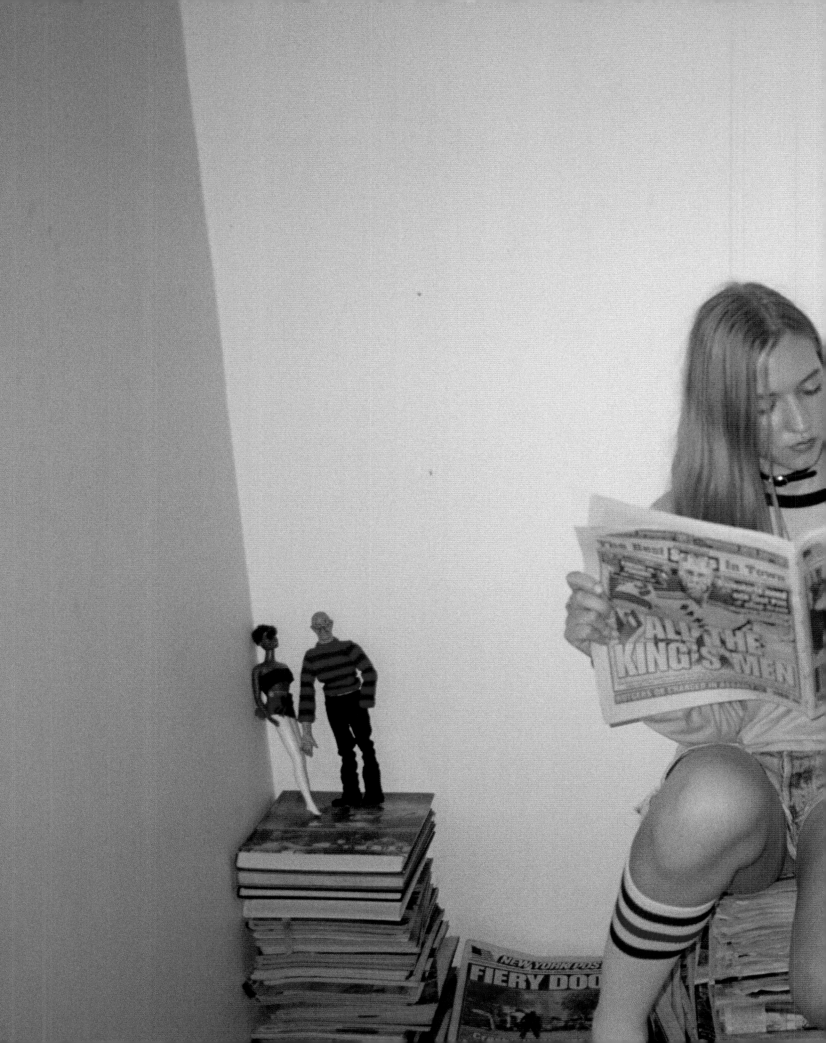

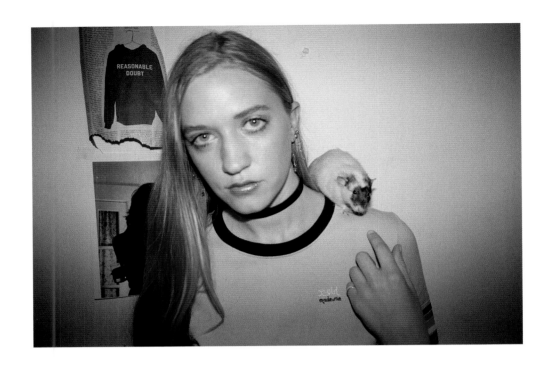

I flew out to LA, where Kim was
living, to do the shoot. Coco
didn't have a cell phone at
the time, and I remember being
asleep in LA and her calling me
on a landline to schedule a cab
to get to the airport at four
in the morning. She was flying
from Massachusetts to LA. Pre-
Uber! We shot in Jason Dill's
house. We rented rats. As Kim was
looking through the clothes, I
was shitting my pants, I was so
nervous. This was shot by Ricky
Saiz, the photos came out so
beautifully — I am really proud
of this moment. We made it happen.

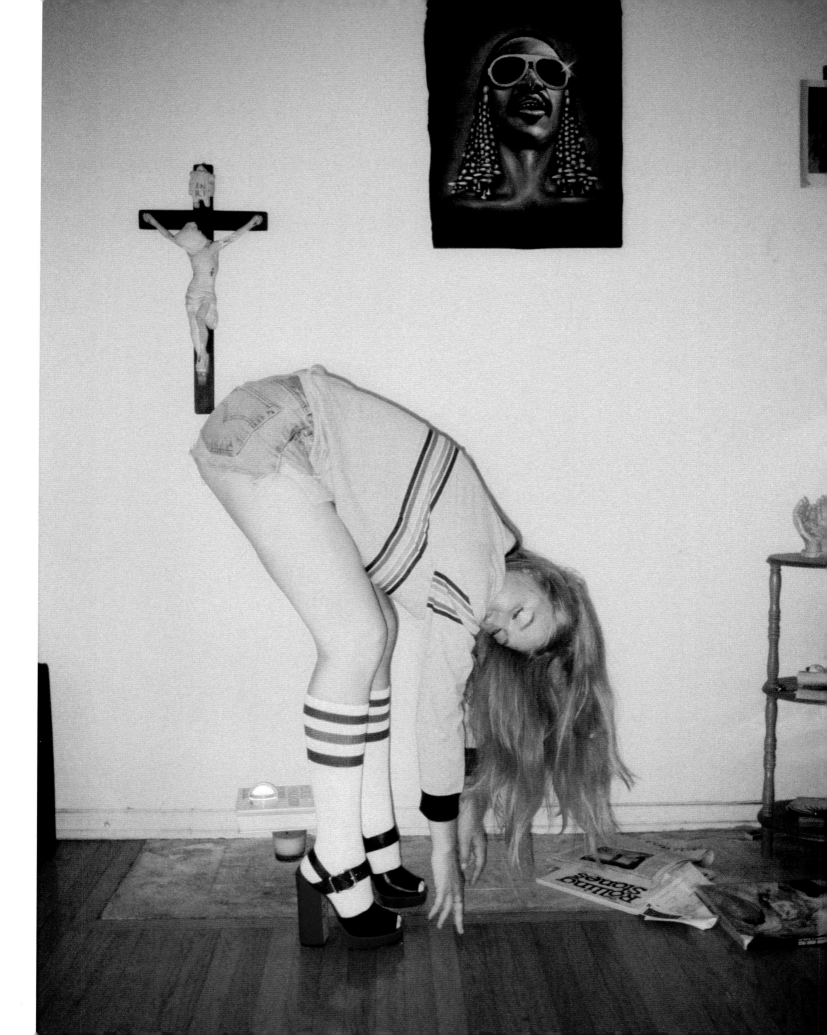

Lisa lived on my block in Chelsea. She had a full face of makeup on every day — a full look, very New York, with a baggy sweatshirt, cargo sweats, and Timbs. She had like a full living room set-up, a TV, a couch, electricity somehow plugged into the side of a building on the street. I'd see her and her boyfriend every day on the block; they were my friends. One day I asked if I could shoot her in a tee, I gave her $100 cash. She's such a MadeMe girl.

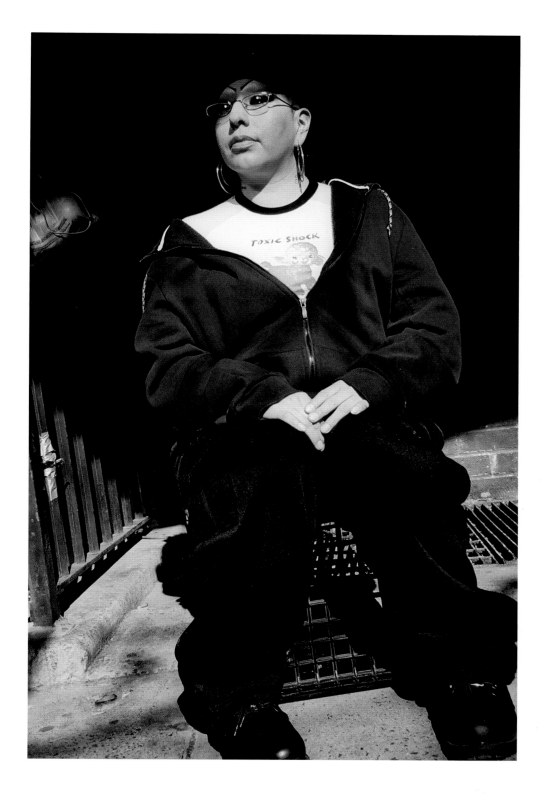

Lisa photographed by Erin Magee. New York, New York, 2017.

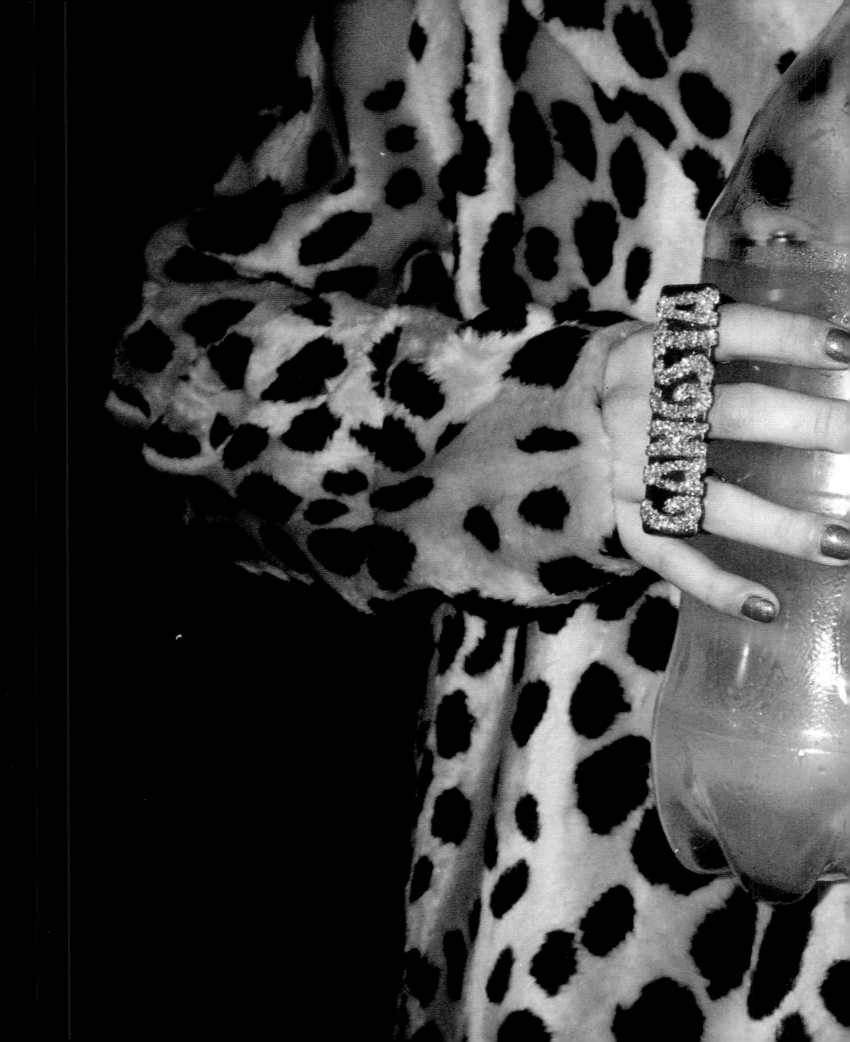

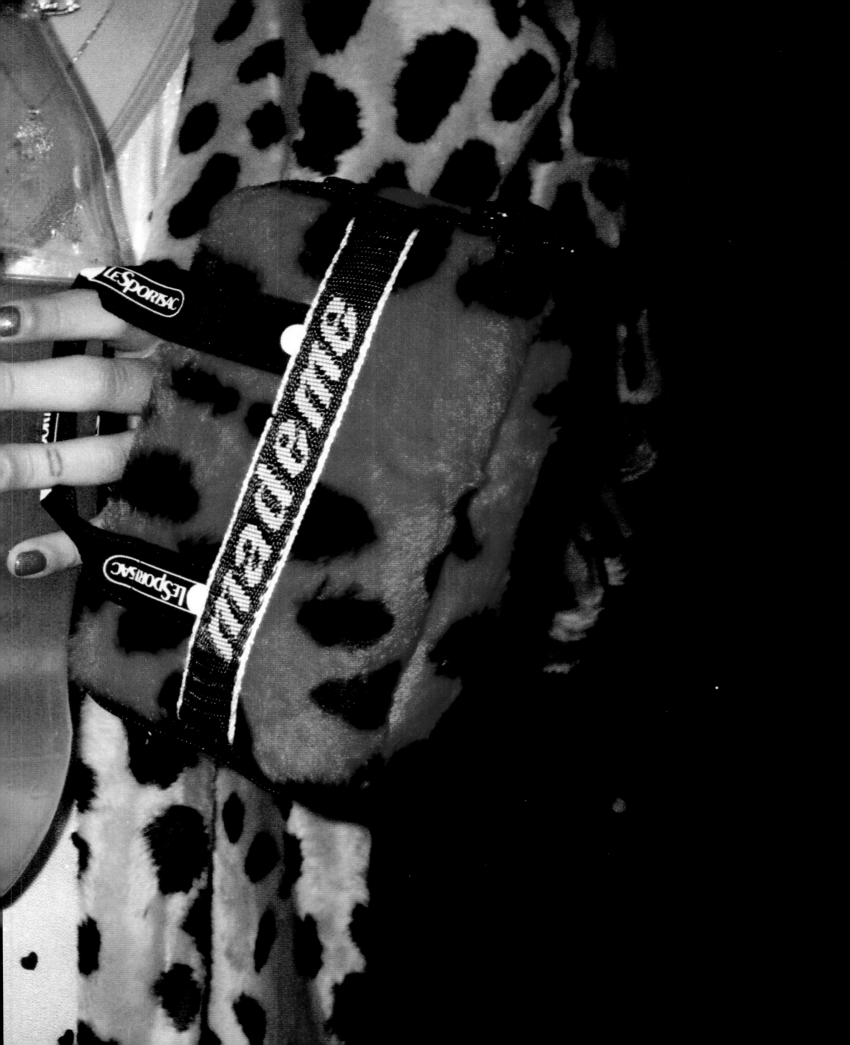

These bags are from the LeSportsac
collection I did for a couple
years. They are shot by Moni
Haworth, and this is her daughter
Amber. I worked with Moni pretty
early on; I found her on the
internet. She used to have this
blog — it was called *Johnny's Bird*
— and I remember thinking, *This
photographer is so fucking good*.
She was one of the first to do the
low-fi scanned look. When I found
out that Amber was her daughter,
everything clicked. Cool-ass mom.

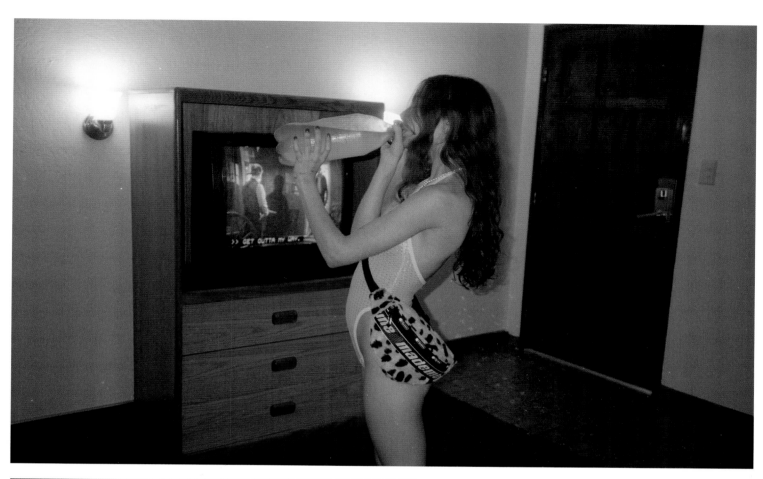
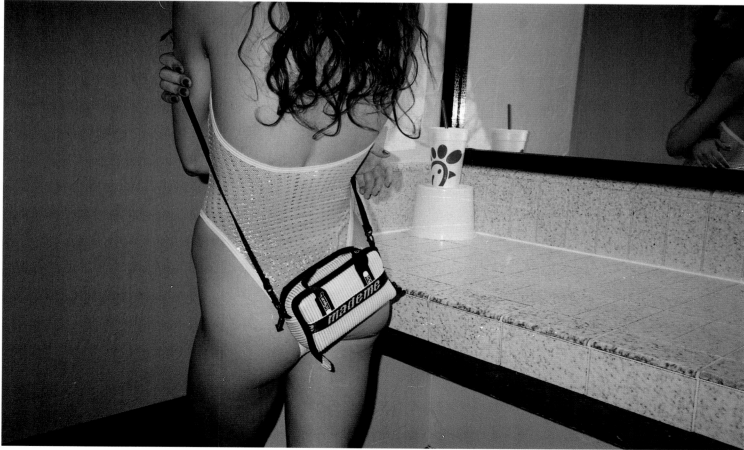

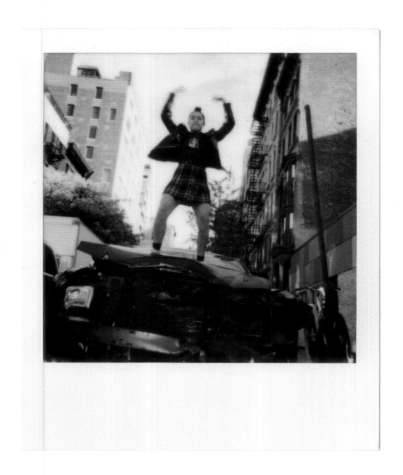

The fully embroidered sleeves on this leather motorcycle jacket are in reference to a jacket that Sinead O'Connor wore. Manon [Macasaet] shot these photos of Destiny. They came to my house, it took like thirty minutes. It was 2016, right after the presidential election. Donald Trump had won the day before, and we were all so depressed. We found this wrecked car, and I told her to get on top of it. Reclamation.

Princess Nokia photographed by Manon Macasaet. New York, New York, 2016.

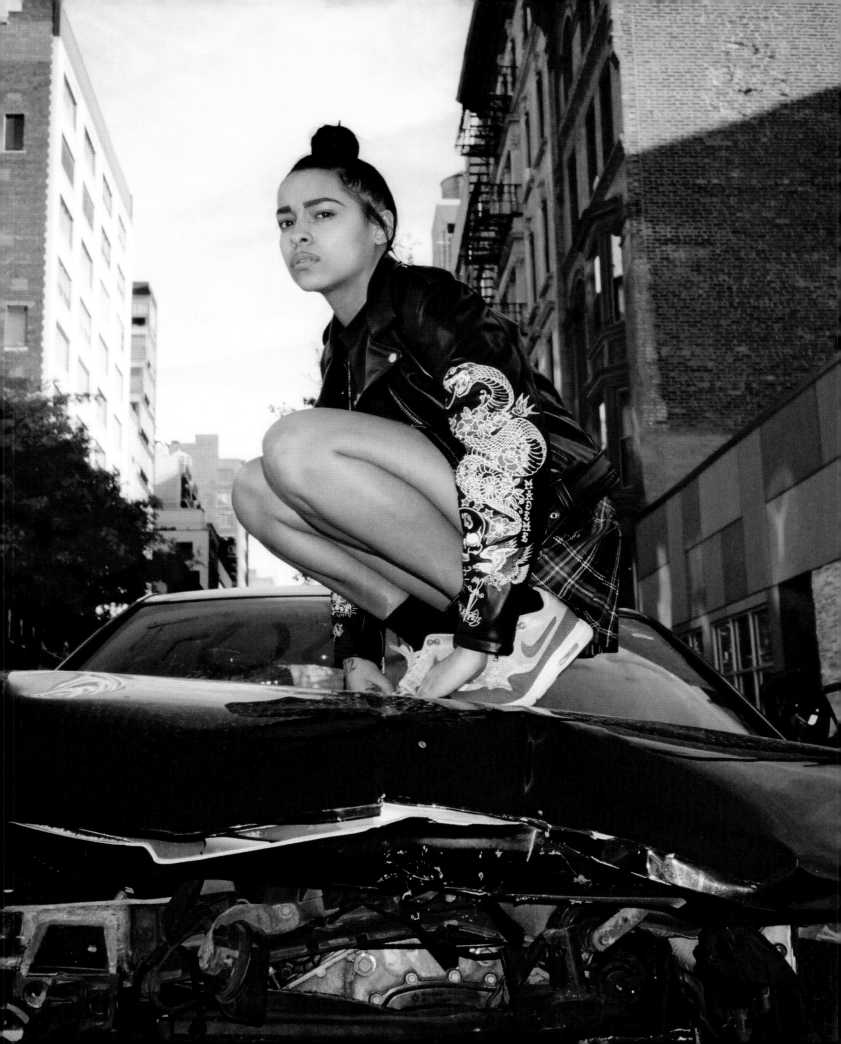

Two-Tone Kilt, Fall 2015.

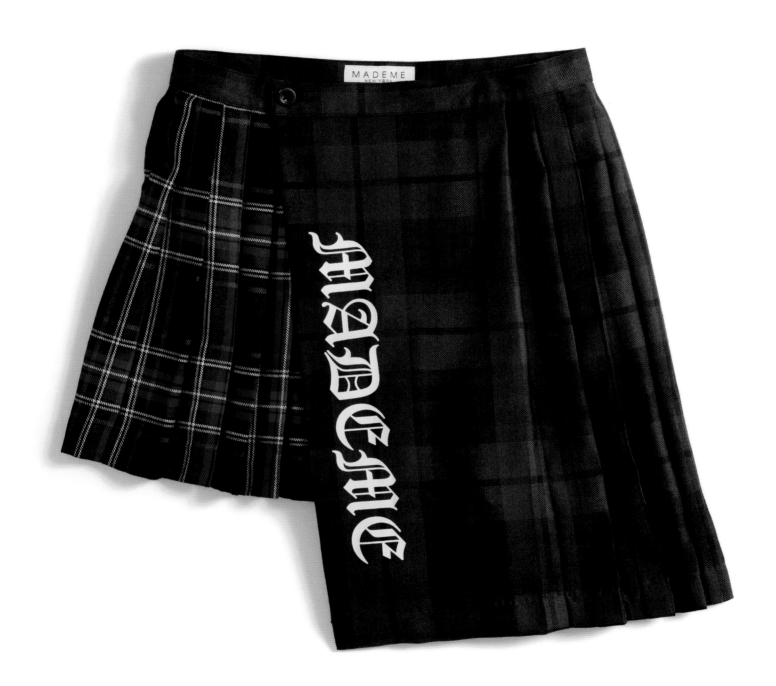

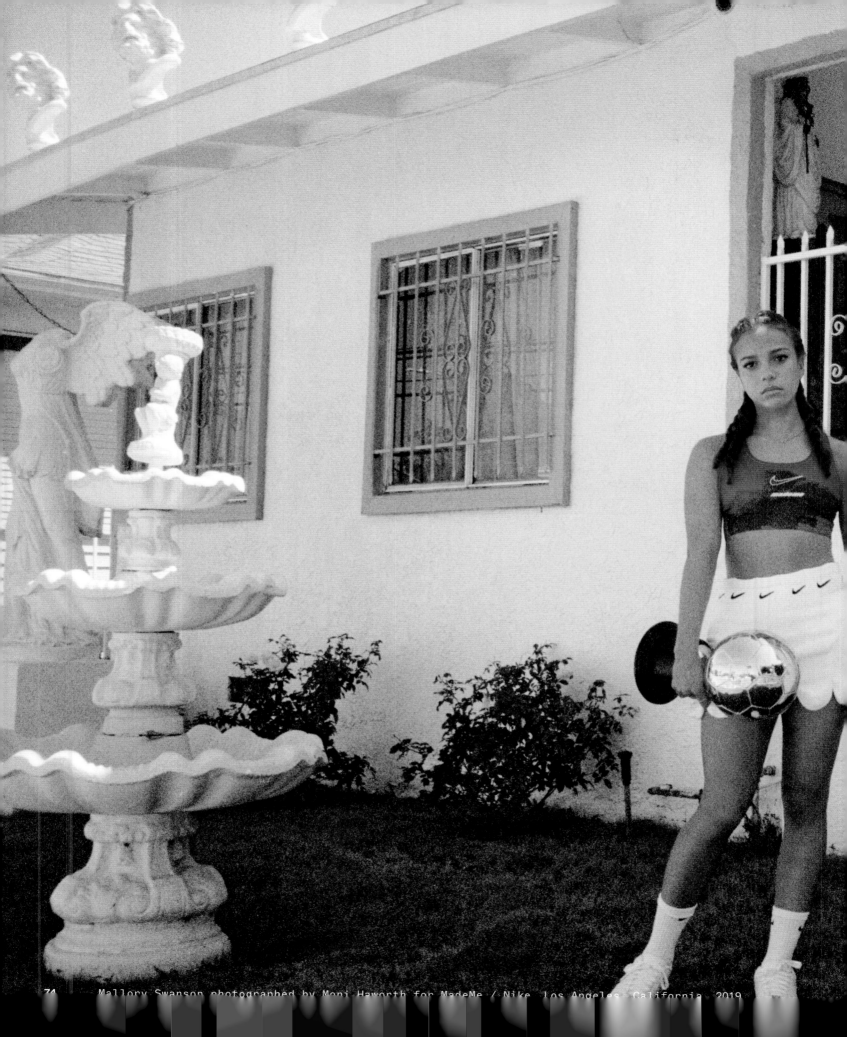

Mallory Swanson photographed by Moni Haworth for MadeMe / Nike, Los Angeles, California, 2019

This was my Nike collaboration.
A crazy meeting of the stars:
my design assistant at the time
spotted this house in LA and
sent it to me. It had statues of
Nike, the goddess of victory, all
over the lawn, even on the roof.
The production staff at Nike was
able to get us into this fucking
dude's house! Moni shot these of
Mallory Swanson, who was playing
for the US Women's National Soccer
Team. At the time, she was the
youngest player to play US Women's
national soccer. Big Deal. Kyle
Luu styled the campaign, and she
sewed together all these Nike
tube socks into this skirt. In
the studio, my concept was to get
infinity mirrors and a million
trophies. A girl covered in
achievement, in victory and gold.

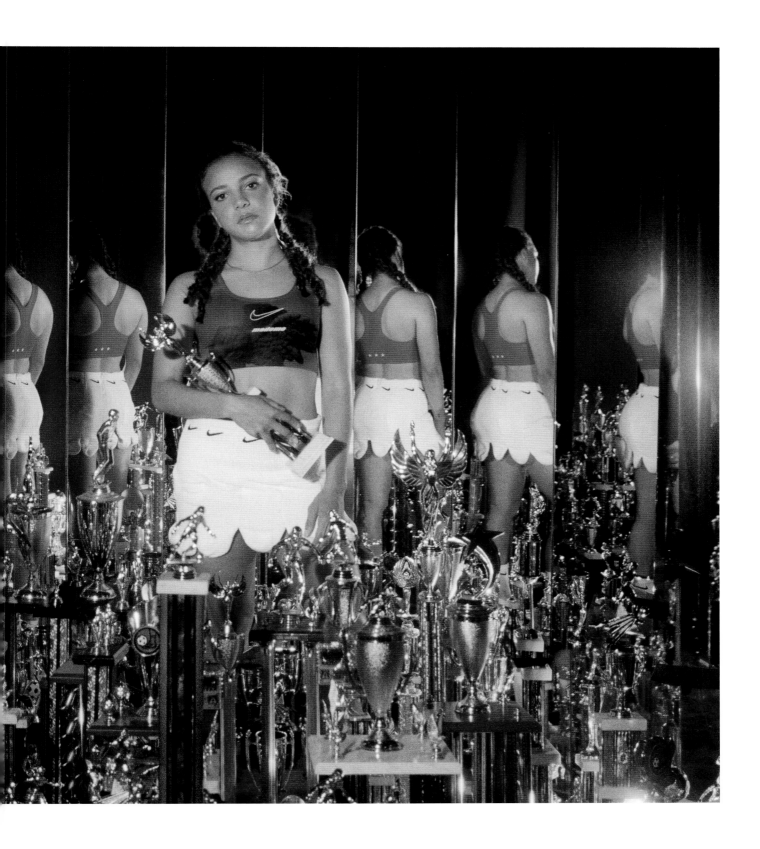

This was early days, Petra
Collins. I was selling this
leather jacket at Opening
Ceremony and Petra DM'd me
asking to trade a photoshoot
for the jacket. Naturally I
said yes. She was like, "Let's
do a zine." This was shot in my
old apartment, in my bedroom,
with Manon and Ajani. It was the
first time I met Mayan. She was
working with Petra at the time.

Caroline Jayna, Manon Macasaet, and Ajani Russell photographed by Petra Collins.
New York, New York, 2015.

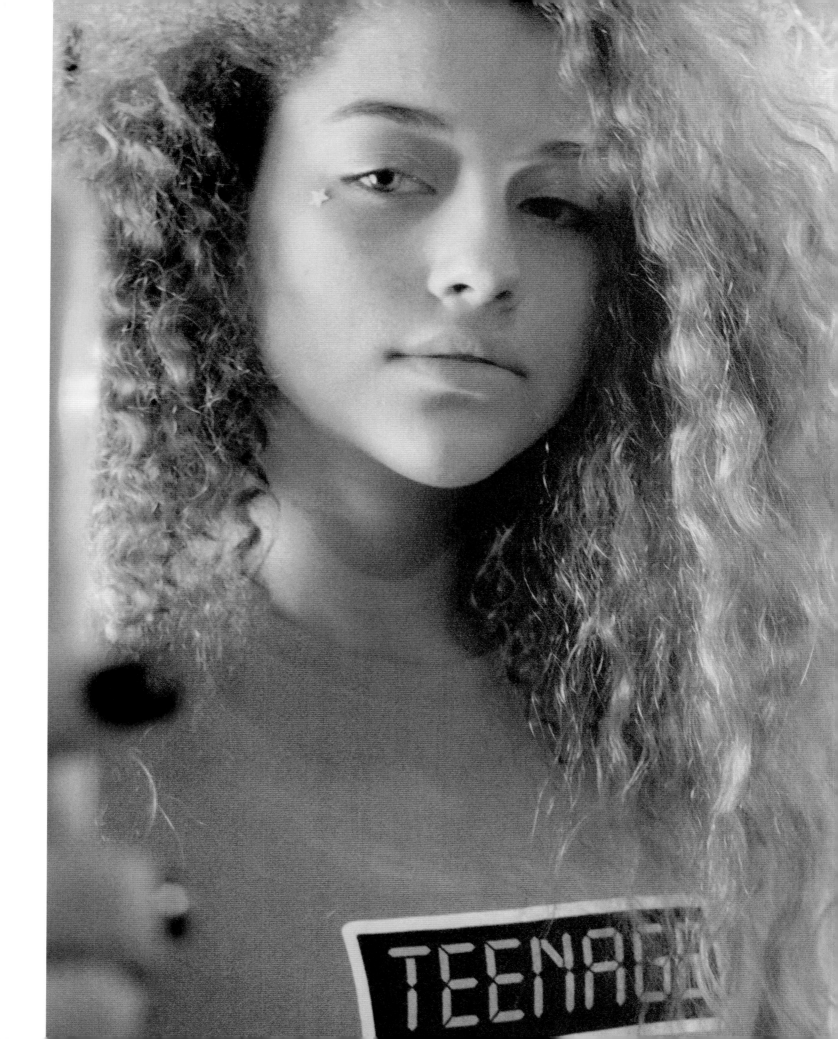

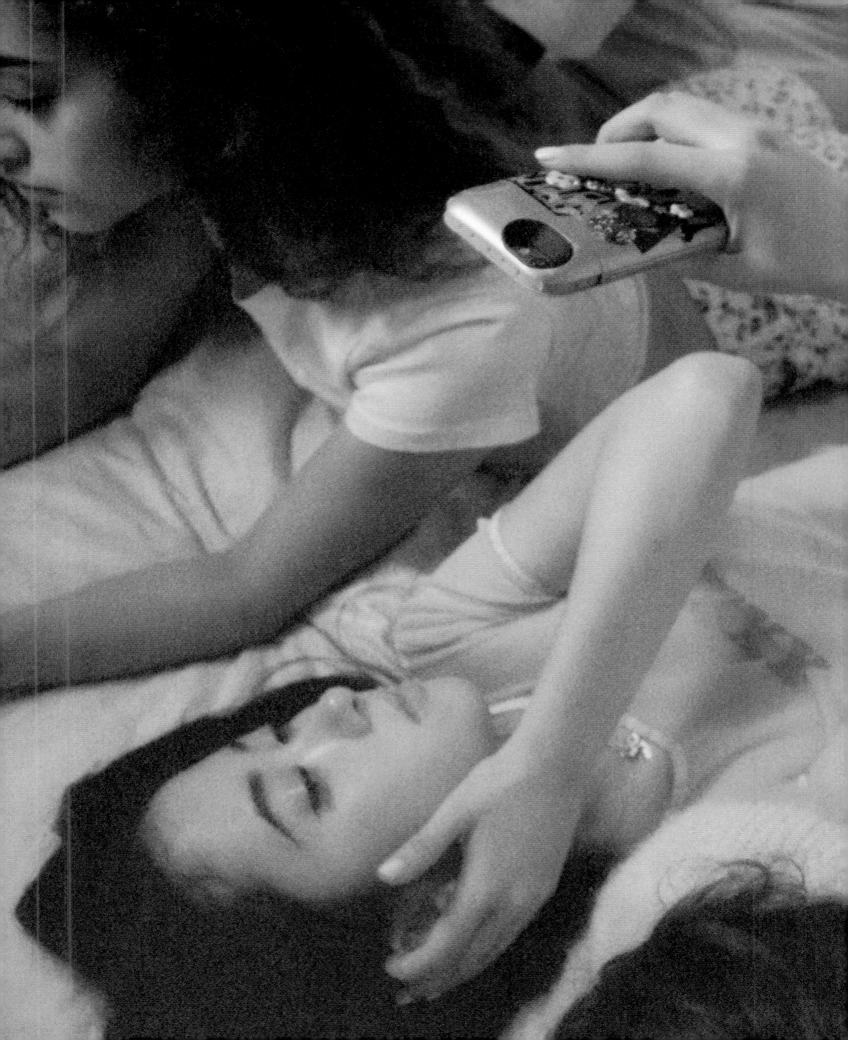

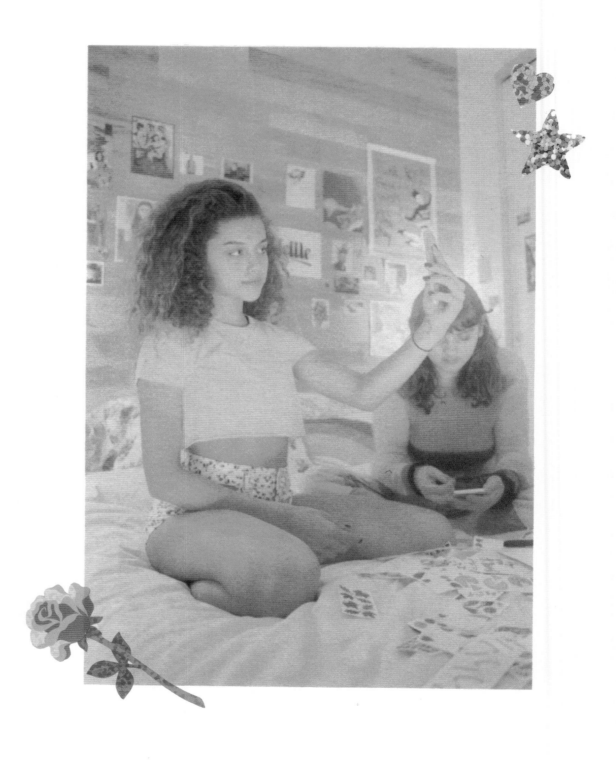

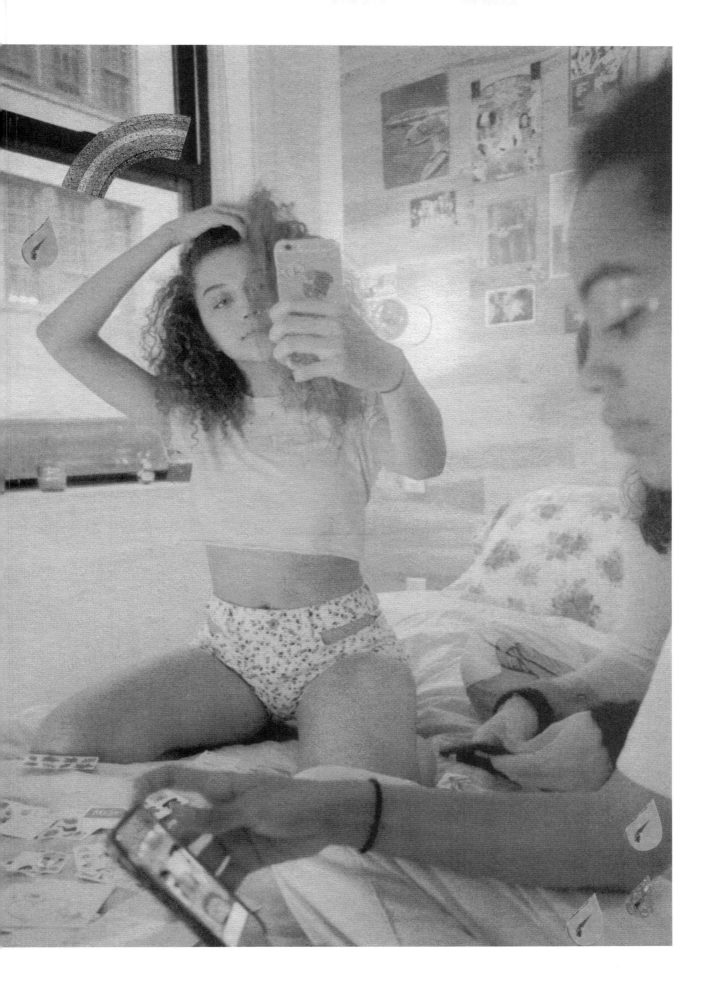

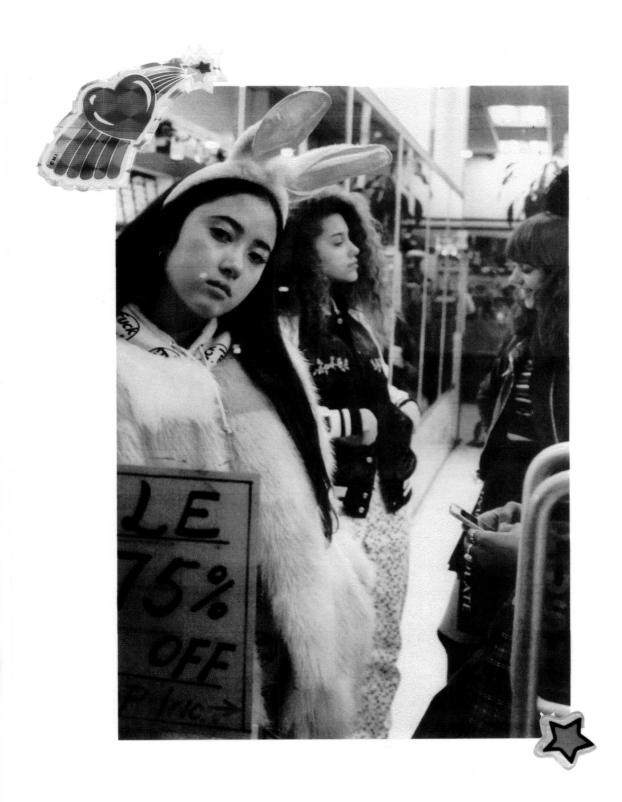

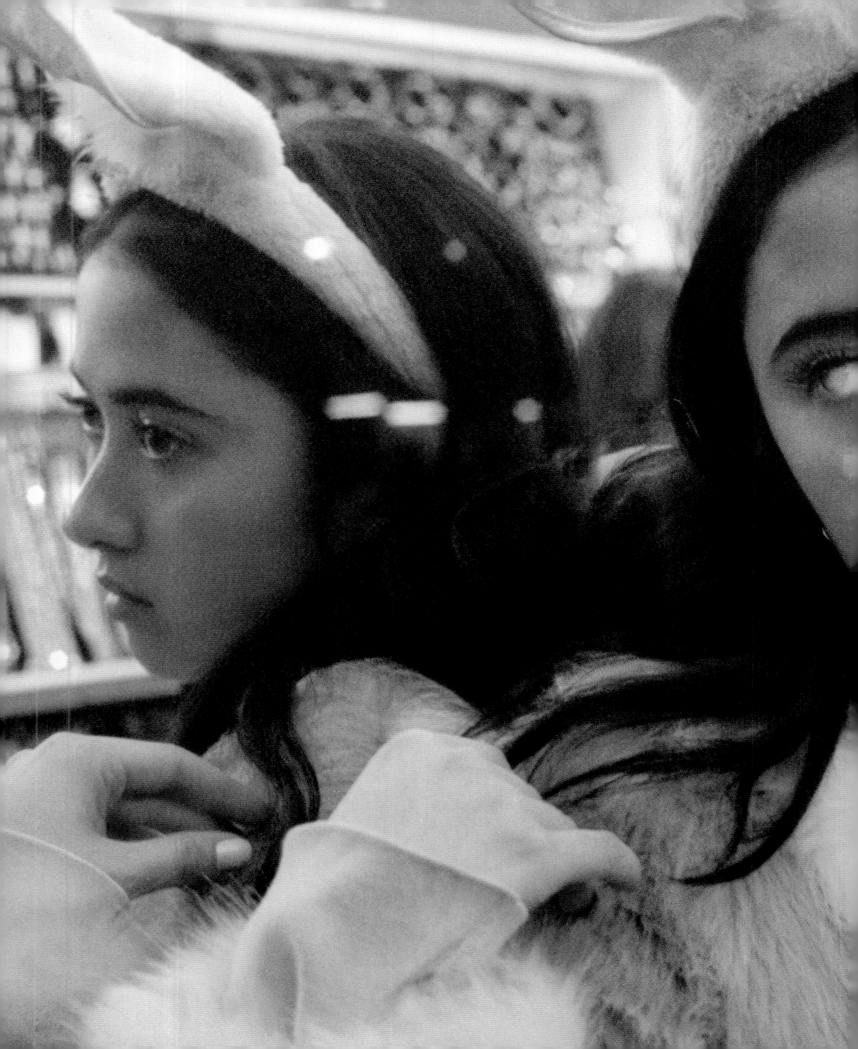

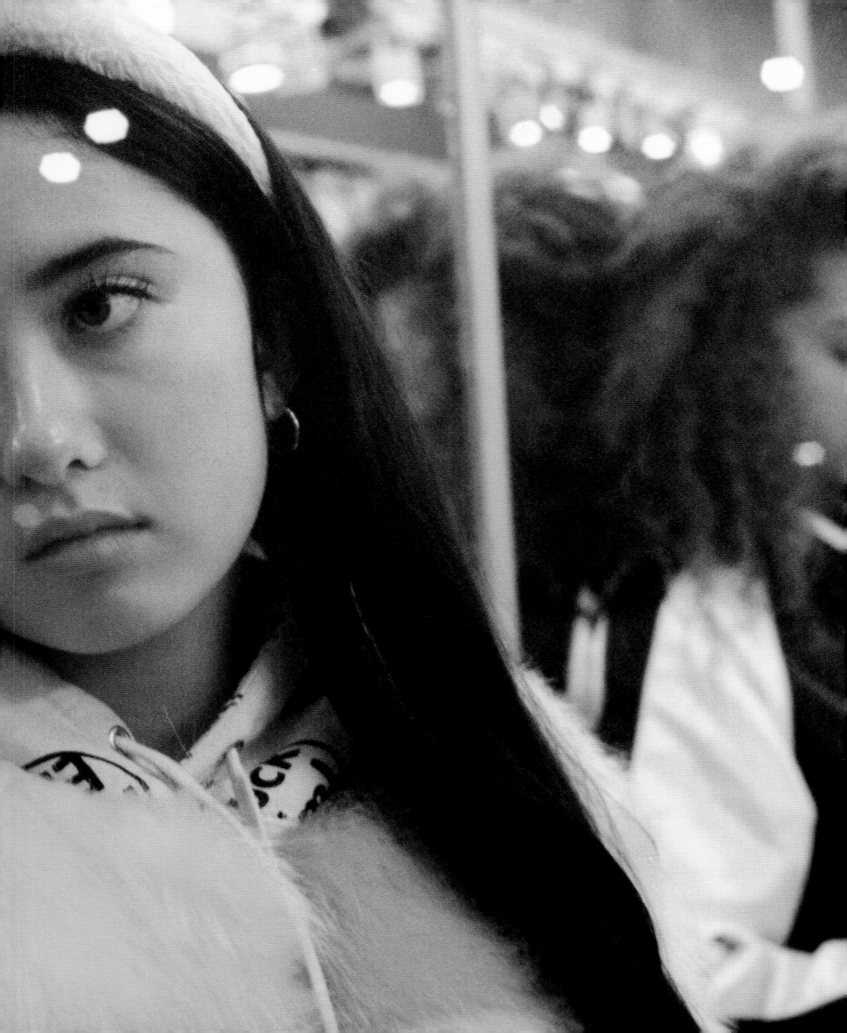

Pussy Tee, Spring 2018.

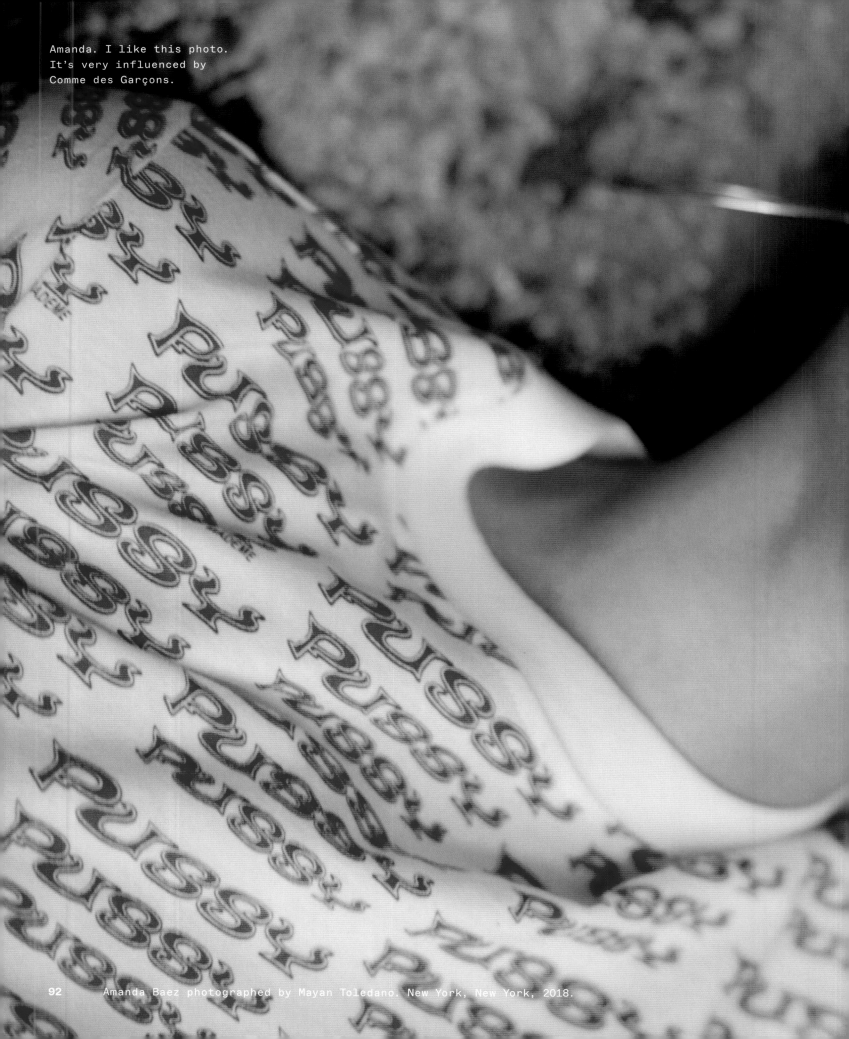

Amanda Baez photographed by Mayan Toledano. New York, New York, 2018.

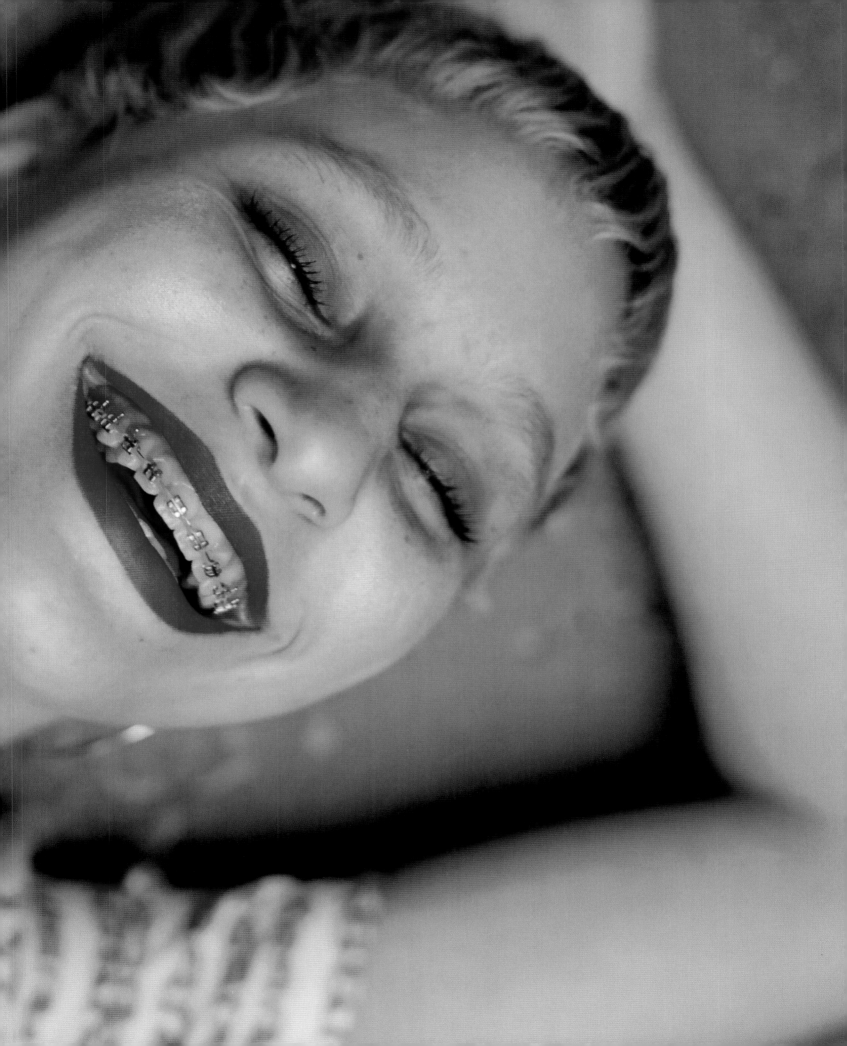

Lola Leon photographed by Mayan Toledano. New York, New York, 2023.

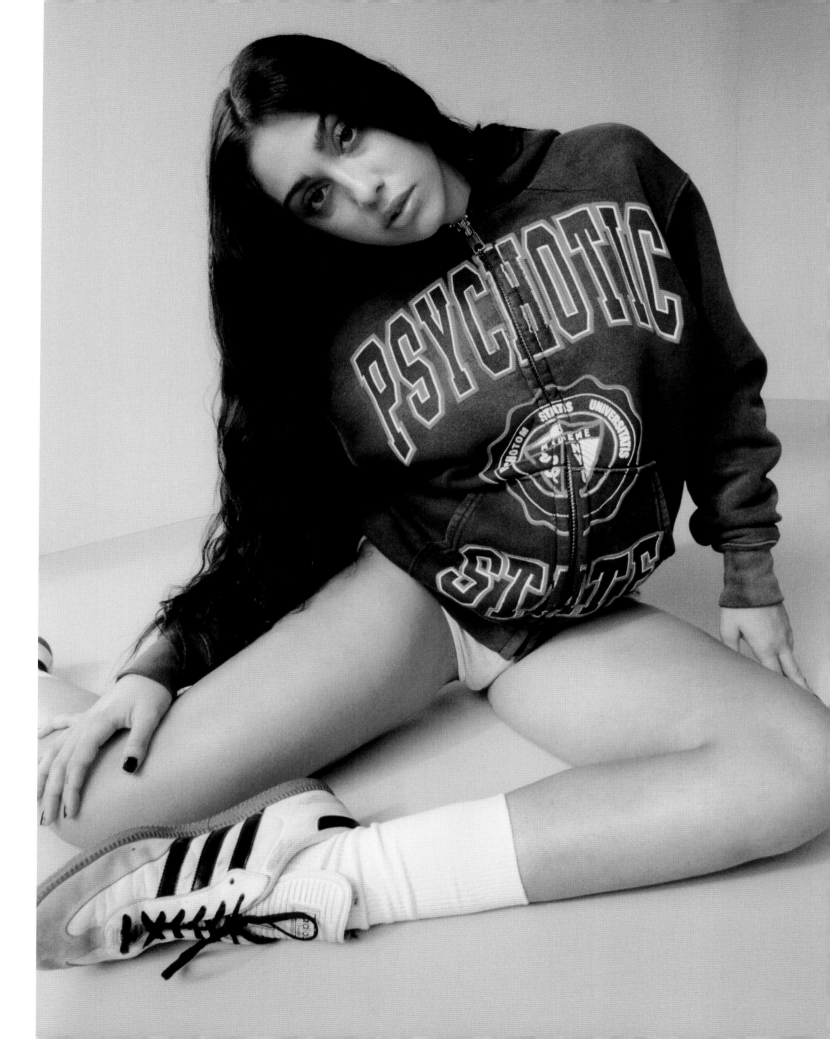

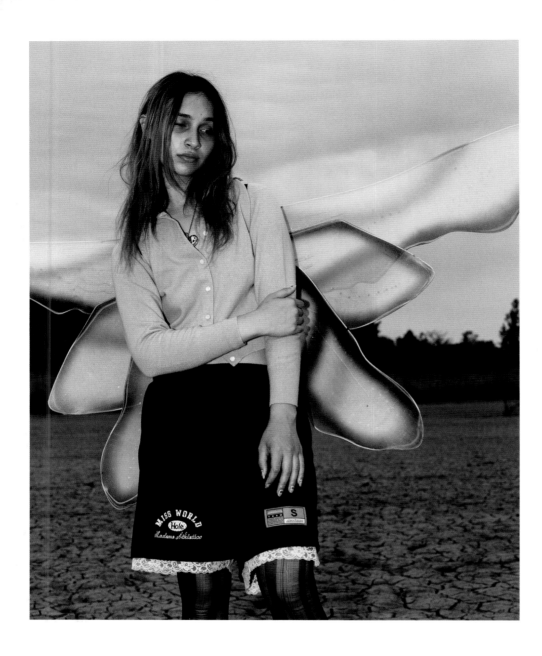

This was shot in Cleveland, Ohio. Most of the girls were street-casted by Zara Mirkin and Michelle Mansoor. I was really scared to visually represent this Hole collaboration because the band had such an influence on my young life, musically and visually. I didn't go to the shoot. Erika Kamano shot them. Later I heard that Paige (smoking vape) was only fourteen and Rylee (eating cake) was ten. In the end, I thought these images were very strong. I wonder if Courtney saw them, she would probably hate them!

Isabella Gianna Reed, Paige Kukuloff, and Rylee Parsley photographed by Erika Kamano for MadeMe / Hole. Cleveland, Ohio, 2024.

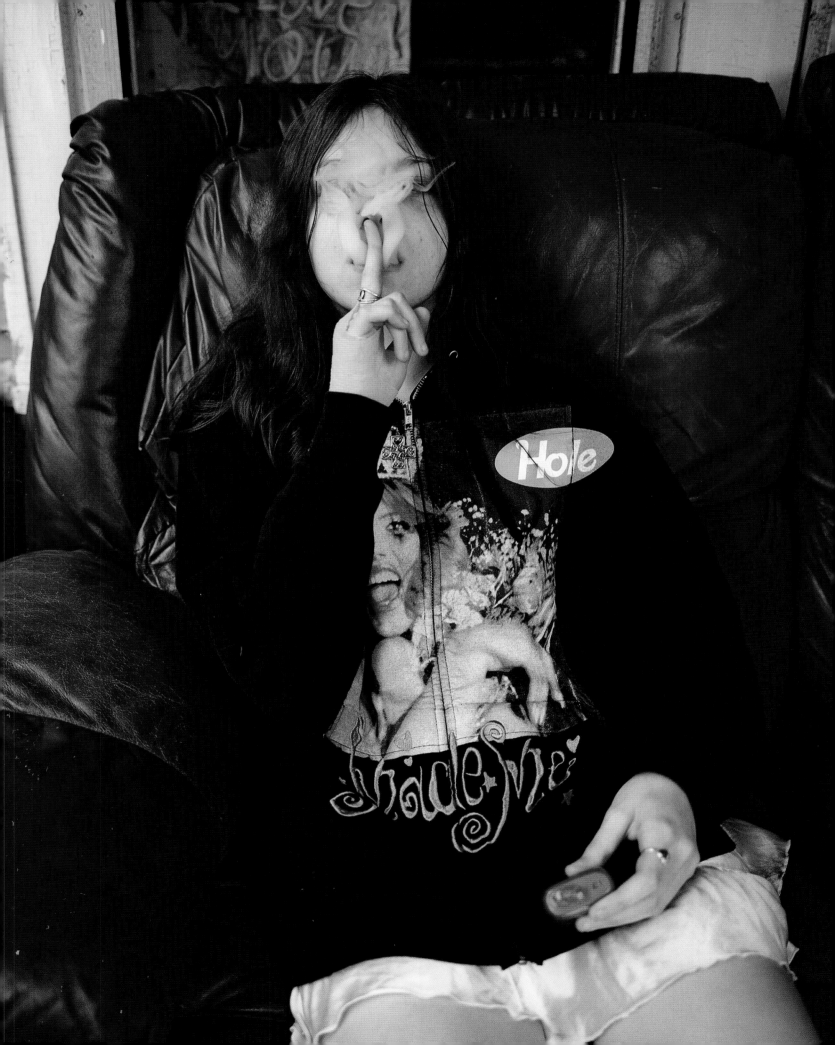

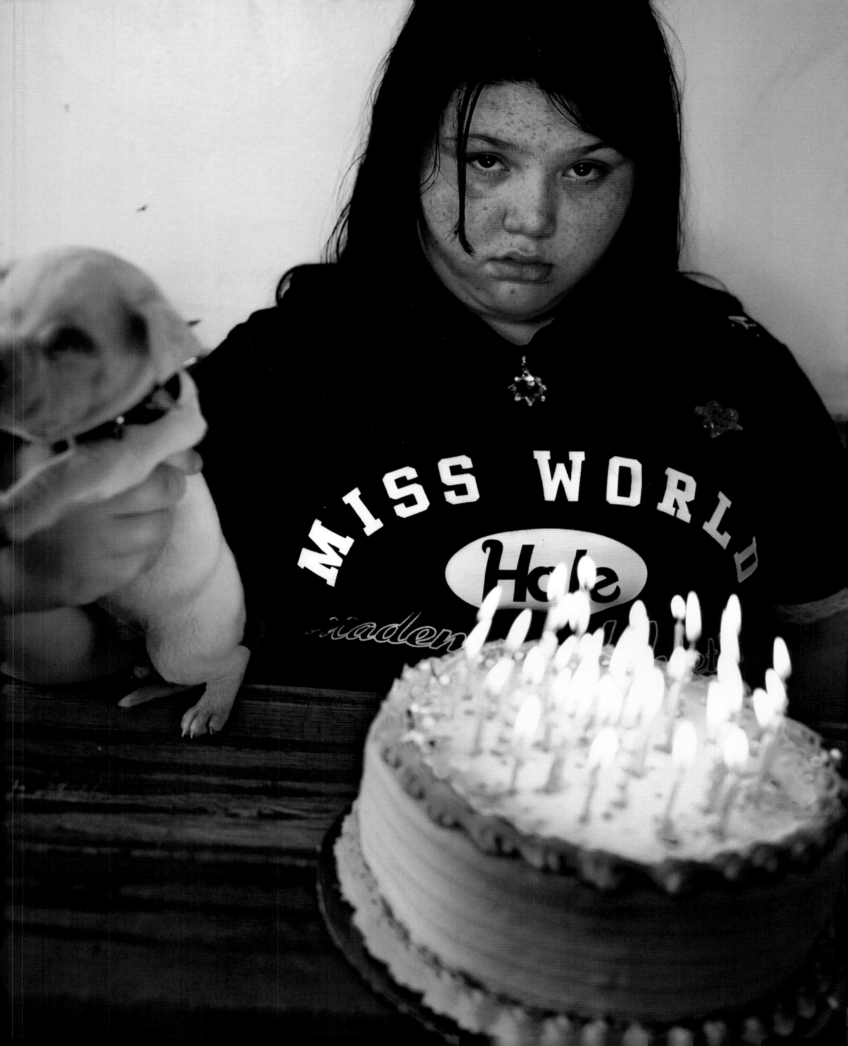

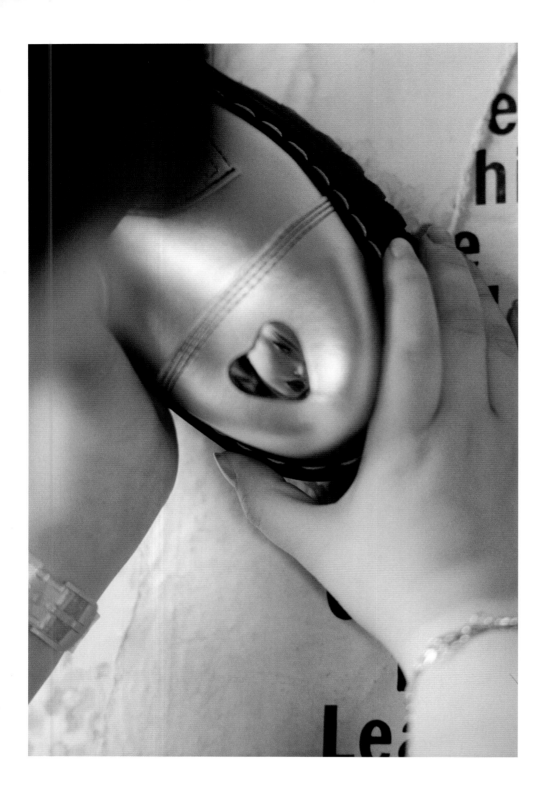

These are from the Dr. Martens collaboration, the first in a series of shoes we're doing together. This is Lola Young. She's a young, cute singer in the UK and I found her on the internet. We flew out to London to do the shoot, and Mayan took the photos. On set was the first time I met Lola; she told me she had stayed up all night to break up a physical fight and call the cops, so she was "tired." Right then, I knew I liked her.

Lola Young photographed by Mayan Toledano for MadeMe / Dr. Martens. London, England, 2024.

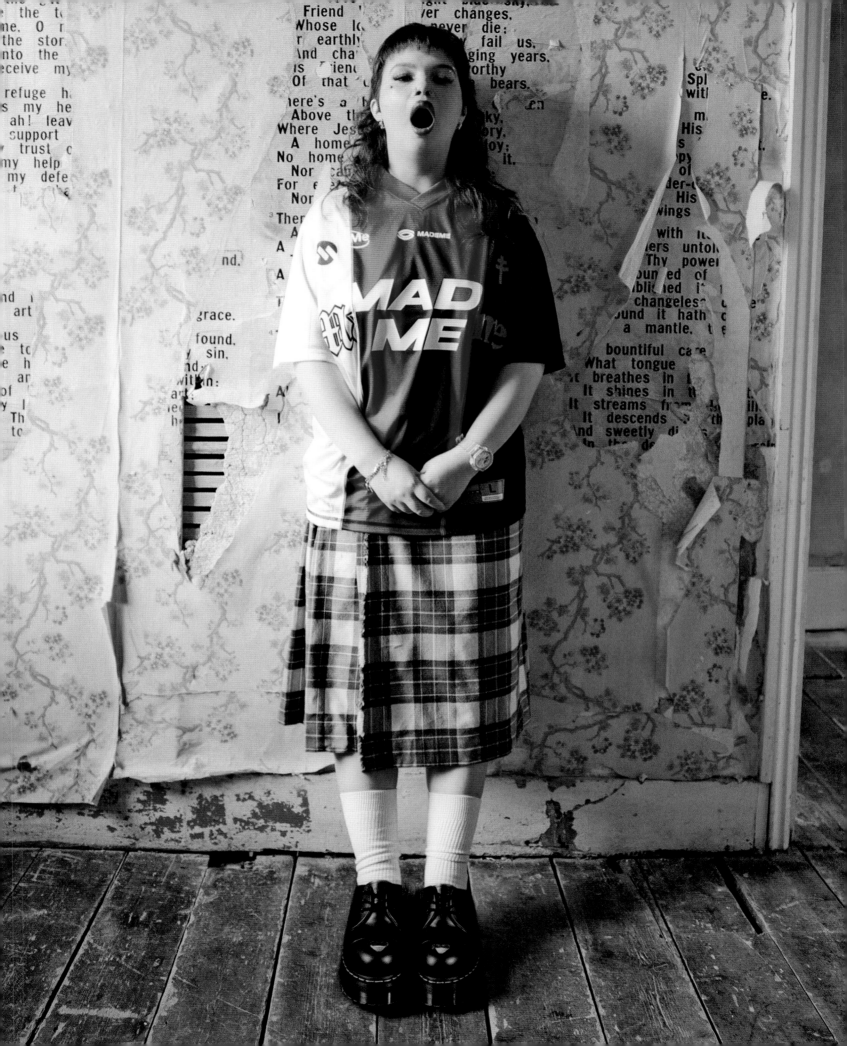

I brought back this '90s sneaker
model called "The Wally" for this
Vans collection. Fat laces, fat
tongues. Alexis Gross shot these;
Vans suggested her. Rarely do I
agree with a person suggested by
a collaborator, but she did a good
job. I like these photos.

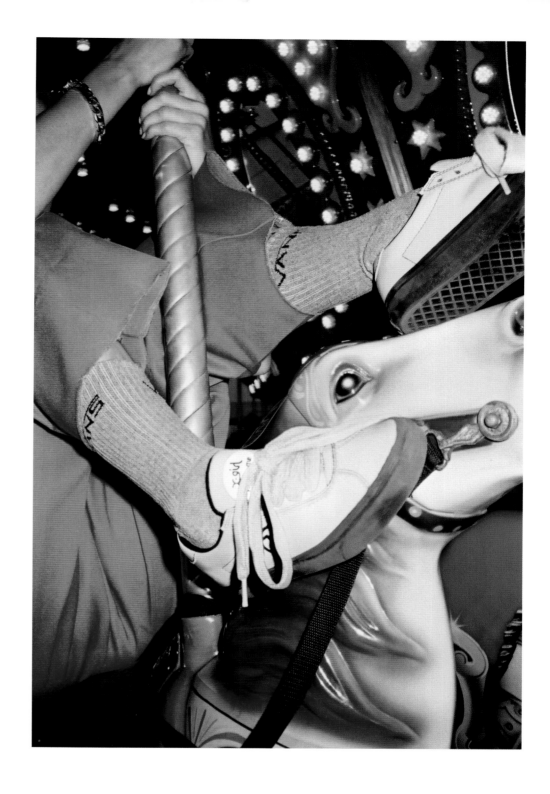

MadeMe / Vans / X-girl photographed by Alexis Gross. Los Angeles, California, 2017.

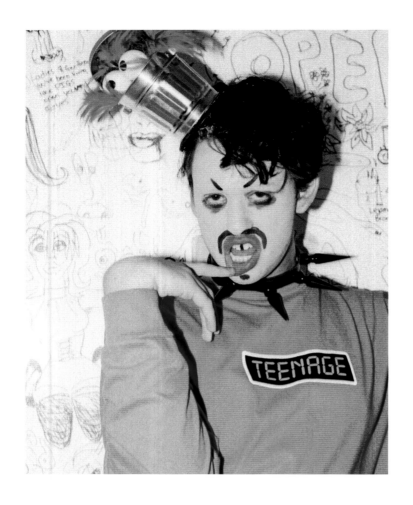

Sussi photographed by Elvin Tavarez. New York, New York, 2015.

This is one of my favorite
photo shoots. The beanies and
sweaters say "Touch Me and Die."
Sussi and I met at Search and
Destroy on St. Mark's Place;
they were wearing MadeMe, so we
started talking. The first time
I went to Sussi's apartment it
was like opening up Pandora's
Box. Costumes, vintage Dior,
and hand drawings on the wall.
Elvin Tavarez shot these the next
day. It needed to happen and it
happened fast.

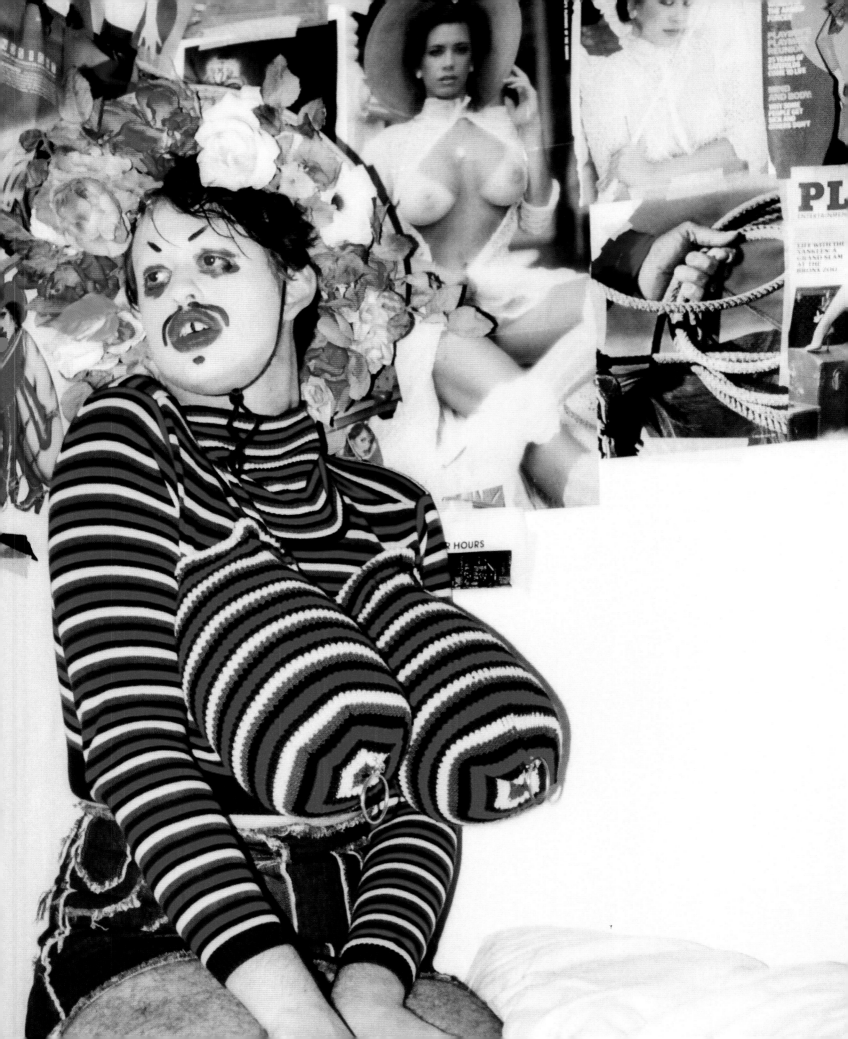

I saw her in Washington Square Park in the summer of 2023. She had a cropped tee and her belly out like that, and it was so cool. I went up to her — she probably thought it was so weird. I told her about MadeMe and that I wanted to shoot her. She told me she had to ask her mom. When we shot, her mom came to the studio with her friend. The mom was sitting down in our studio and I was like, "You know, I'm a mom too, so don't worry." Mayan took these photos.

Alia Vasquez and Nadirah Mitchell photographed by Mayan Toledano. New York, New York, 2023.

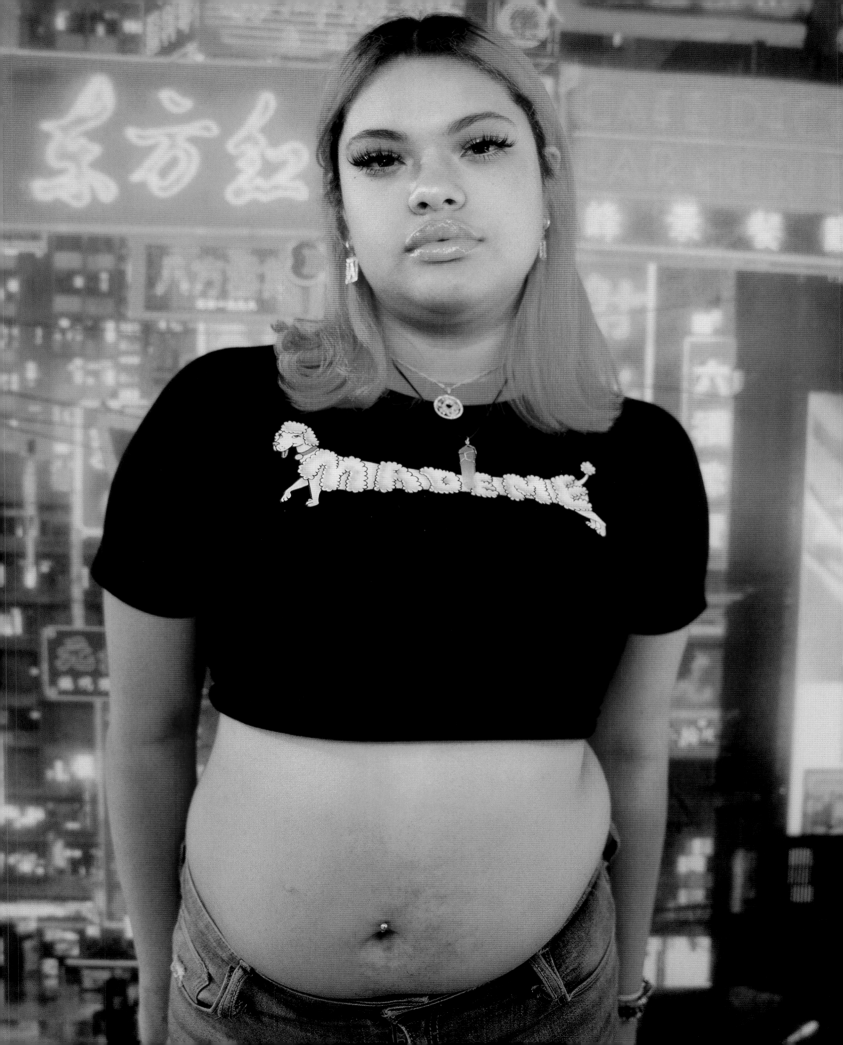

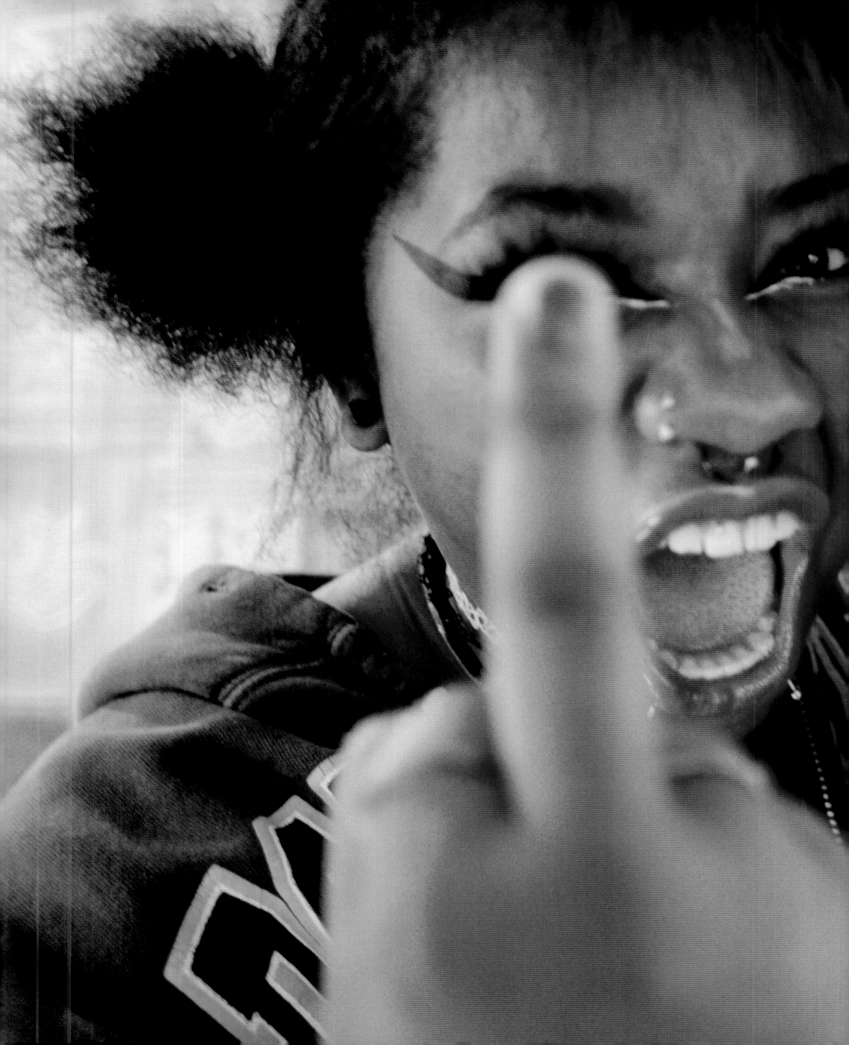

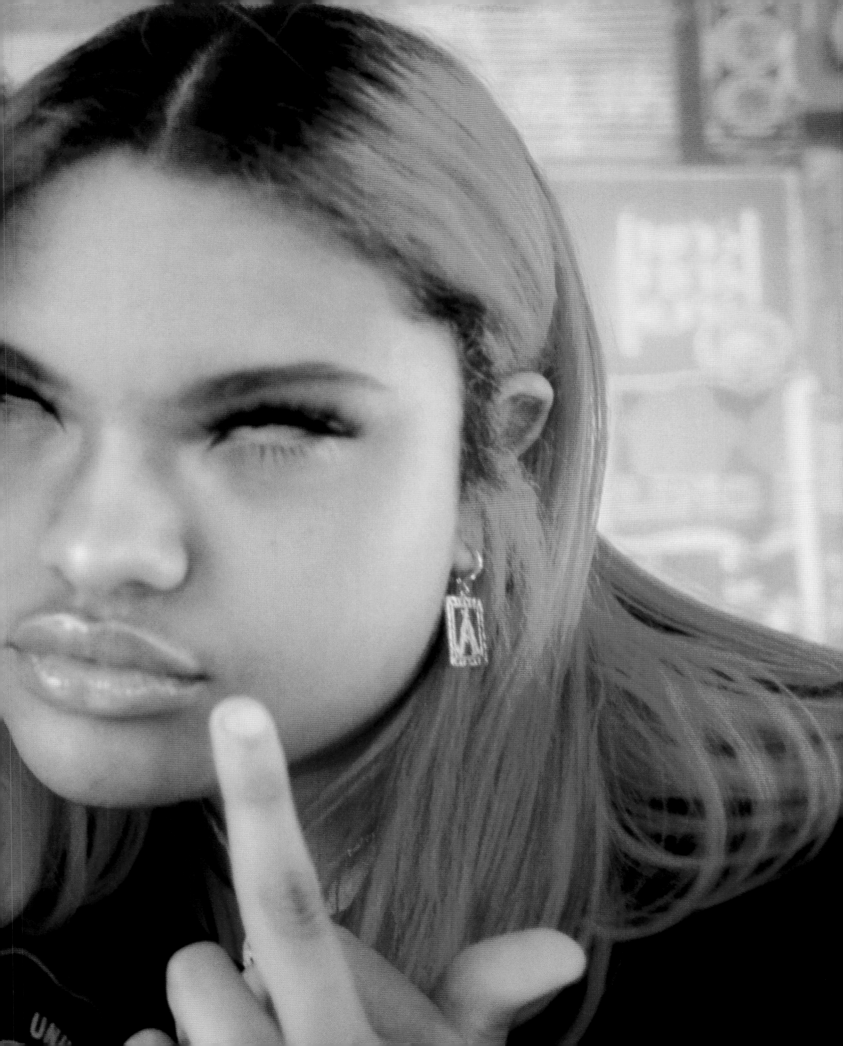

I had done this bag collection,
and I needed a new and
interesting way to shoot it.
I was going to Japan and had
the idea to do *FRUiTS* magazine
campaign covers. My friend Aiko
knew Shoichi Aoki, the founder of
FRUiTS, and she asked if he'd be
down to work on this, even though
FRUiTS had been semiretired. He
was down to do it. Iconic. We
casted these girls and told them
to wear whatever they'd regularly
wear, and then we spent the whole
day shooting in Harajuku.

MadeMe / *FRUiTS* Magazine Campaign photographed by Shoichi Aoki. Tokyo, Japan, 2022.

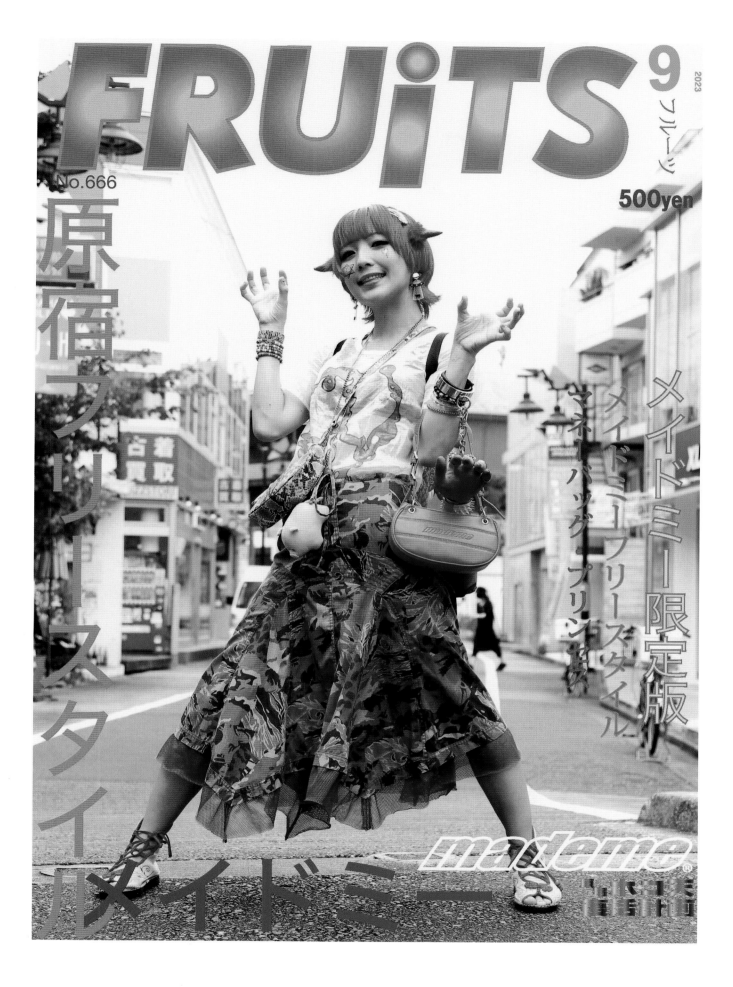

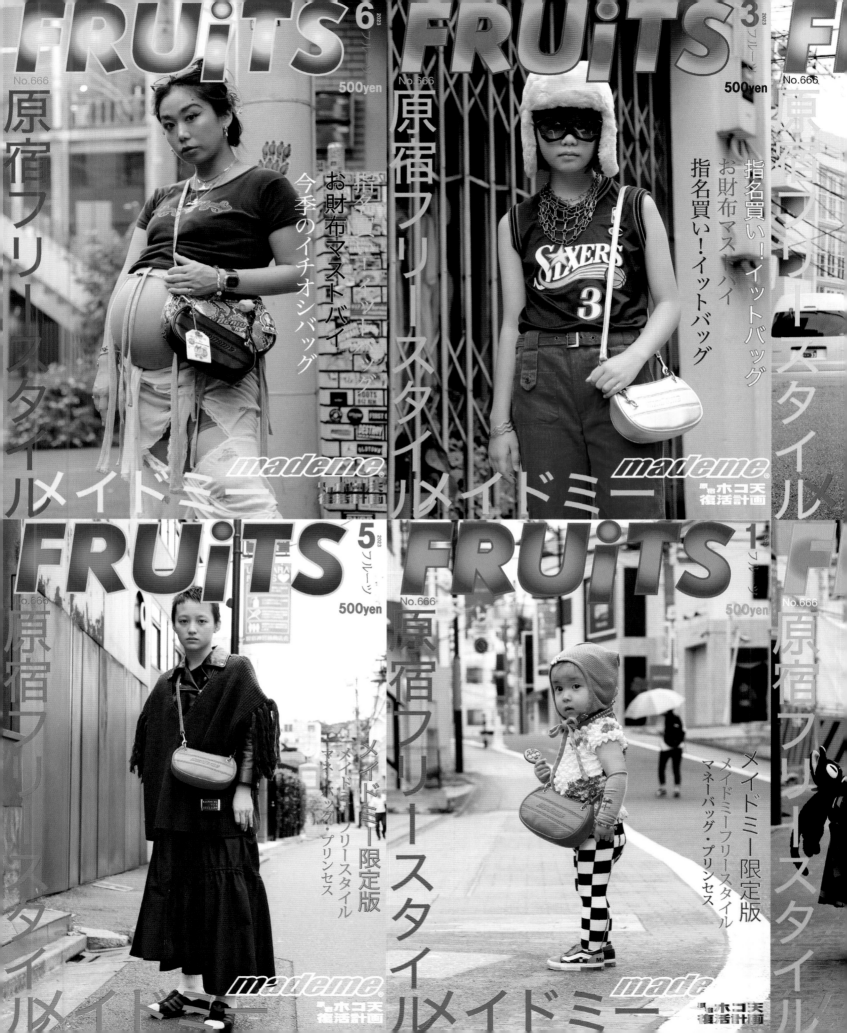

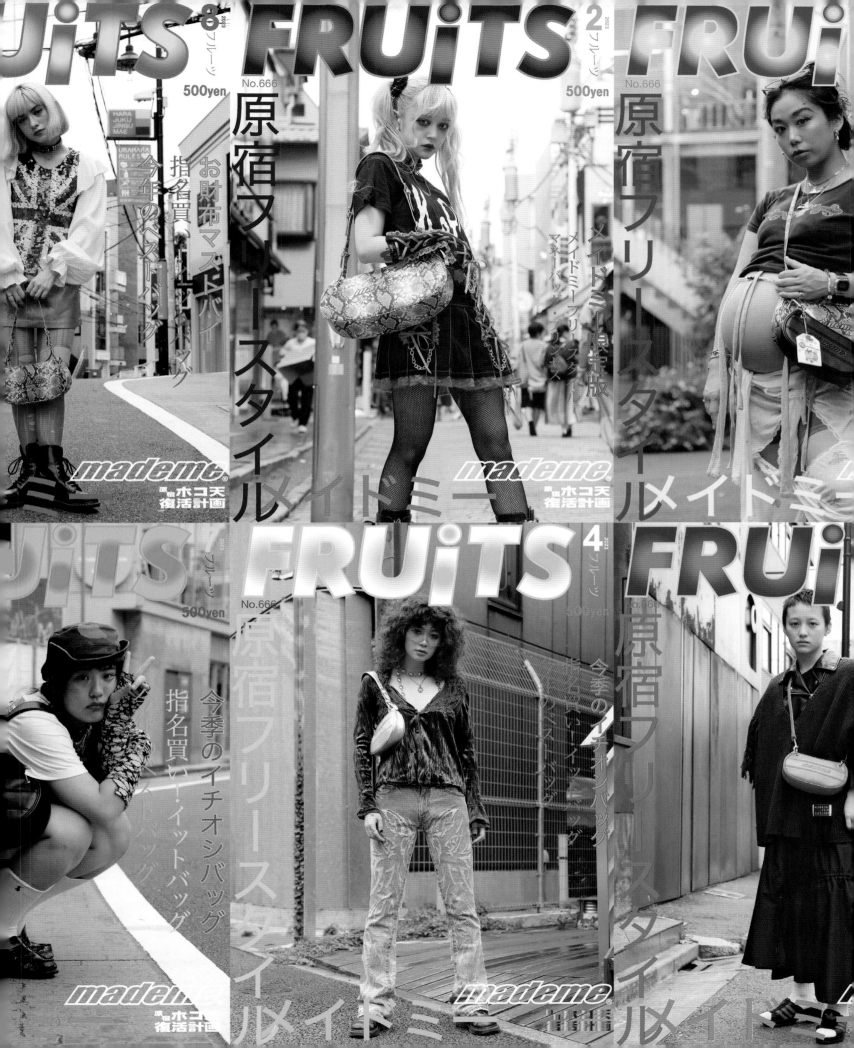

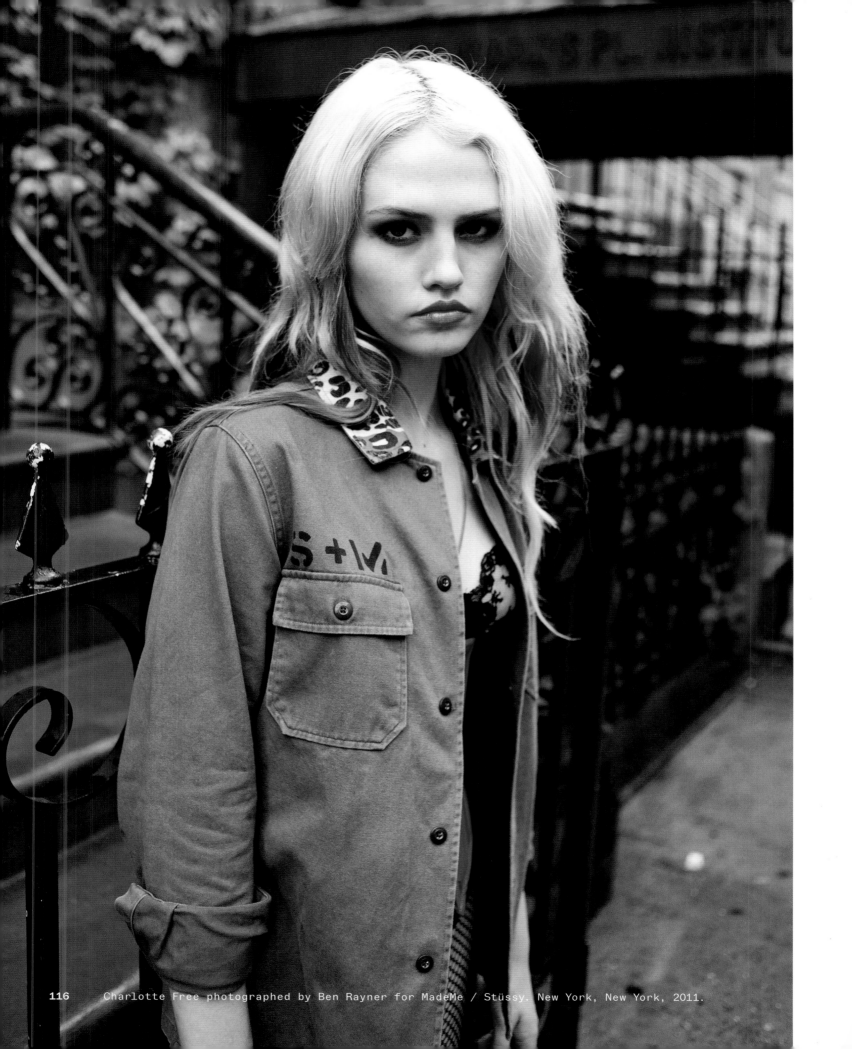

Charlotte Free photographed by Ben Rayner for MadeMe / Stüssy. New York, New York, 2011.

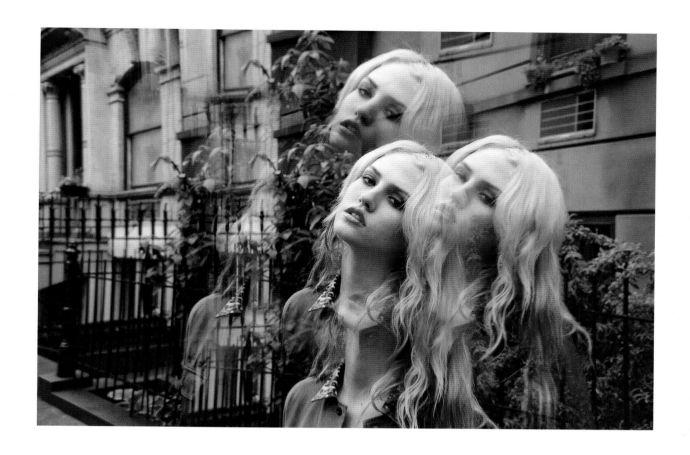

Ben Rayner shot these images
of my Stüssy collaboration in
2011. S&M, Stüssy, and MadeMe,
get it? Charlotte Free was the
coolest, newest, It girl before
being an influencer was a thing.
Before Instagram. We flew her
to New York, got a room at the
Bowery Hotel along with these
individually hand-dyed colored
hair extensions. I remember she
had her period. Her tampon was
bothering her, and I had her
wearing these black-and-white
striped pants. As we were walking
down the Bowery, she undid them,
whipped out her tampon, bloody,
and threw it down on the sidewalk.
The blood got on the pants, blood
all over the crotch. Needless to
say, we had to retouch that part.

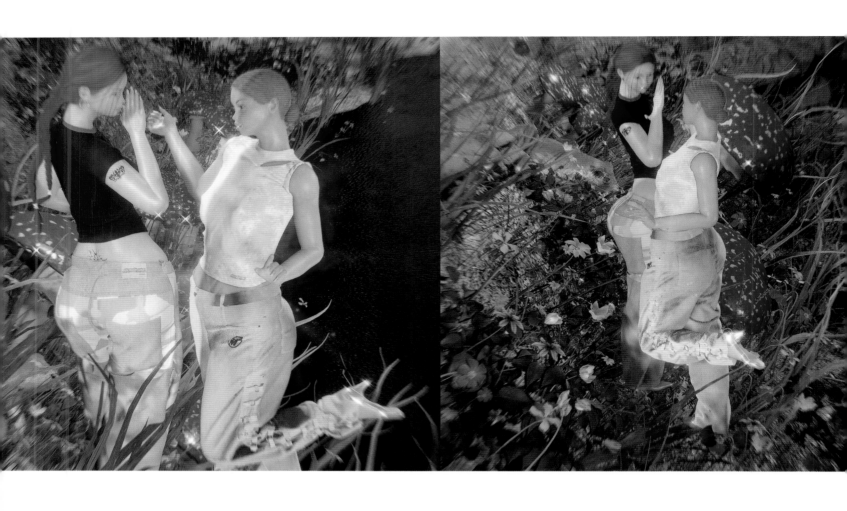

Art by Sacha Alexander, 2023.

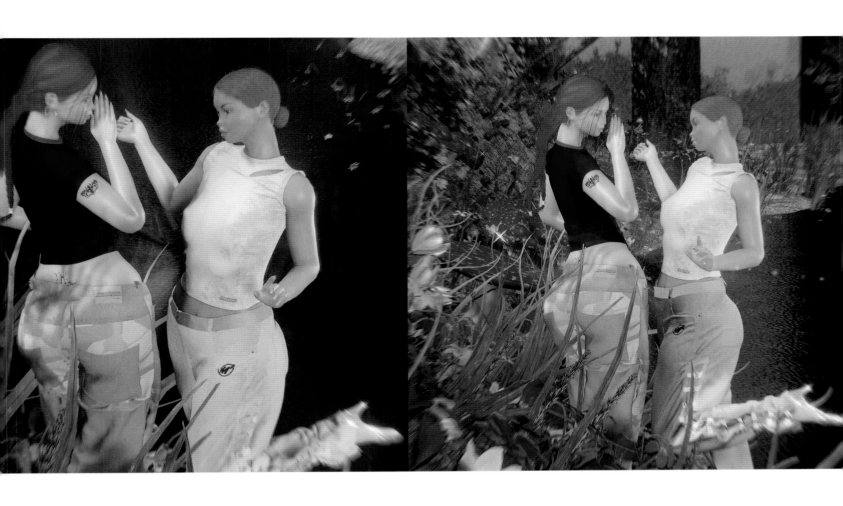

Sacha made these digitally
animated MadeMe girls; they even
walk and move. I took screenshots
of them whispering because I
thought it was really cunty.

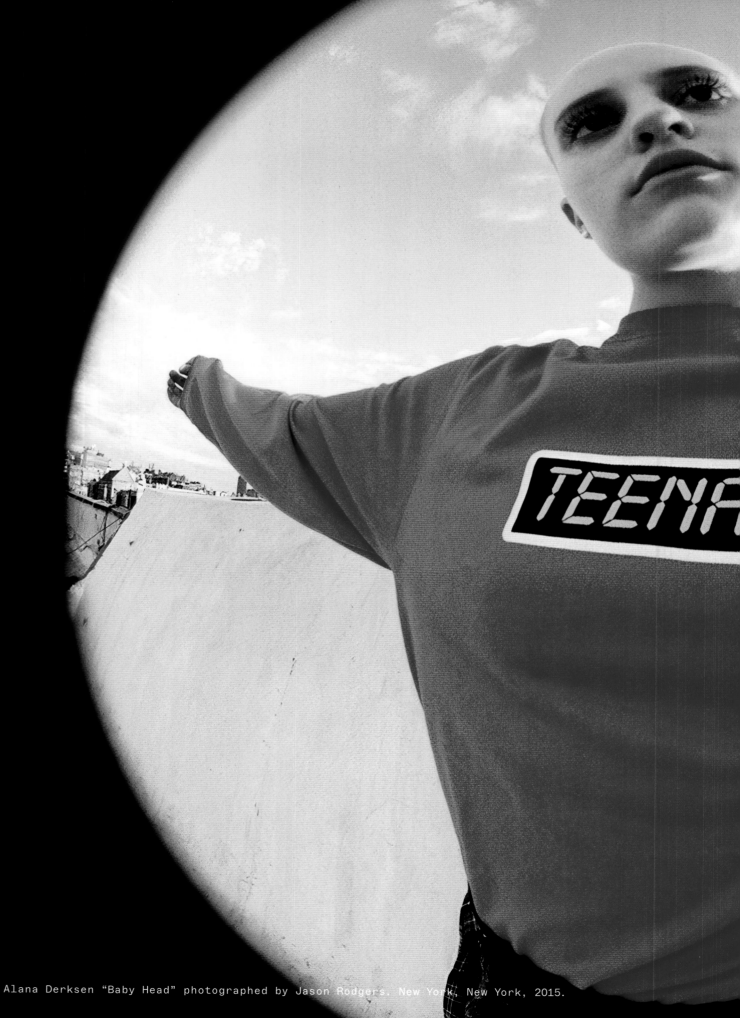

Alana Derksen "Baby Head" photographed by Jason Rodgers. New York, New York, 2015.

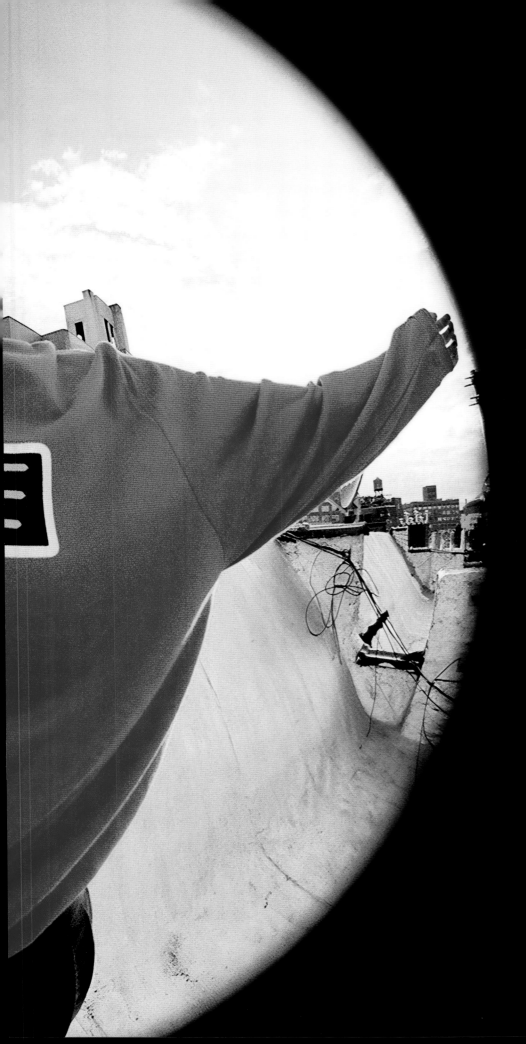

This was another time that I flew Baby Head to NYC from Toronto. My friend Jason Rodgers shot this, and it was his first time shooting on film. He usually shoots digital. The day after the shoot, he got the film back and was like, "I didn't do it right, I don't have any photos. All the rolls are black." Fuck. Baby Head was already on her way to the airport to fly back to Toronto. We turned the cab around and had to redo the entire shoot. Of course I was furious, but she was so cool about it, she didn't mind staying. The photos ended up being some of my favorites.

I've always wanted to shoot
with Omahyra. These are from an
HommeGirls editorial, shot by
Dani Aphrodite. I went to the set
because I had to meet Omahyra.
Icon. I brought her flowers.
Cooler in person than she looks,
if that's even possible.

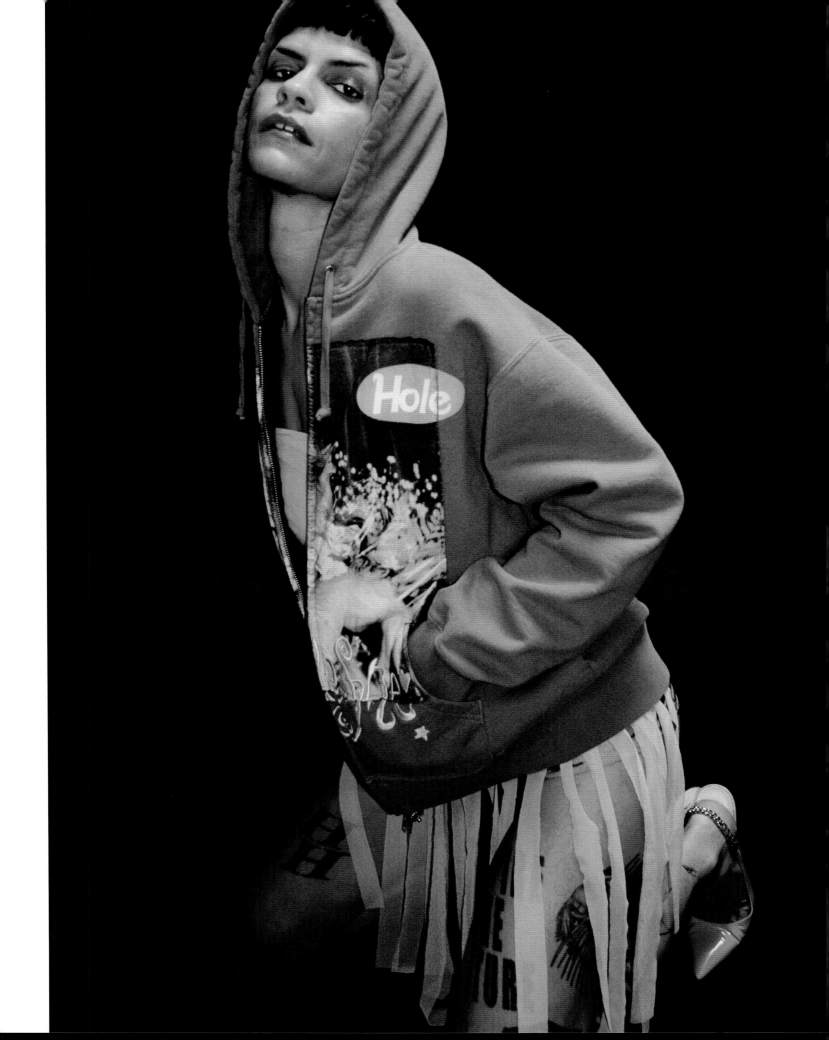

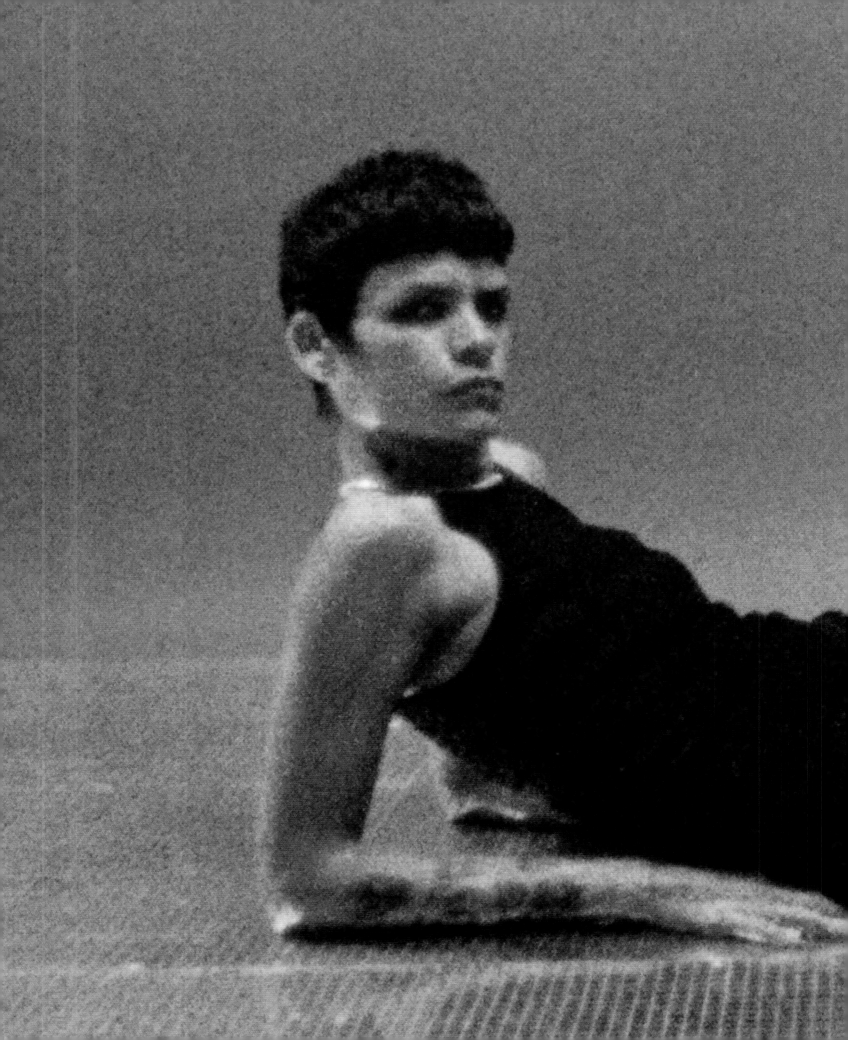

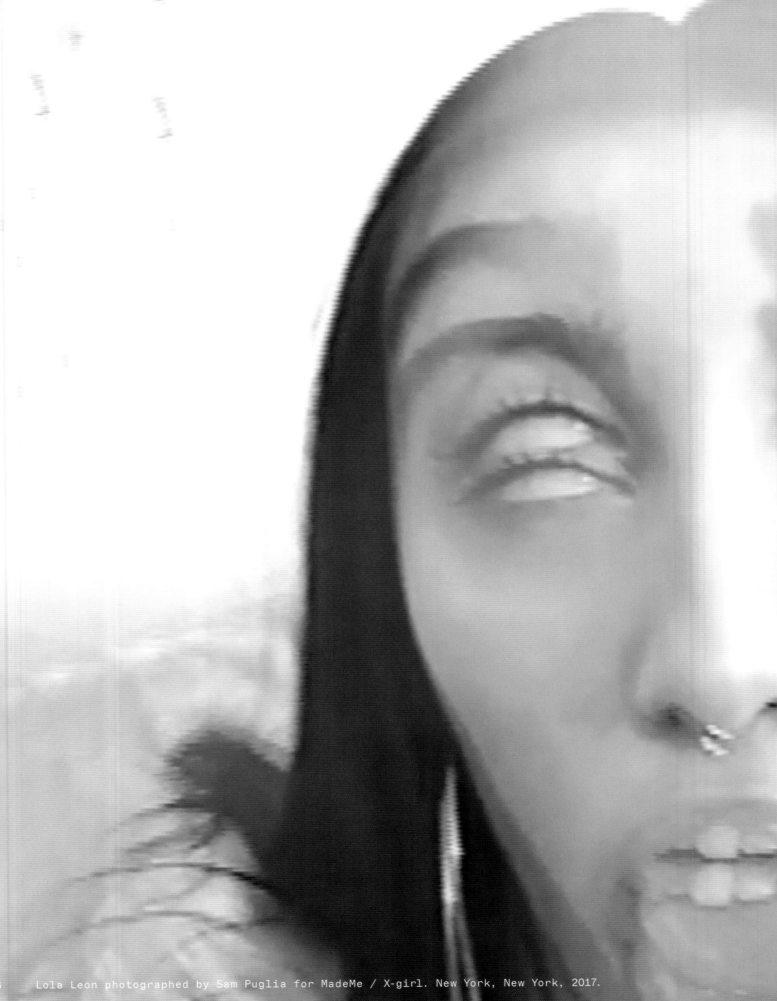

Lola Leon photographed by Sam Puglia for MadeMe / X-girl. New York, New York, 2017.

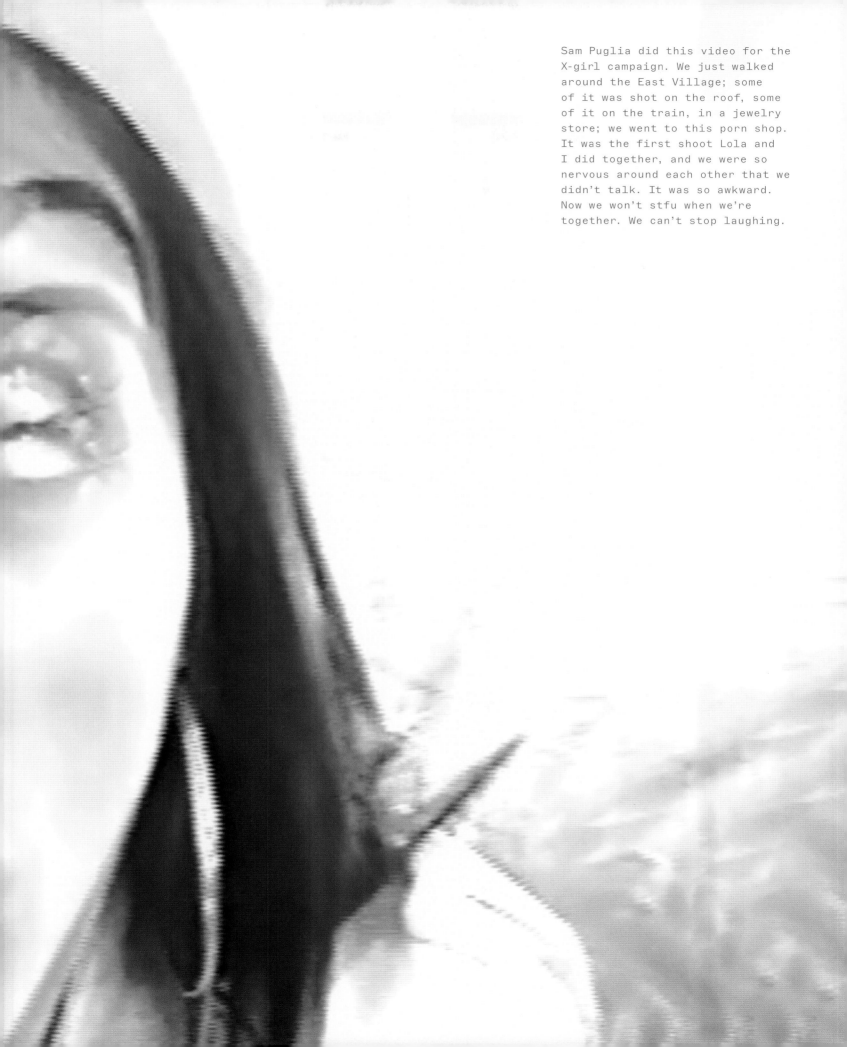

Sam Puglia did this video for the
X-girl campaign. We just walked
around the East Village; some
of it was shot on the roof, some
of it on the train, in a jewelry
store; we went to this porn shop.
It was the first shoot Lola and
I did together, and we were so
nervous around each other that we
didn't talk. It was so awkward.
Now we won't stfu when we're
together. We can't stop laughing.

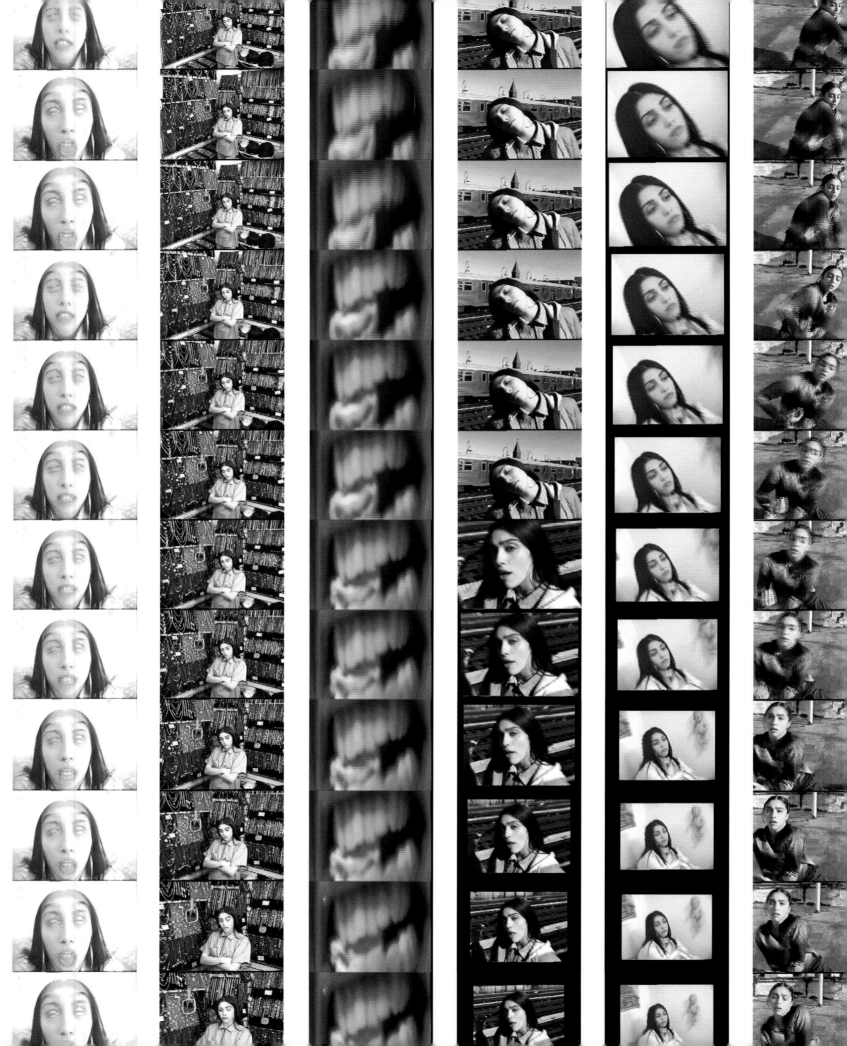

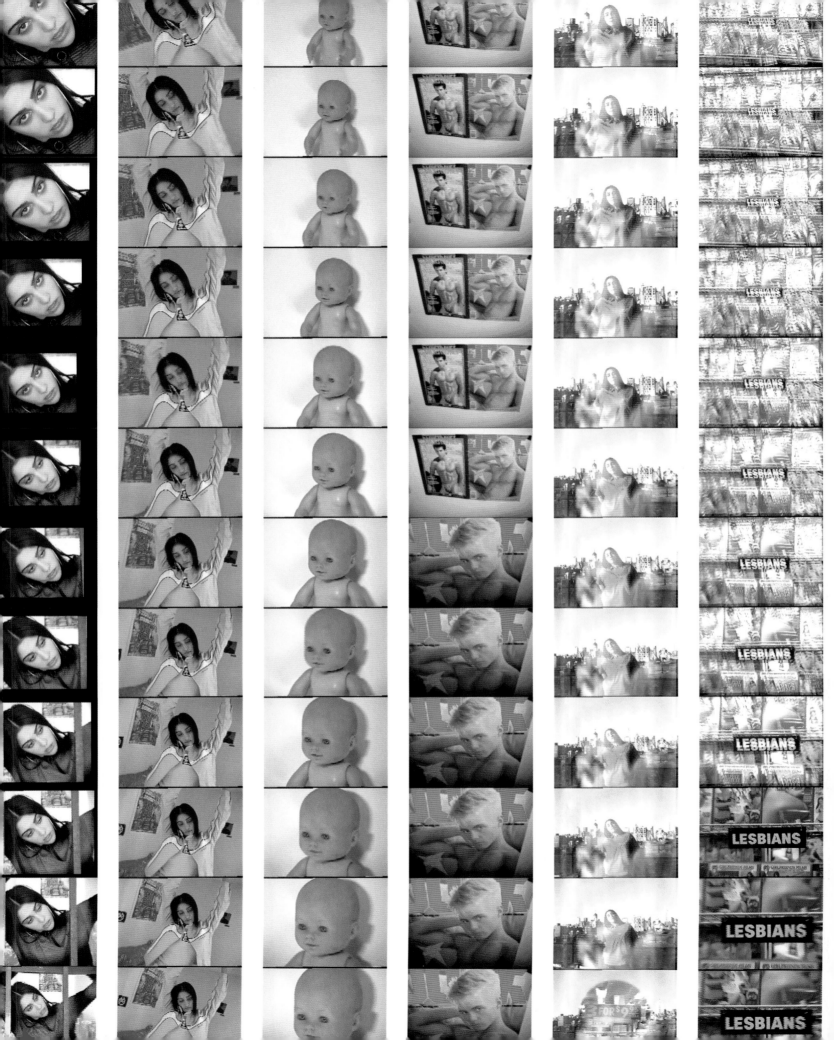

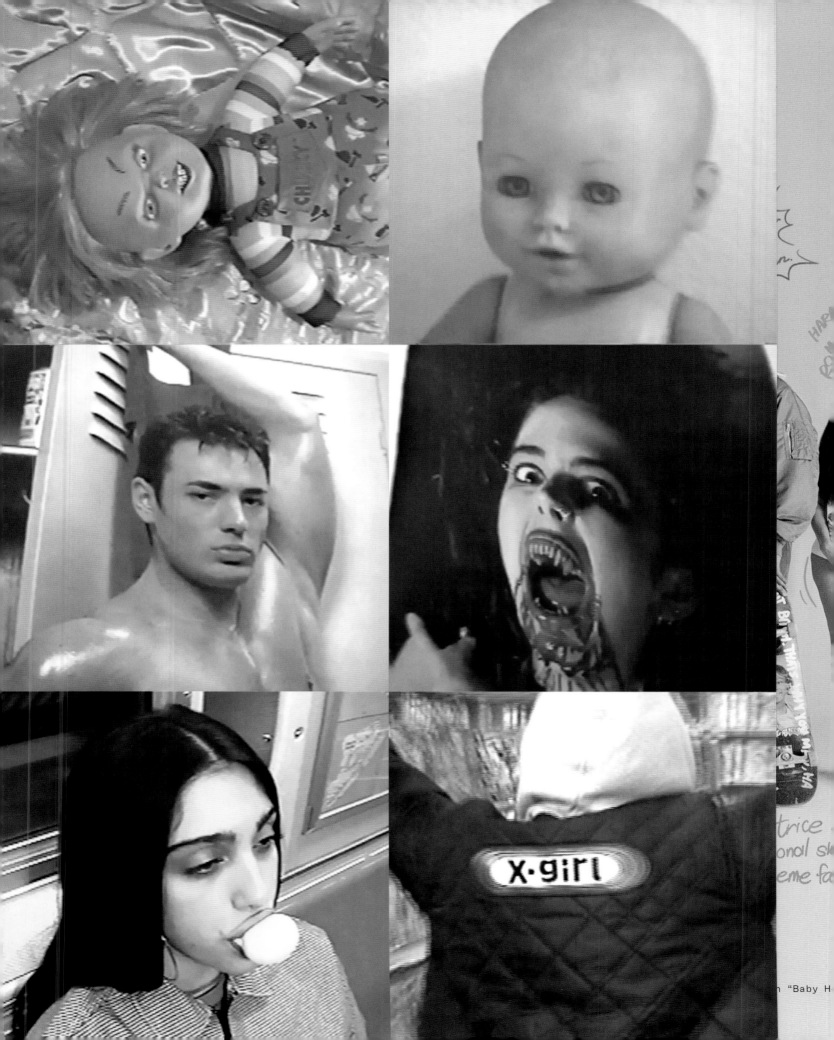

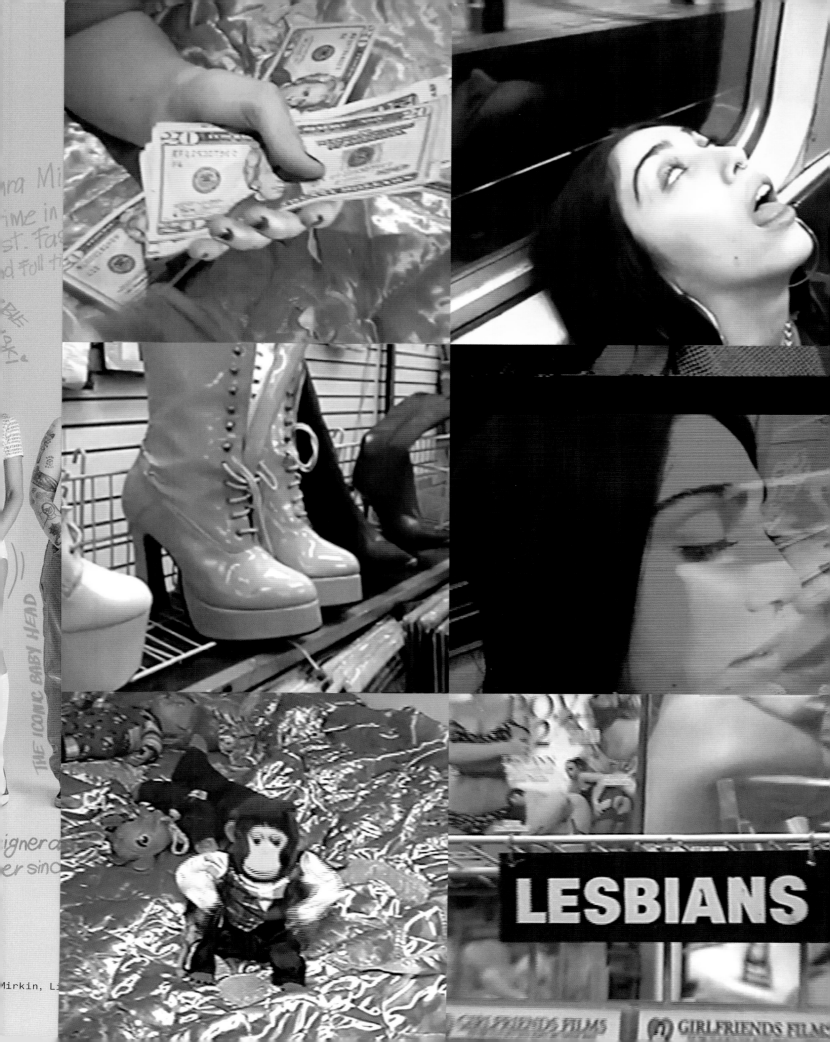

THE ICONIC BABY HEAD

LESBIANS

Mirkin, Li

GIRLFRIENDS FILMS

This was Lola Leon on the cover
of *Sneeze* magazine, which at the
time was a big deal for MadeMe.
I think she was the first girl to
be on the cover. Lola was so high.
Her eyes were almost completely
shut. I really love this photo.

Lola Leon photographed by Mayan Toledano for *Sneeze*. New York, New York, 2017.

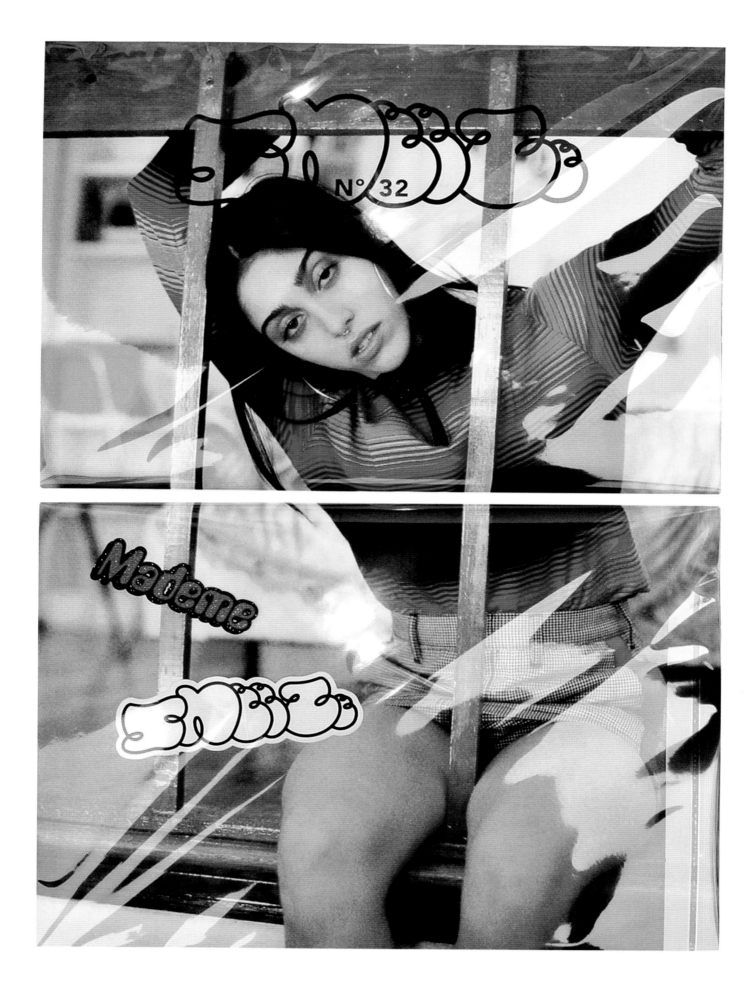

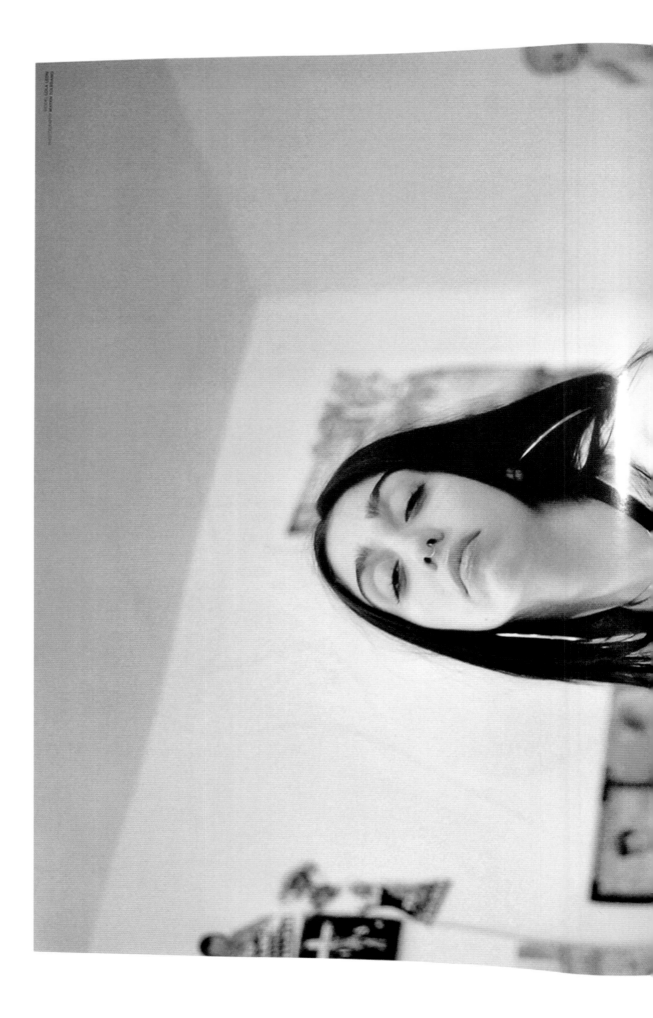

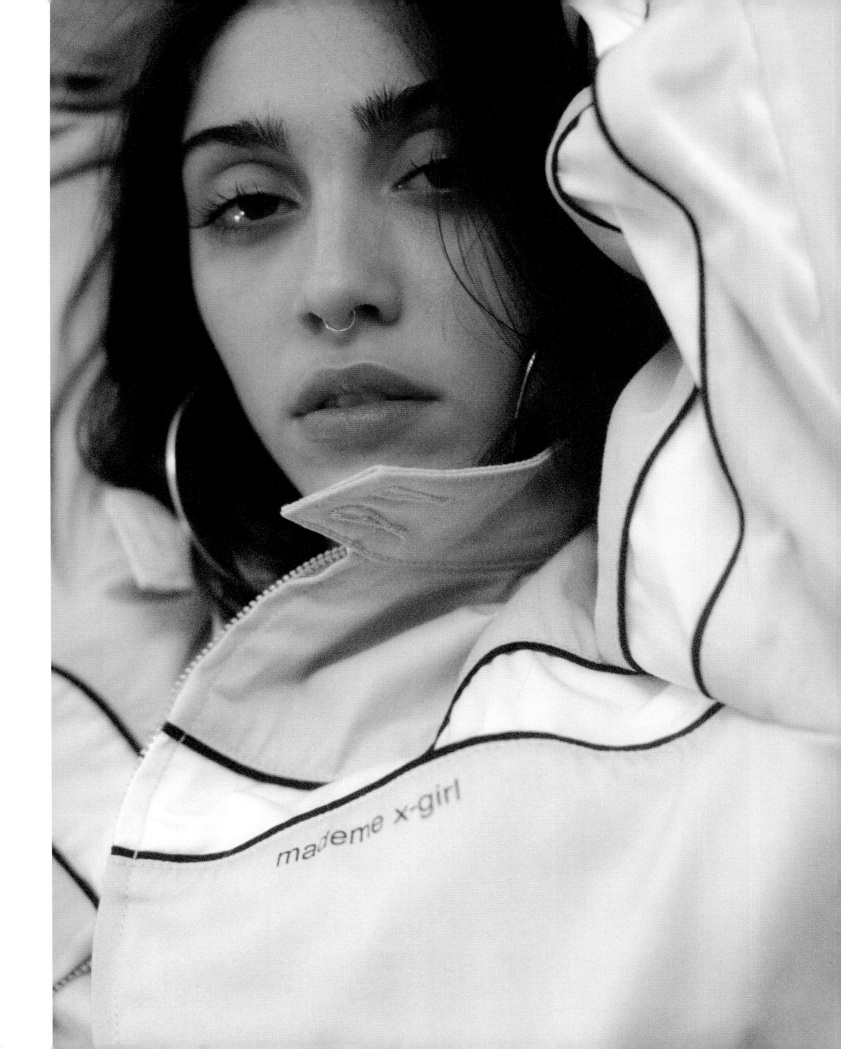

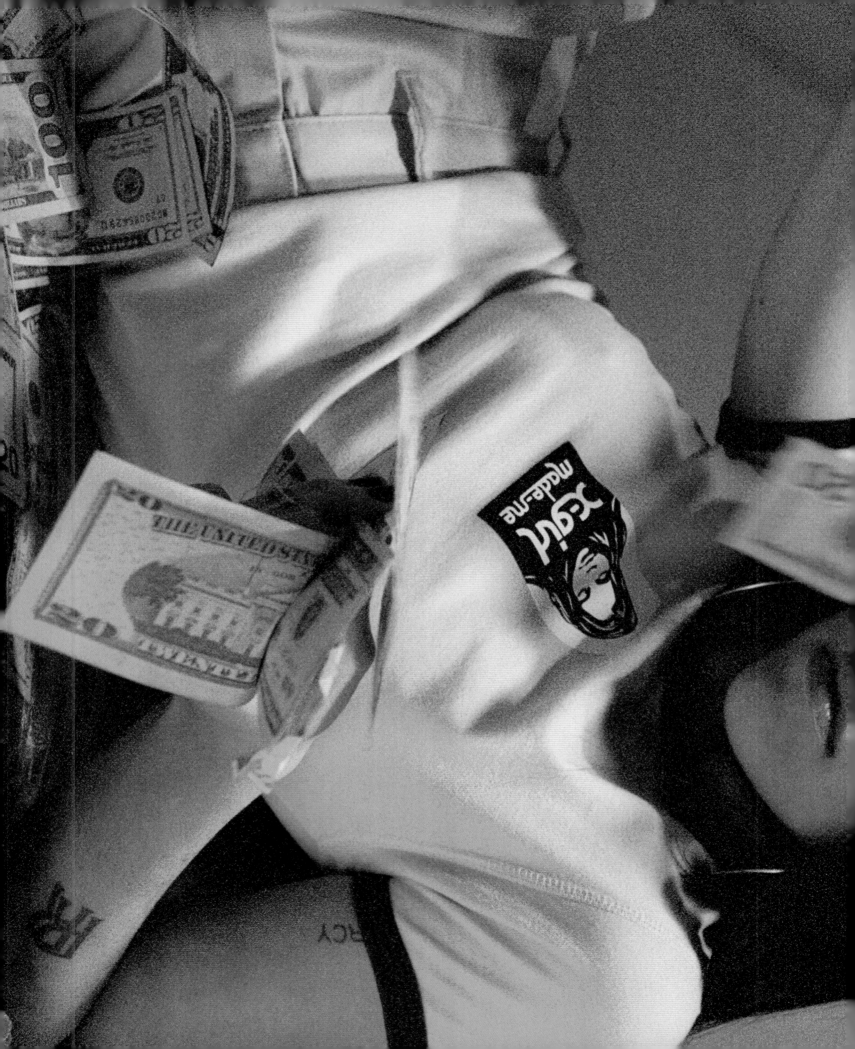

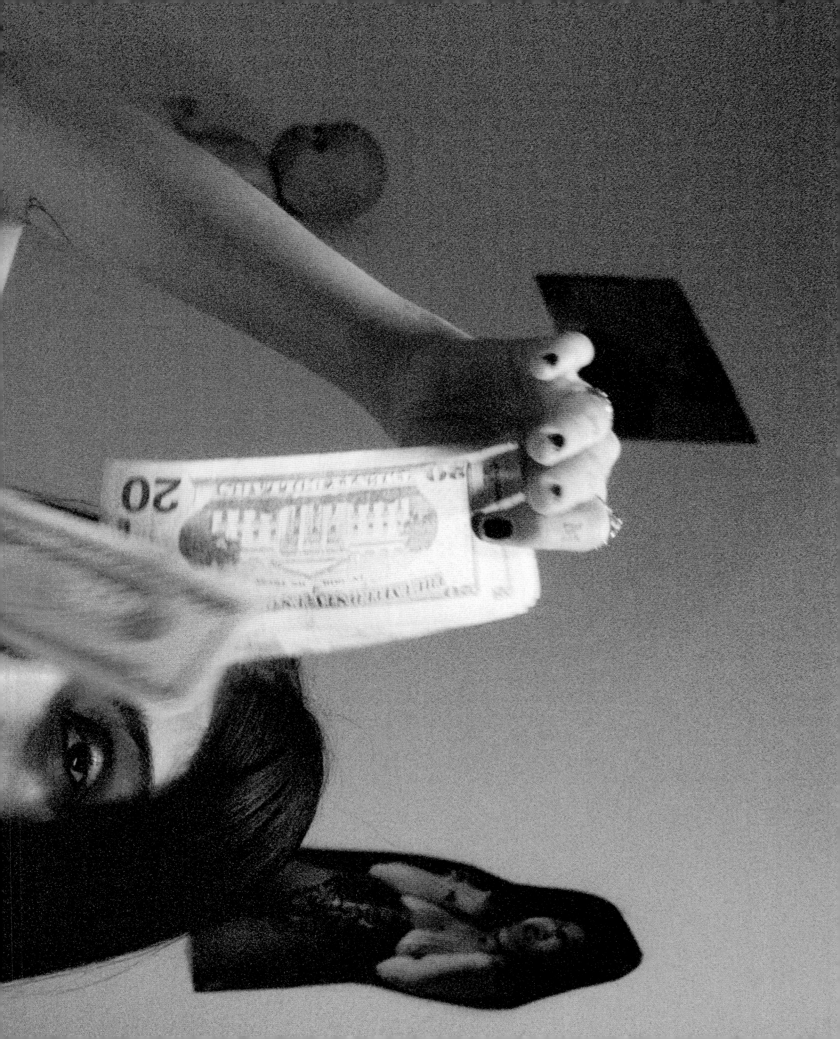

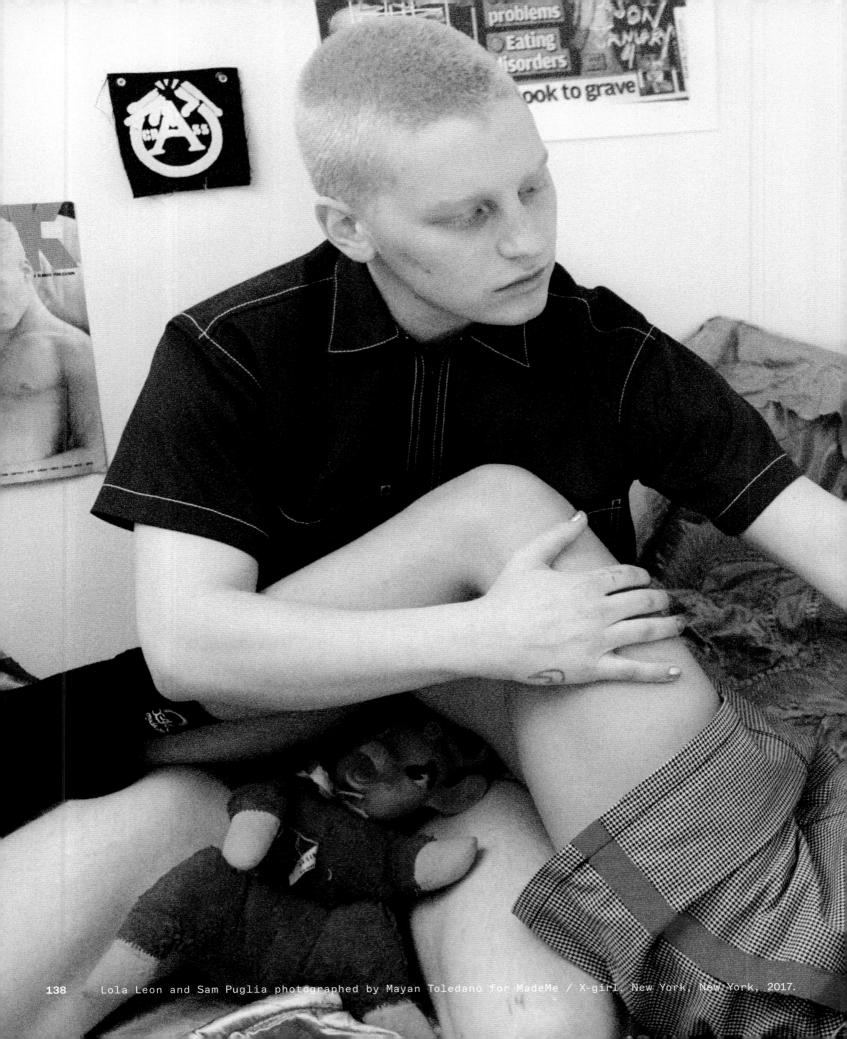

Lola Leon and Sam Puglia photographed by Mayan Toledano for MadeMe / X-girl. New York, New York, 2017.

More Lola X-girl. This was shot in Zac's apartment on Christopher Street. Zac was in Paris and let us use his place for the shoot. I remember Zac being really pissed he wasn't there; he wanted to meet Lola. Sam is with Lola in this picture. At the time, he and Lola were best friends. Sam always finds his way into the MadeMe world, either behind the camera or in front of it. If Sam is around, we always have fun. He's the center of a lot of the relationships.

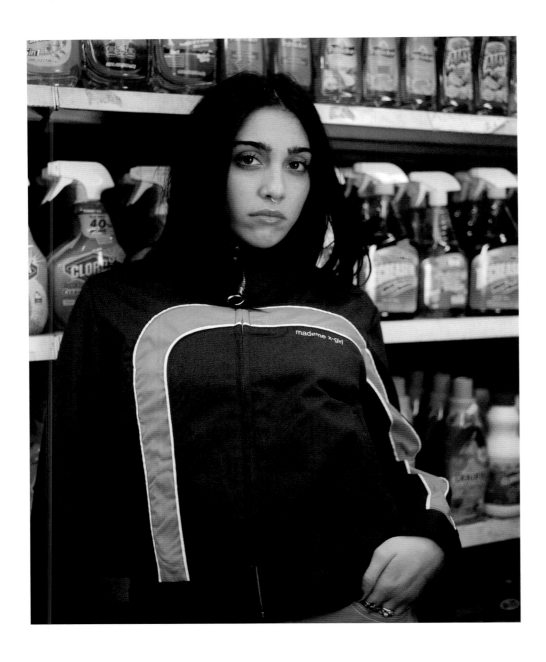

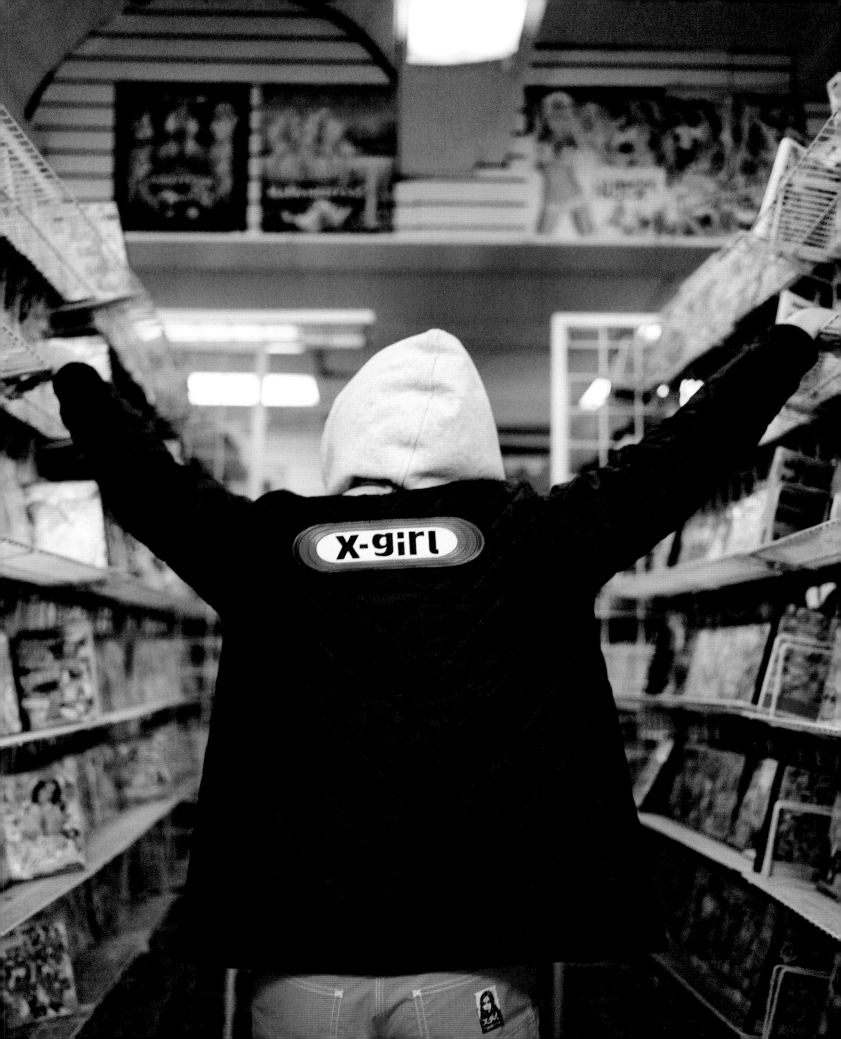

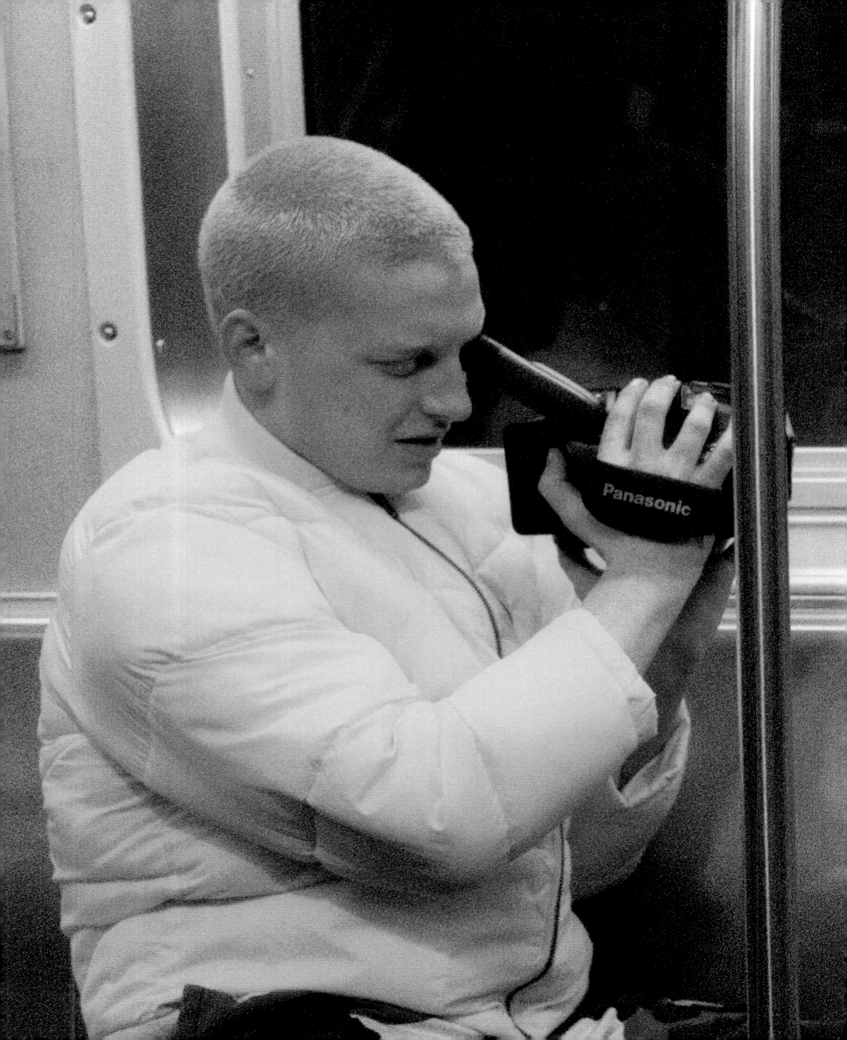

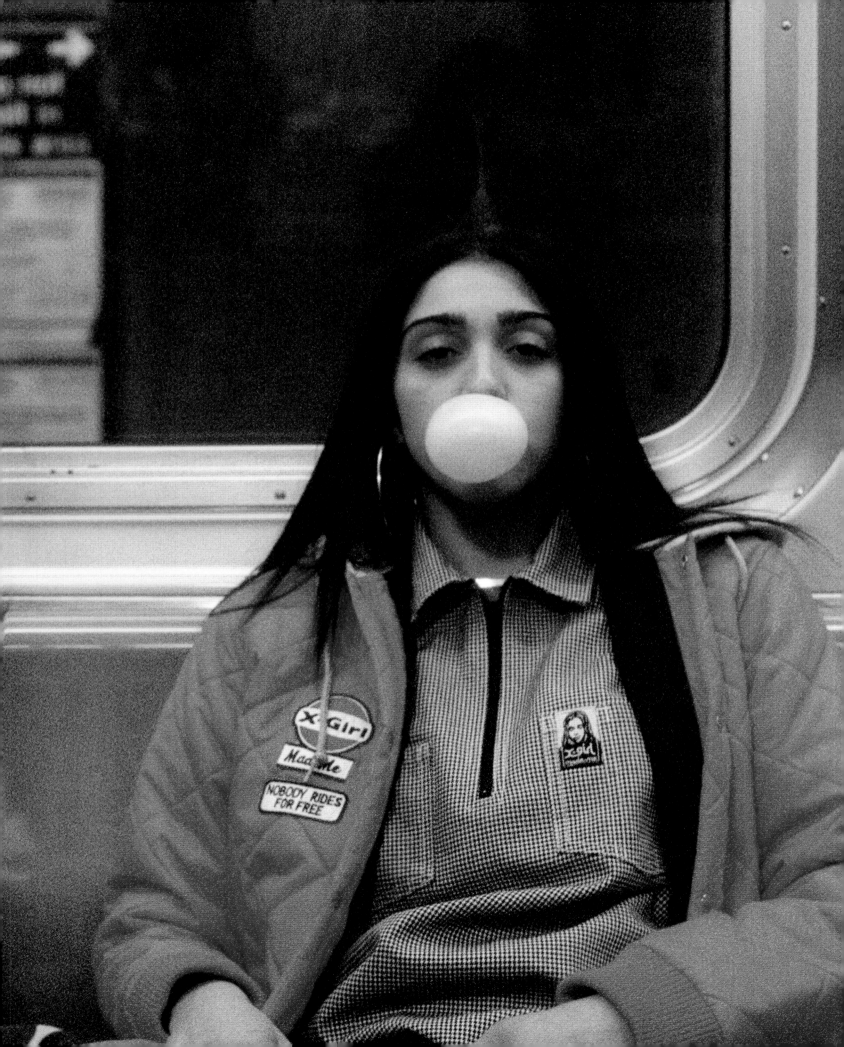

This campaign felt like a dream.
We shot this on a roof downtown.
Lola looks so innocent and
natural. It captures a time and
a place in our story. I remember
that Lola sent this photo to
her mom; she showed me the text
message. I think she sent it
because she was proud of it. So
was I. I have it printed five feet
tall in my office.

Lola Leon photographed by Mayan Toledano. New York, New York, 2017.

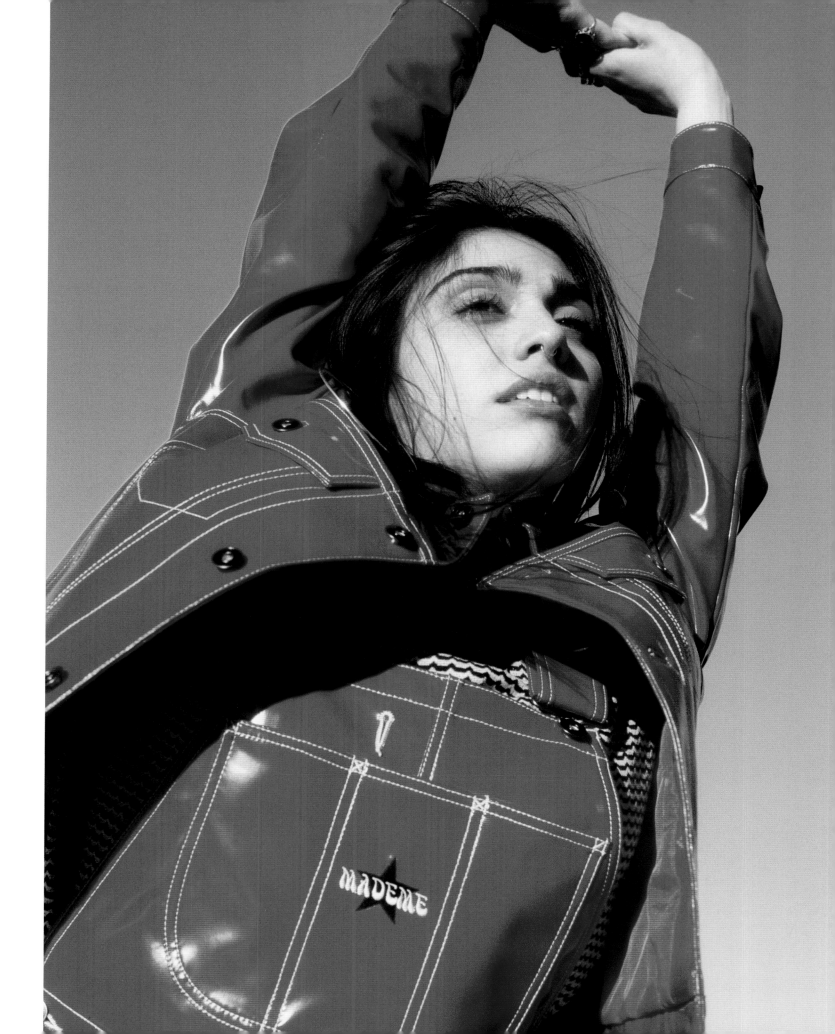

This was 2018, my second Converse
collection. The whole concept was
to do a western thing because of
the One Star. I hadn't shot Paloma
before, and of course she was
starting to get insanely popular.
I always knew about Paloma from
around downtown, as usual, but I
was afraid to ask if she wanted
to do the shoot. She said yes
immediately. The real challenge
was with Converse. I really
struggled with them to approve
her as the campaign model. Many
phone calls. It was very tough
and I fought hard for it. On that
shoot, I learned firsthand what
significant boundaries Paloma
has broken around body positivity
in the industry. They said, "The
clothes won't fit." And I said,
"Yes, they will. I'll make it
work." Clearly we did.

Paloma Elsesser photographed by Mayan Toledano for MadeMe / Converse. New York, New York, 2018.

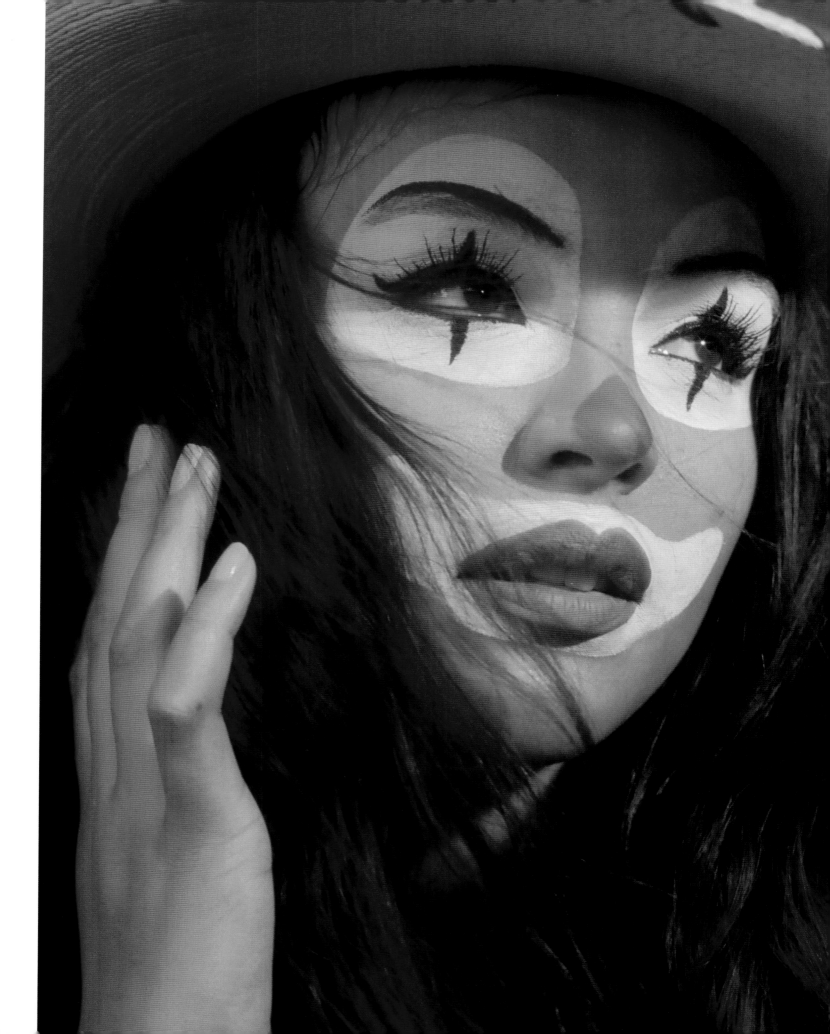

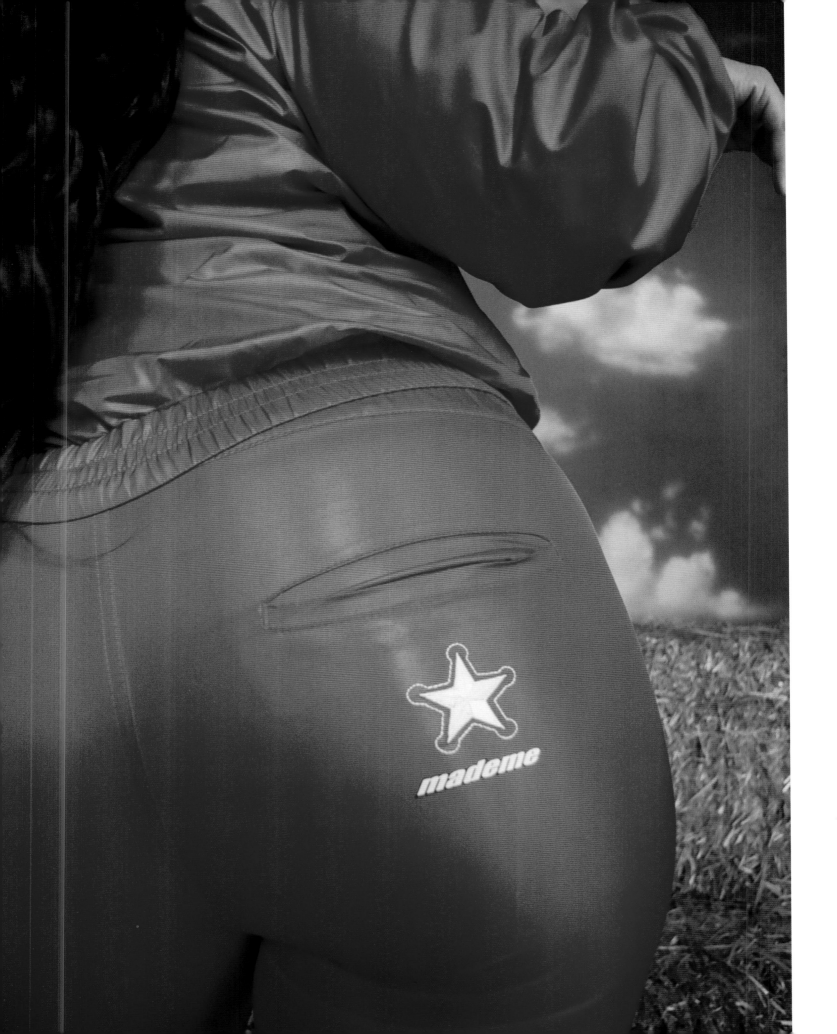

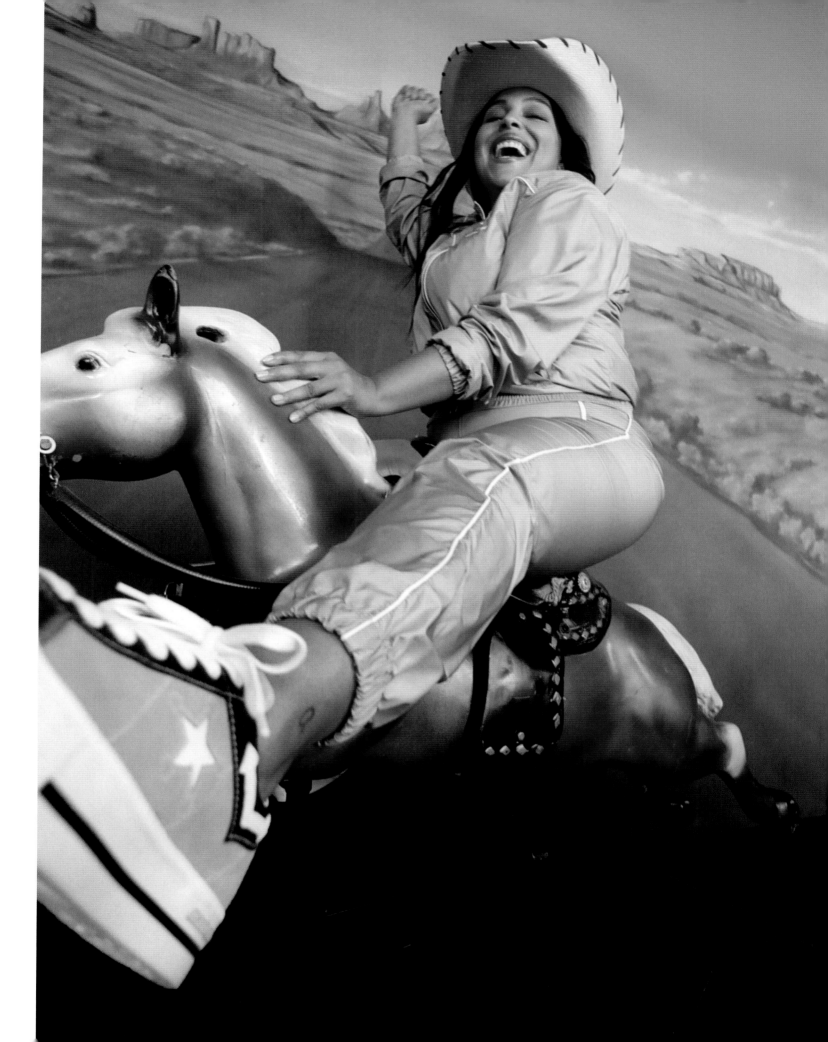

Milah Libin shot this kilt in Tokyo. She told me to send her a suitcase of clothes so she could do a shoot while she was there. I didn't like any of the other shots she sent back except this.

Cai Tanikawa Oglesby photographed by Milah Libin. Tokyo, Japan, 2018.

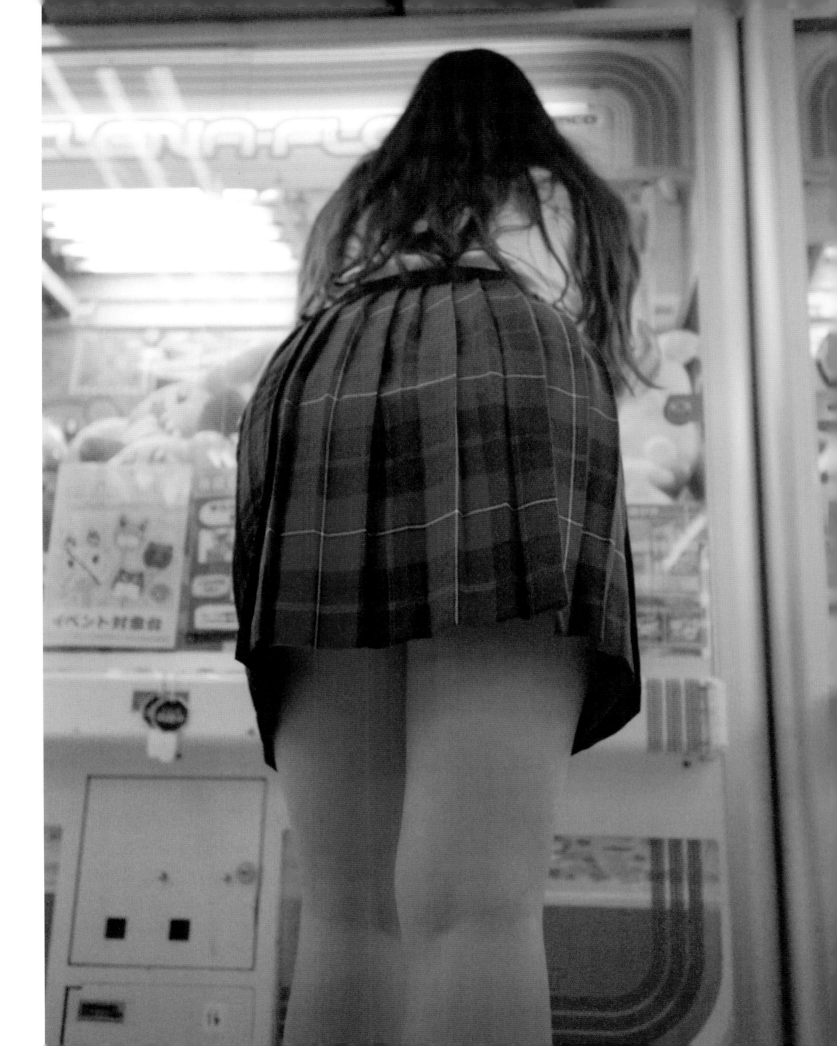

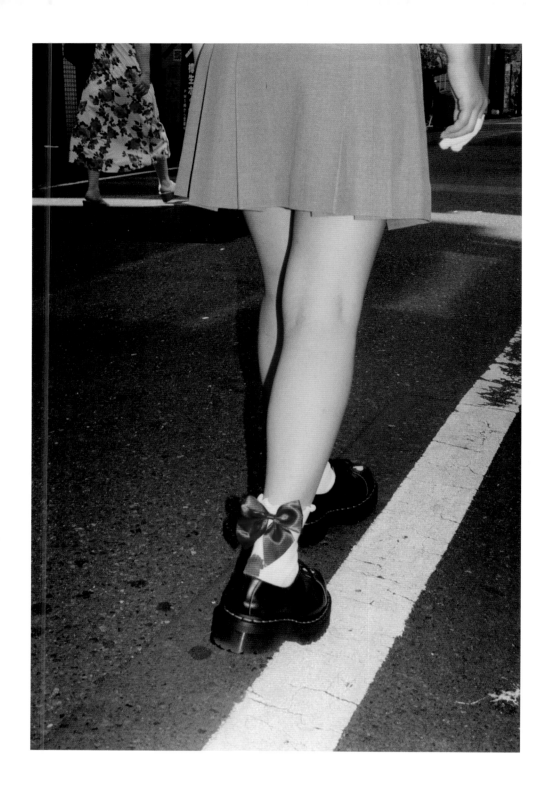

Zara Mirkin and I were in Japan and wanted to put together a shoot while we were out there. We met up with Fish, who I love. We found this Batman mask in a vintage store and shot it in Shinjuku. We were giggling while taking photos of the bloody socks.

Ki Ukei photographed by Fish Zhang for MadeMe / Dr. Martens. Tokyo, Japan, 2024.

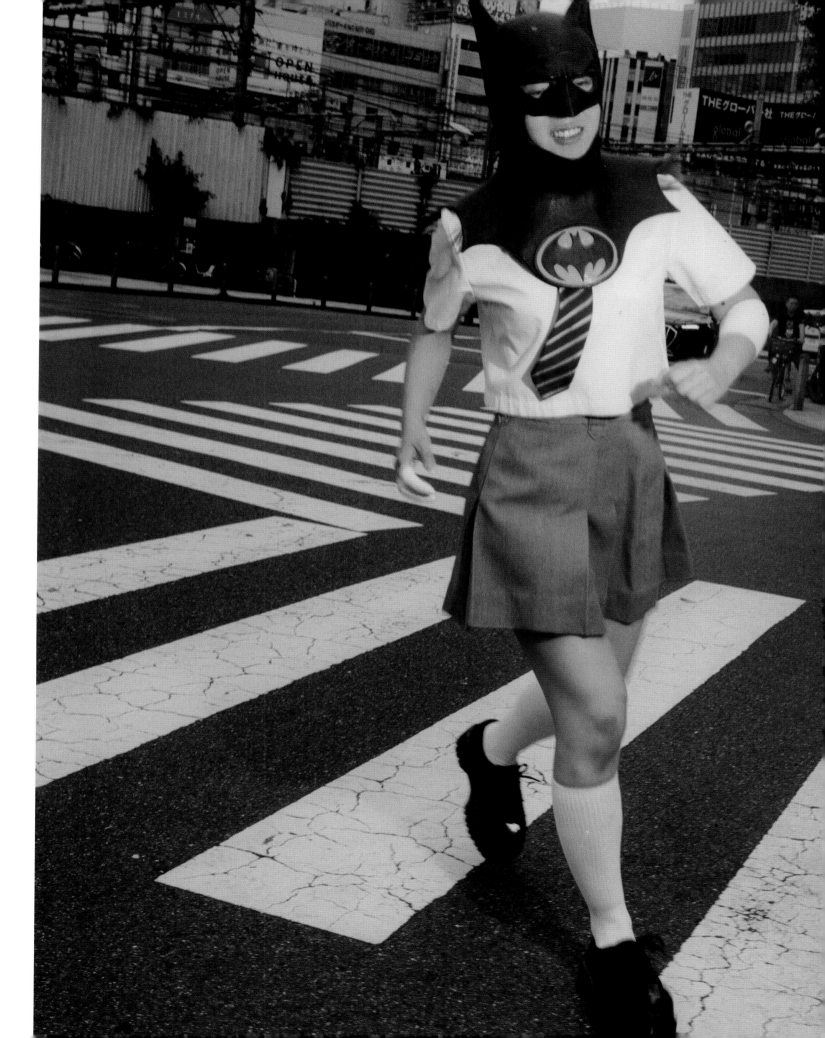

This was our first shoot with
Moni's two daughters, Amber and
Jessica. I really love these
girls. I found Moni on the
internet through her blog *Johnny's
Bird*. I wrote Moni an email and
said I wanted to work with her.
I flew to LA and visited her at
her house, where she lived with
her daughters. This is one of my
favorite photos ever.

Amber Propper and Jessica Propper photographed by Moni Haworth. Los Angeles, California, 2016.

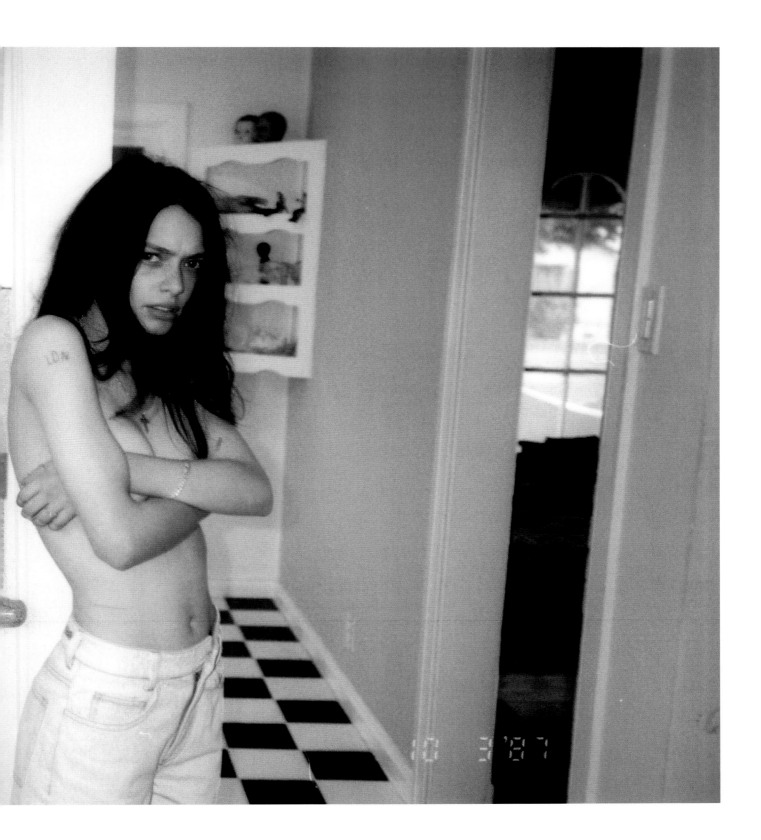

I showed up with Nicole, my wife, and a bag full of clothes. Moni chain-smoked cigarettes the entire time, and we talked about motherhood. She talks and moves really fast, and so do I, so it works. She had this amazing couch with a built-in ashtray in the middle. Those are my Fluevogs and my boots on the girls. She also had those mannequin legs in her backyard on top of a cement wall, which is totally fucking insane but why I love her so much.

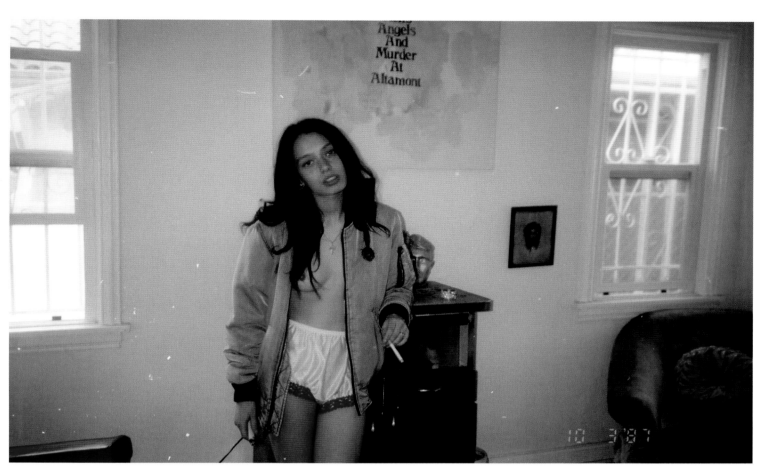
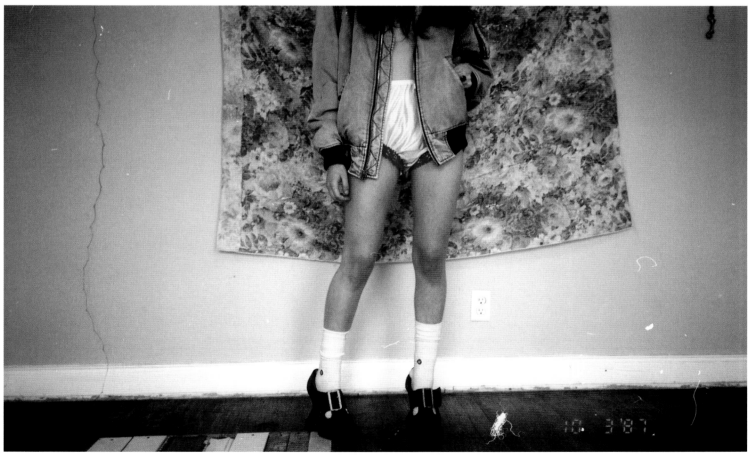

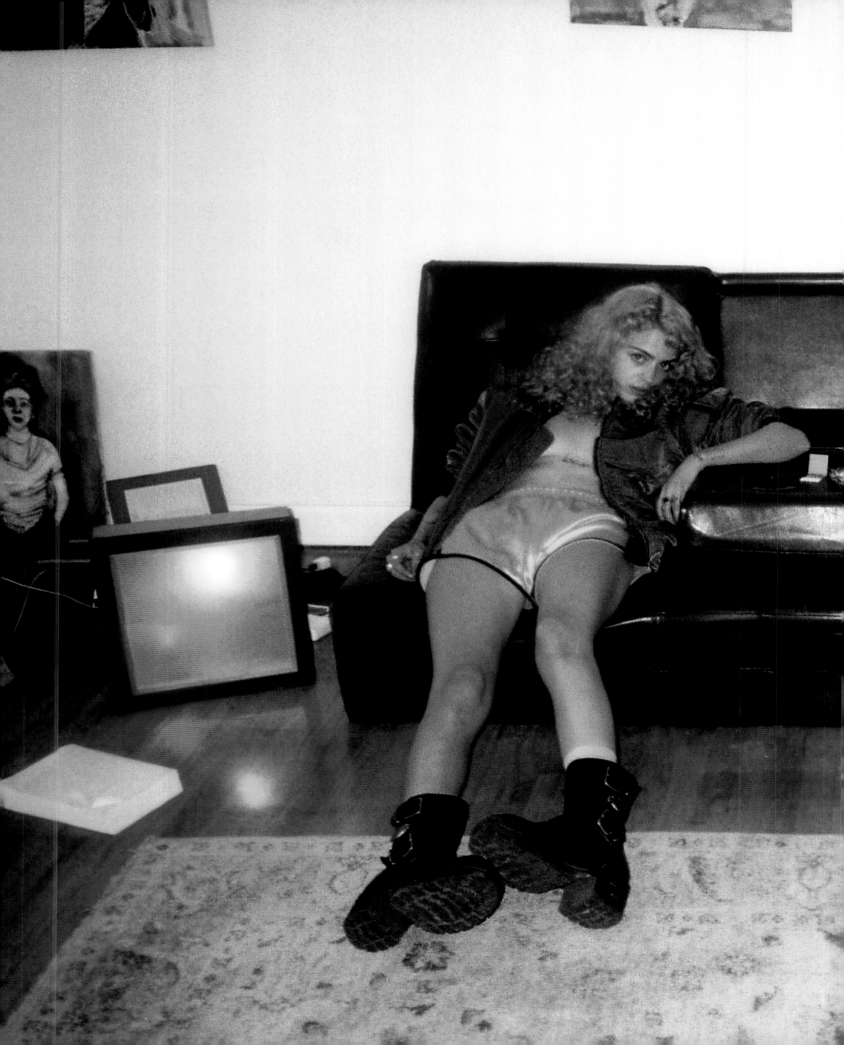

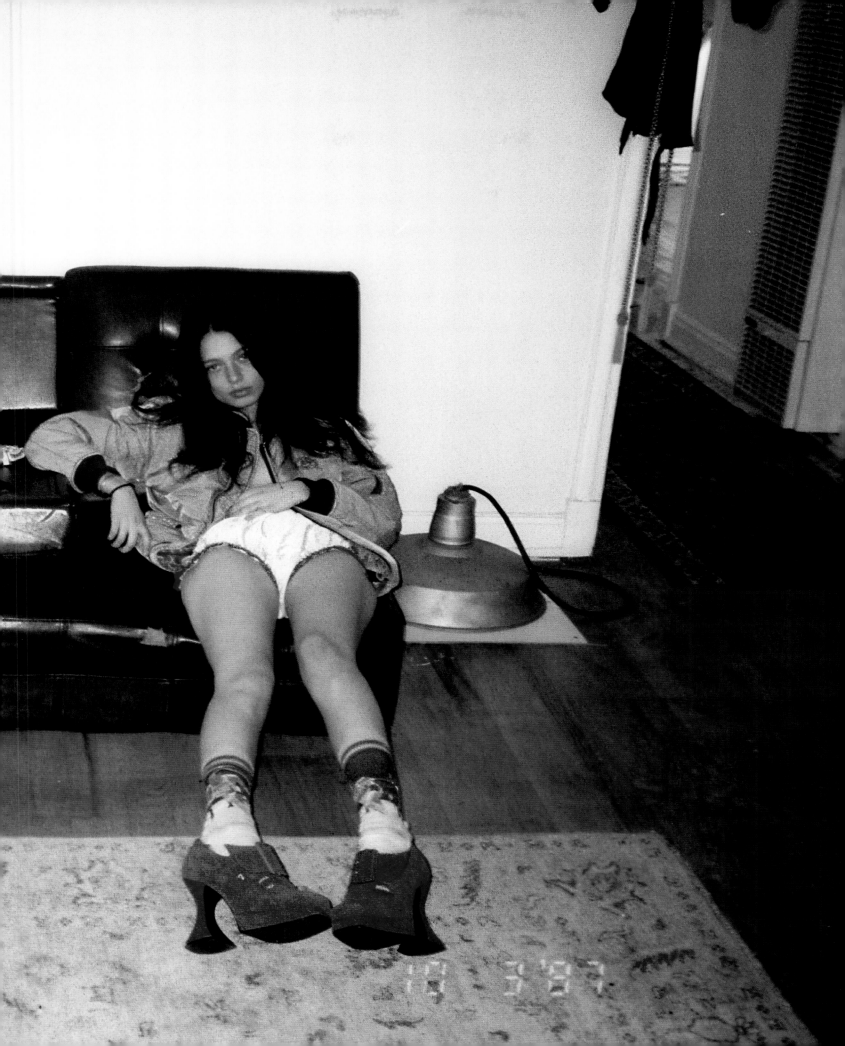

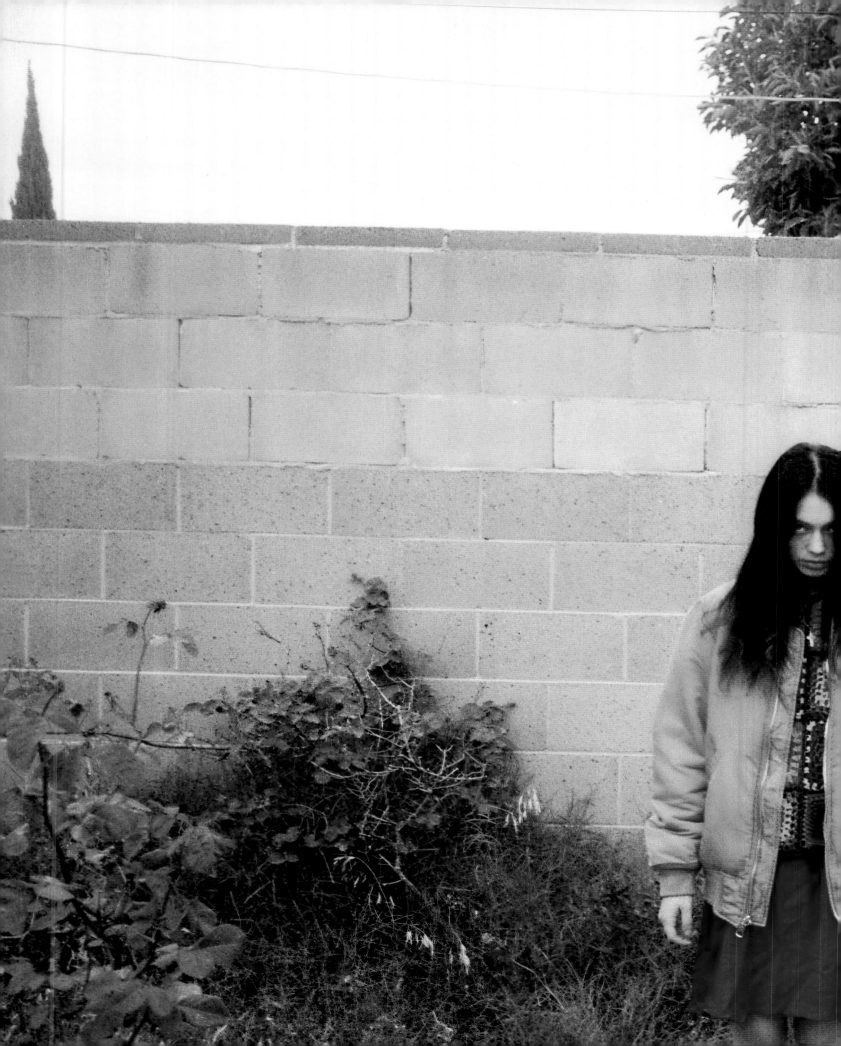

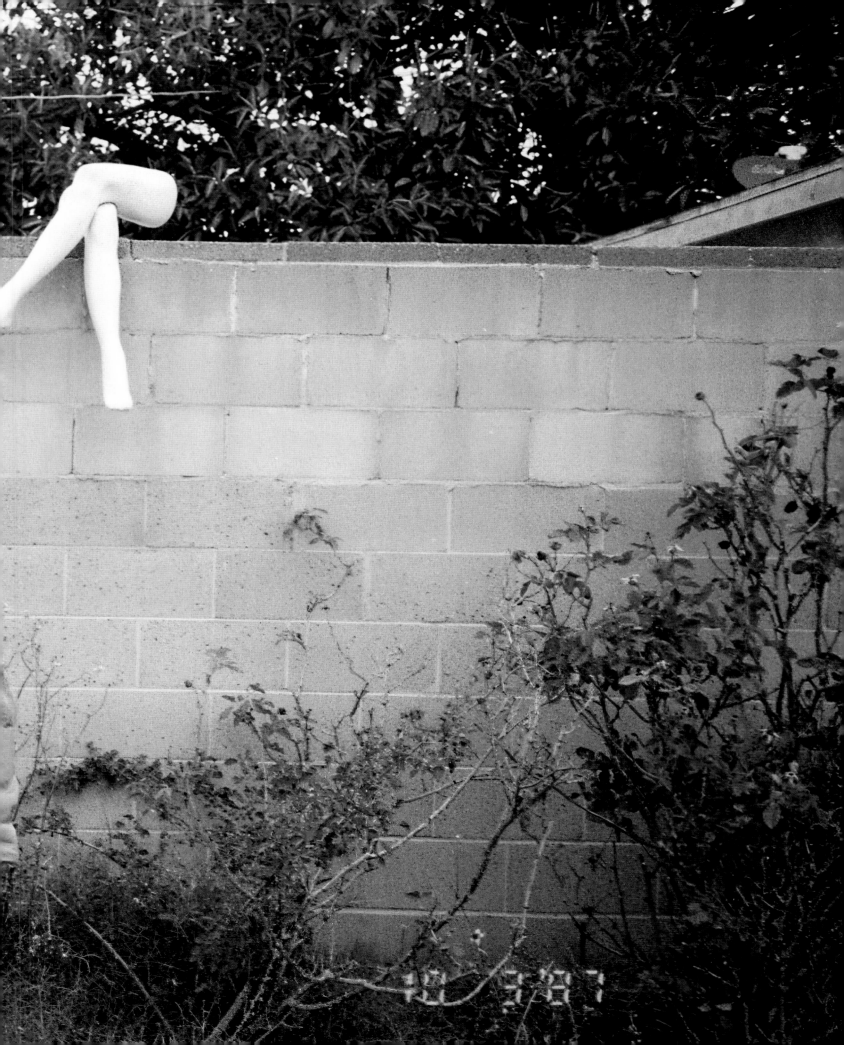

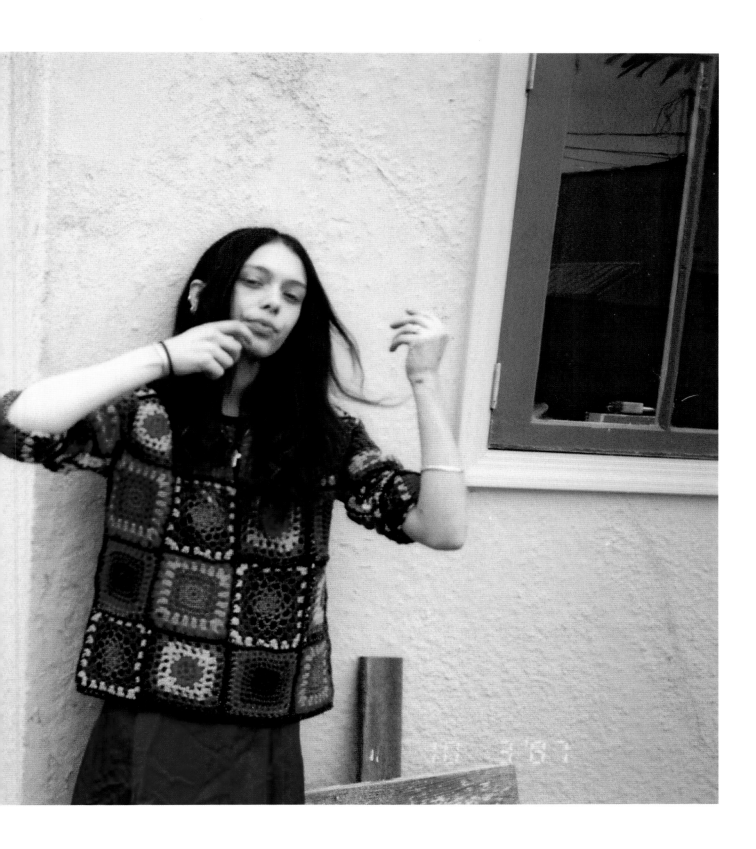

Contrast-Stitch Vinyl Overalls, Fall 2017.

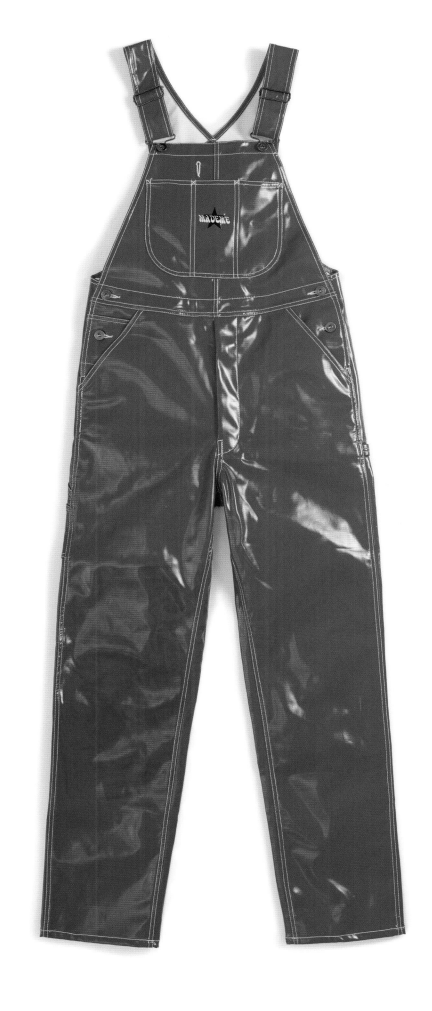

That's Sam. I took that photo.
We laughed for hours.

Sam Puglia photographed by Erin Magee. New York, New York, 2017.

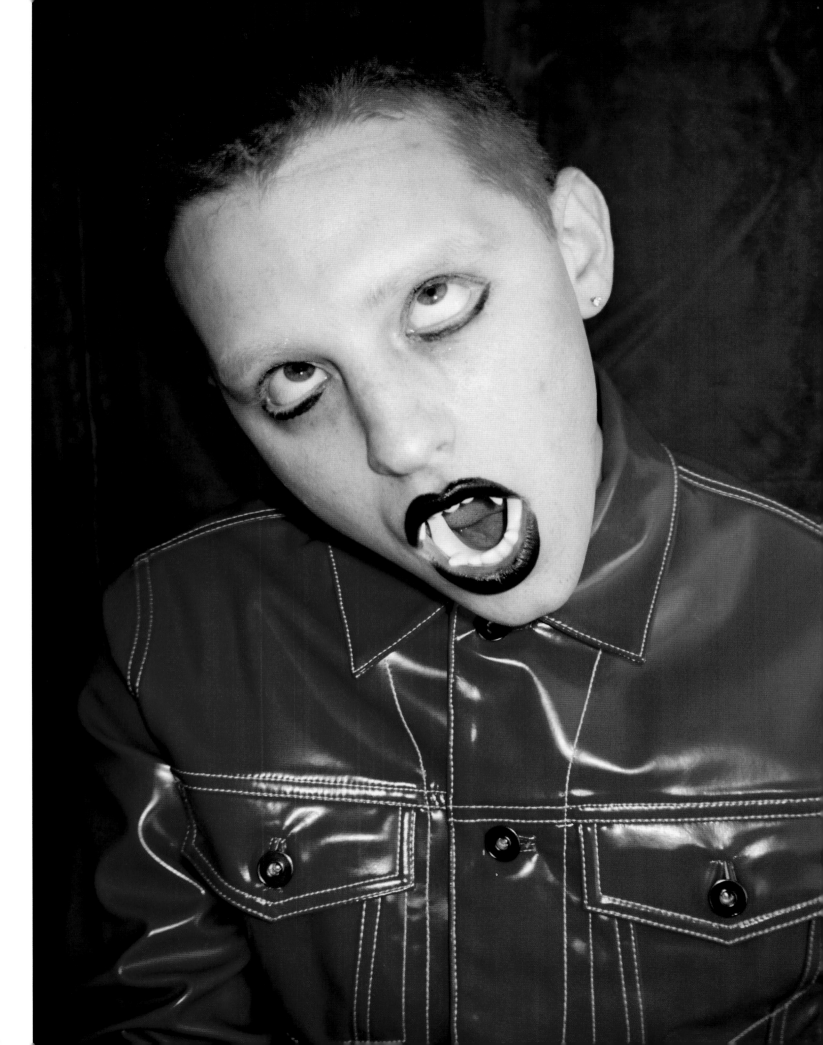

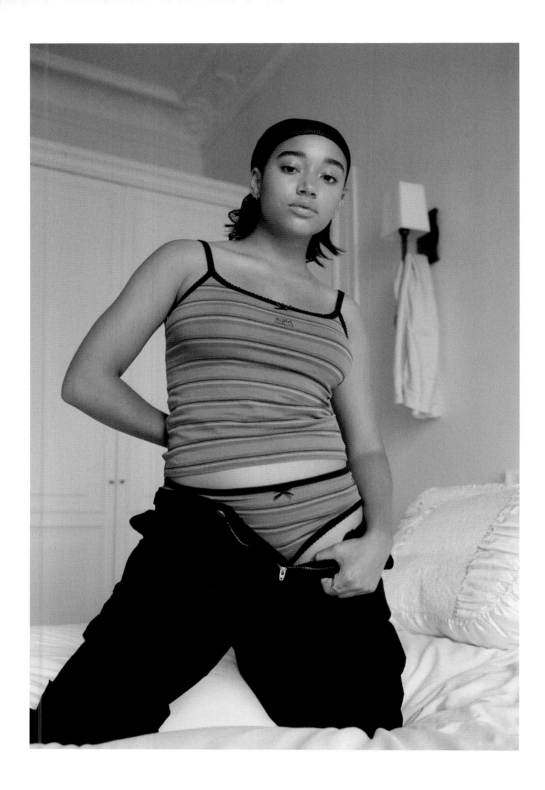

Amandla shot in Paris. This was another X-girl collection, and I wanted to find someone cool and new who could change it up for us. We had already done Coco, we had already done Lola. Amandla was new and very big. A real Hollywood movie star. She was doing a movie in Paris at the time, so her agent told us that if we were going to make it work, we would have to fly to Paris. I had a newborn baby at the time, my daughter Goldie. I booked Mayan and me a ticket to join on set in Paris, but at the last minute I told Mayan, "I can't go; you're going to have to do this on your own, without me." I needed to be with my baby.

Amandla Stenberg photographed by Mayan Toledano for MadeMe / X-girl. Paris, France, 2019.

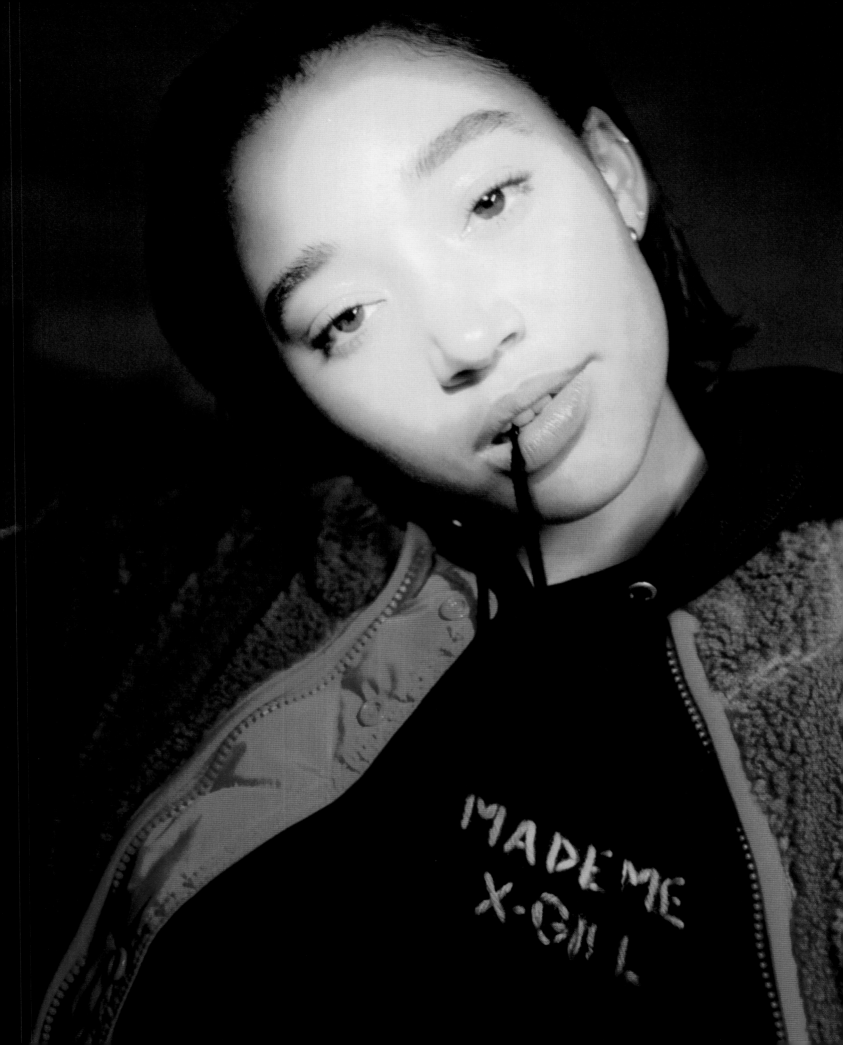

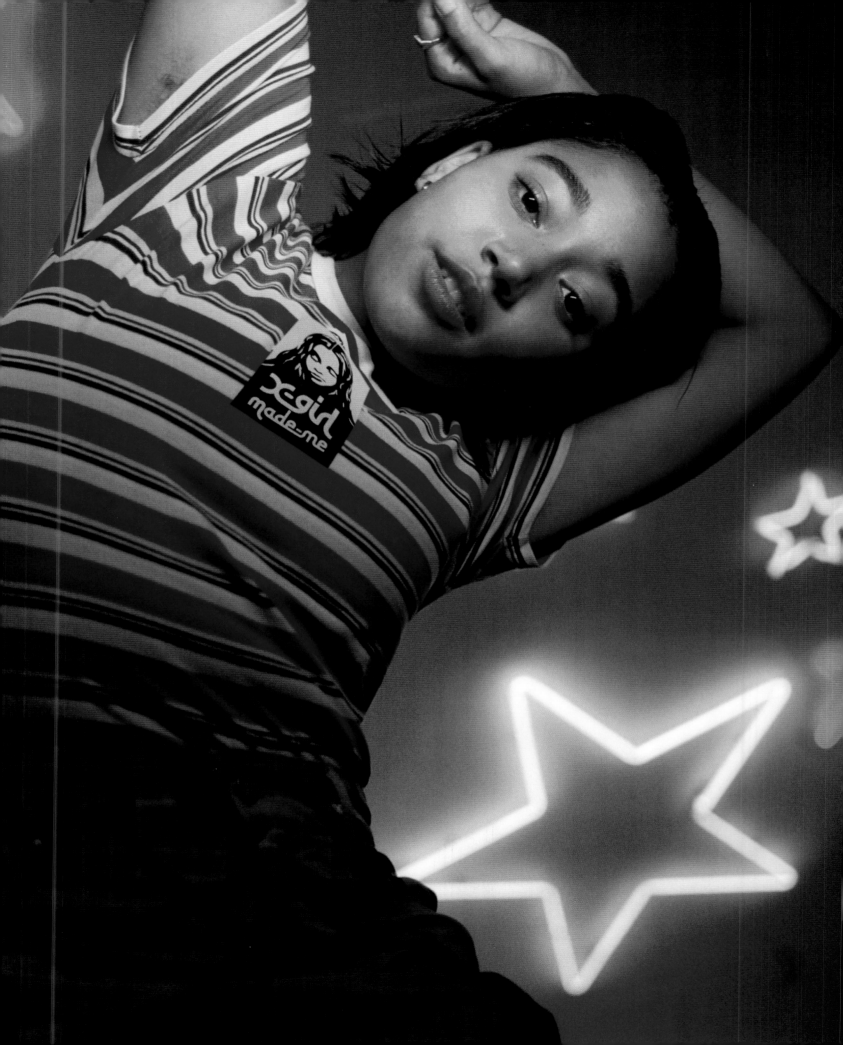

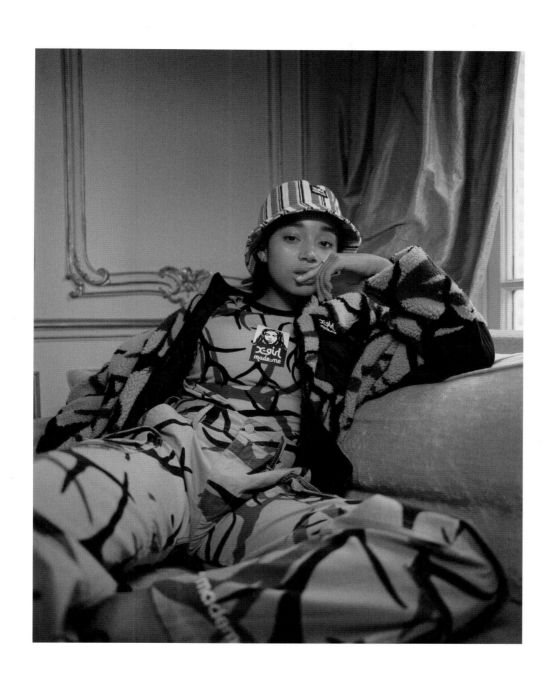

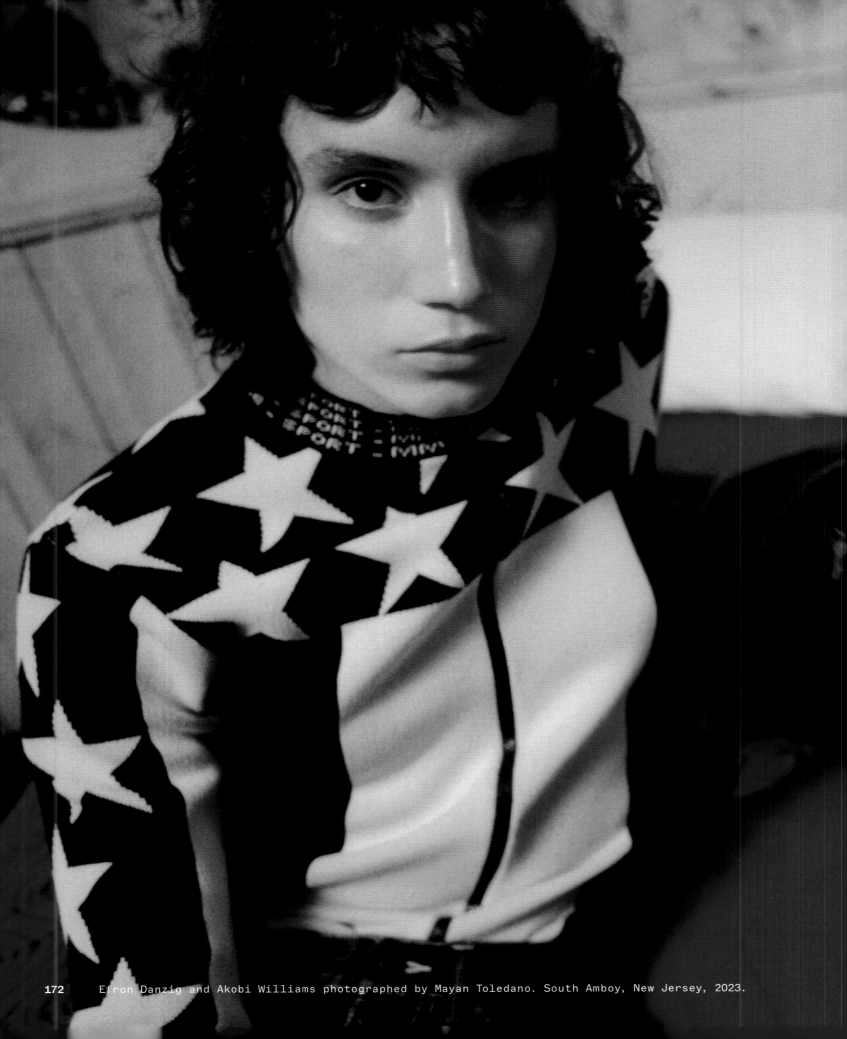

Efron Danzig and Akobi Williams photographed by Mayan Toledano. South Amboy, New Jersey, 2023.

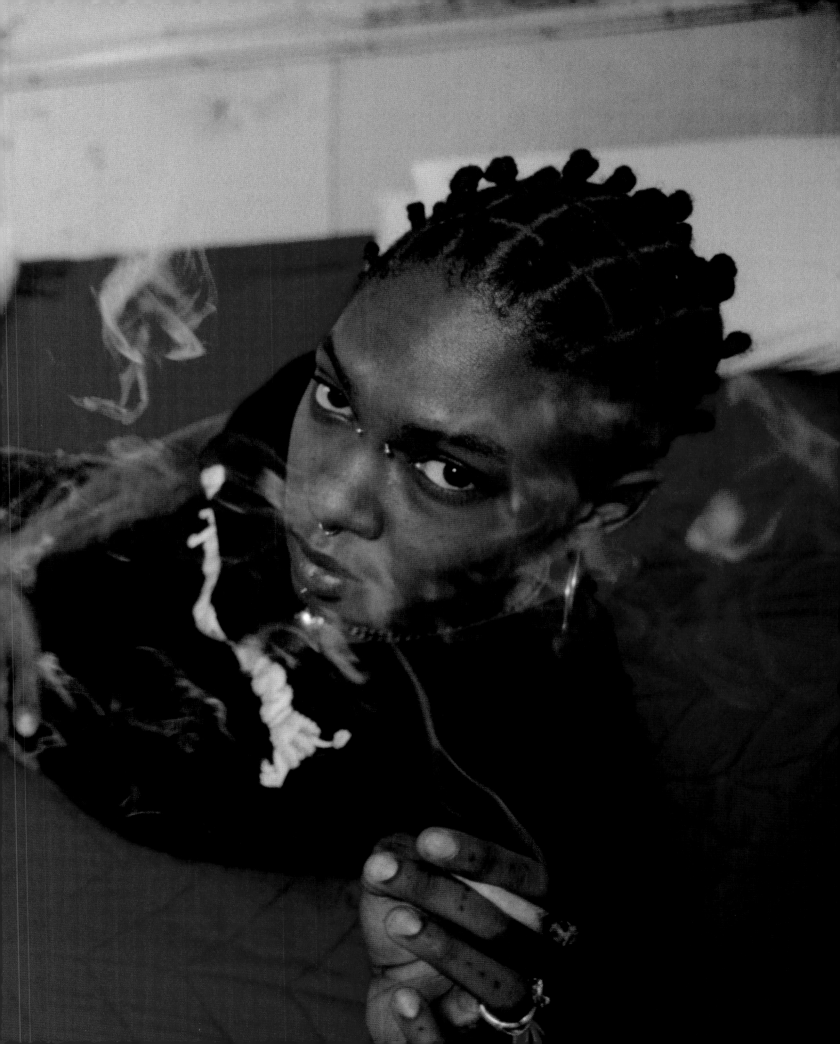

We walked into this hotel room
in Jersey and there were greasy
ass and tit prints all over these
mirrors, used nipple clamps on
the ground. I went right back out
and told the guy at the front desk
to clean that shit up! It was the
sketchiest place, but I know that
when we're in these situations,
the photos are going to be good.
However, I do start to feel
protective of the crew on set.
Once they got it all cleaned up,
we were like, "Start modeling!"
Almost immediately, Akobi and
Efron started making out. I got
really awkward and decided it
was best for me to leave. Like,
"Anyone want coffee? Water?" I
left for an hour and drove around;
Mayan stayed and took the photos.
I love these photos.

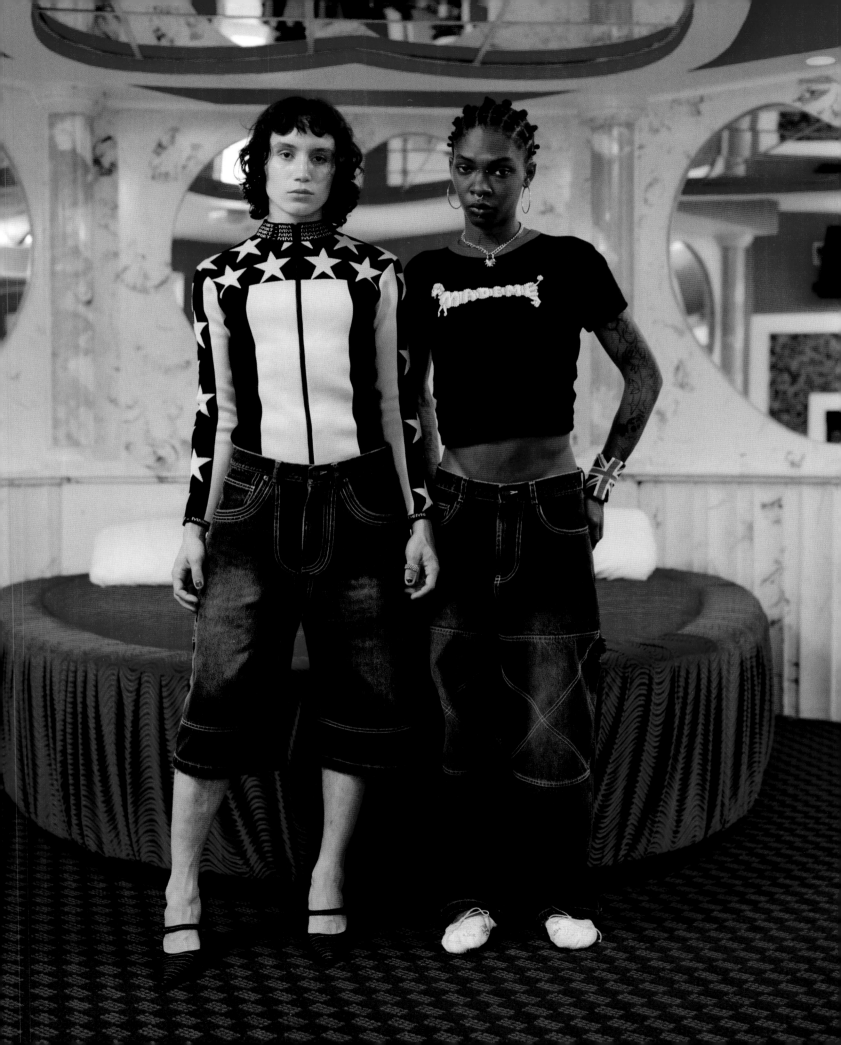

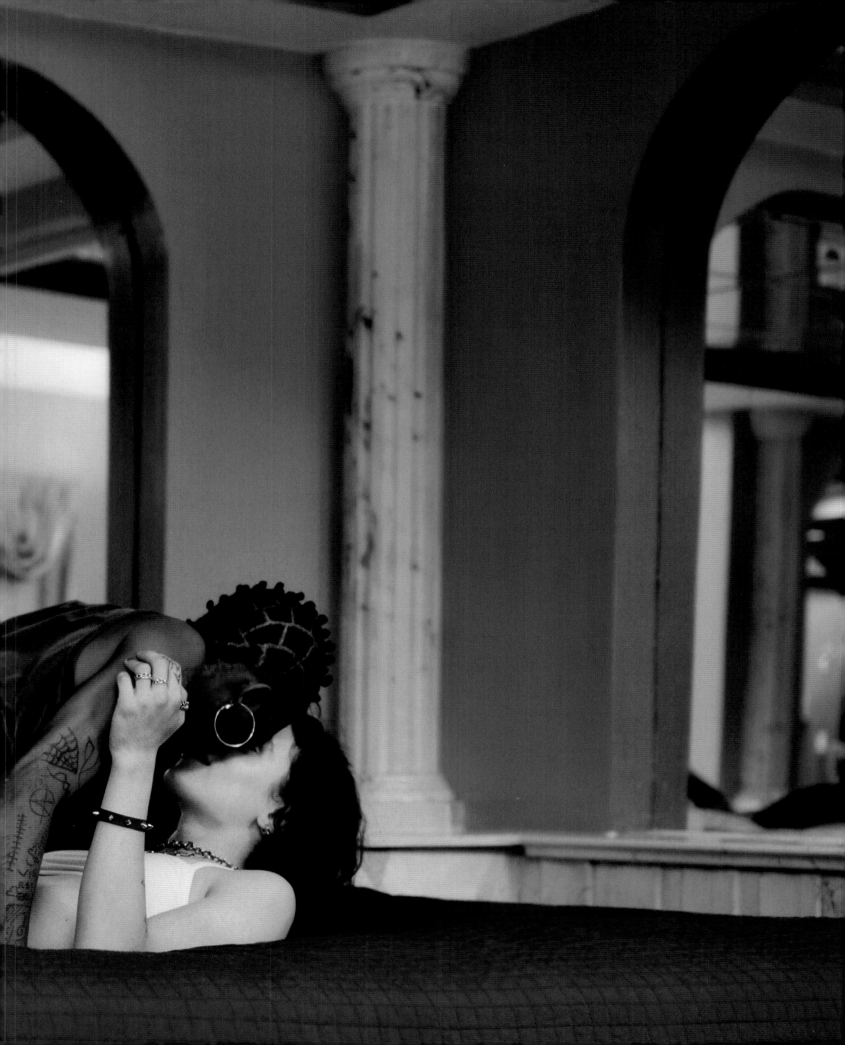

Mayan took this picture in Mexico
City. I wasn't there. It was when
she was living there finishing
work for her book. It was another
one of those things where she's
like, "Send me a suitcase of
clothes — I'm going to shoot it
on these girls. I have the best
girls here!"

Karla and Sheila photographed by Mayan Toledano. Mexico City, Mexico, 2022.

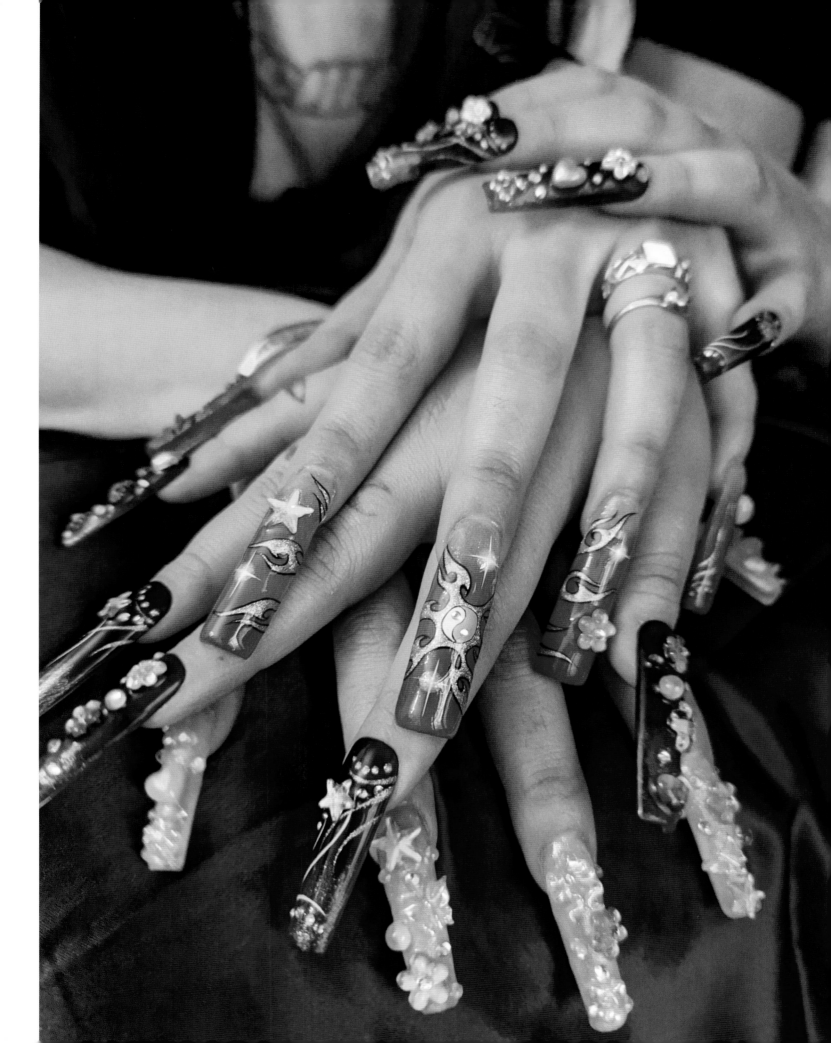

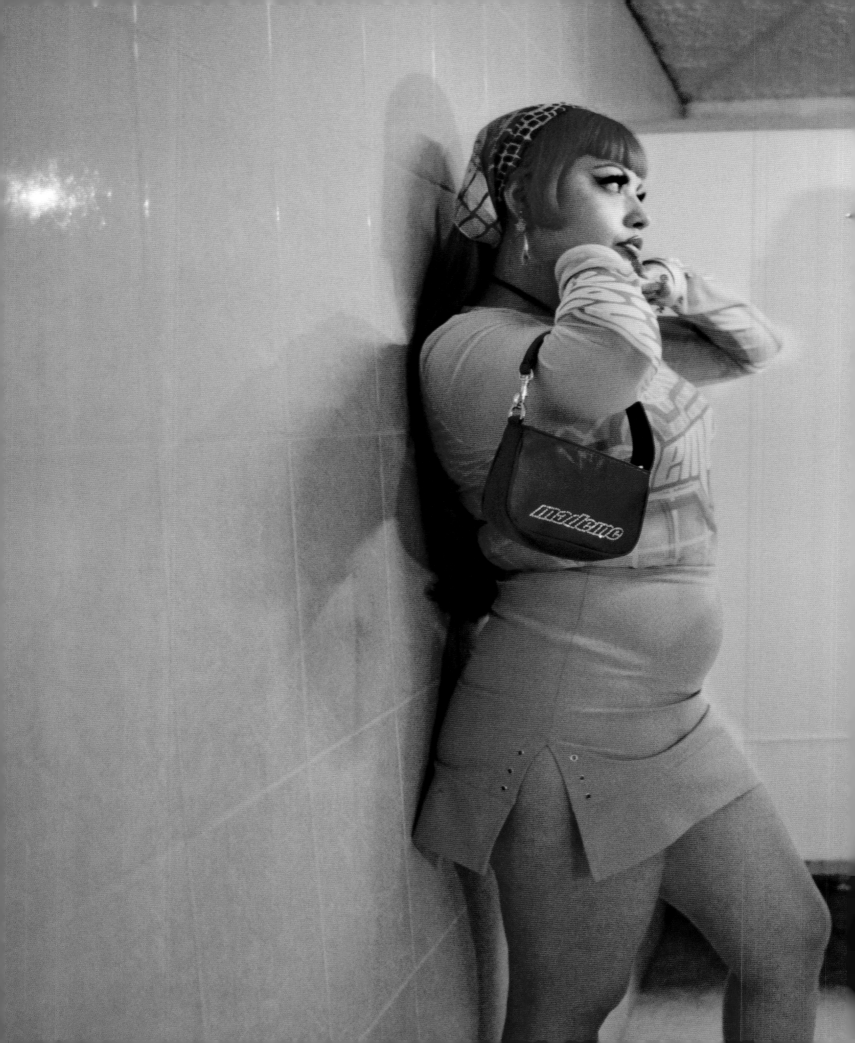

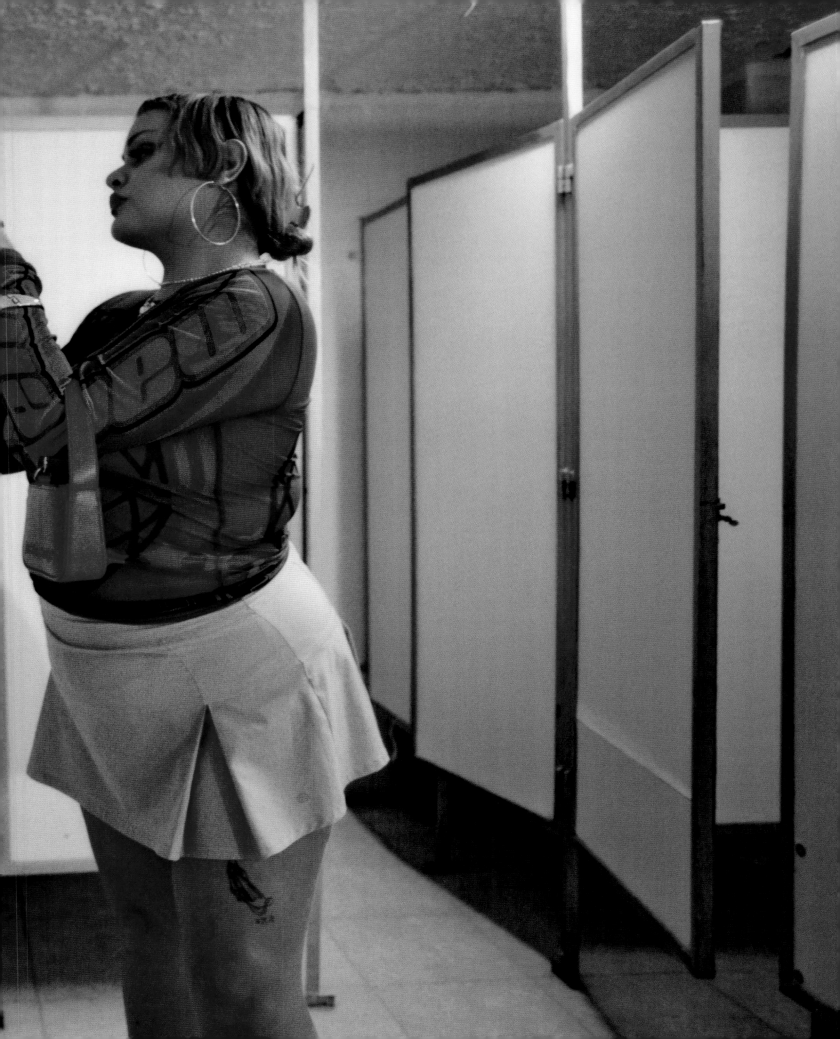

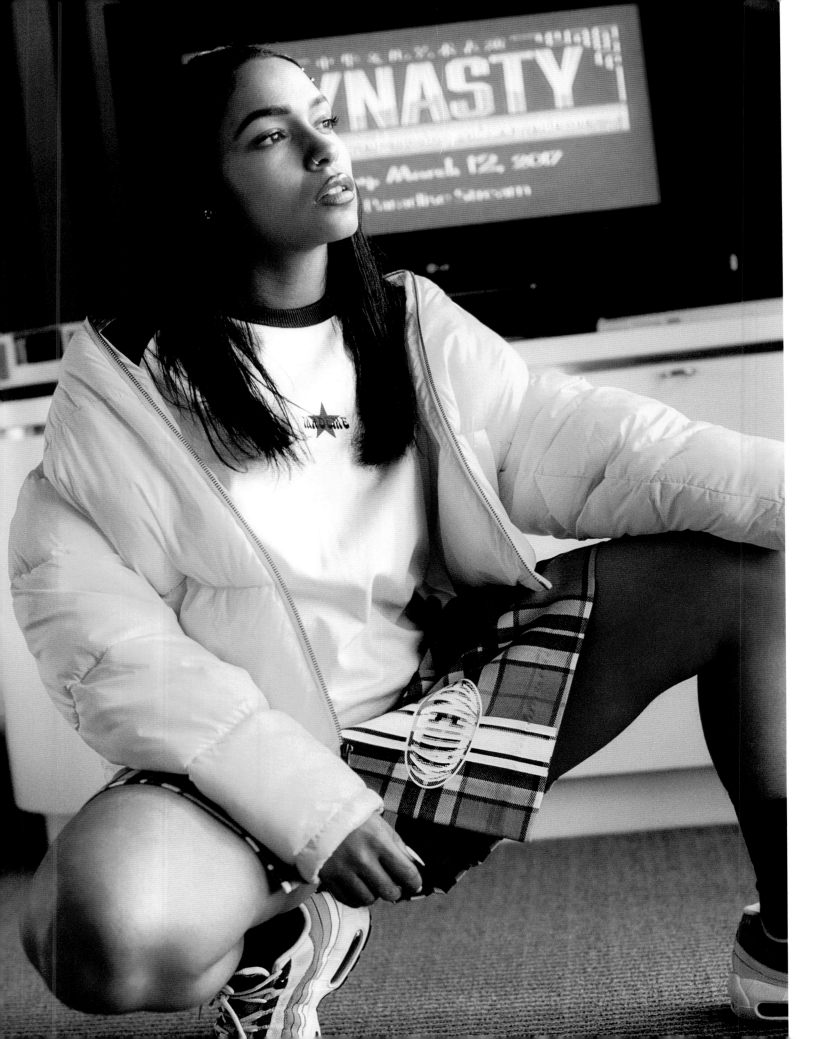

This might be one of my favorite shoots of all time. I was very nervous about doing it because it was my first time working with Destiny, and she was getting really popular. I had my wife, Nicole, come along to help me break the ice because she's also from New York, also a Puerto Rican musician, and they knew each other from around downtown. Mayan was shooting, and I found this weird sex motel in the Poconos.

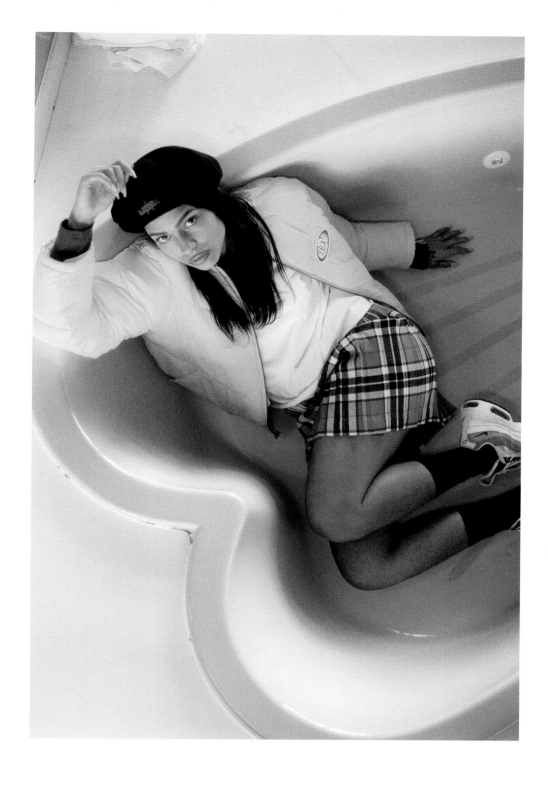

Princess Nokia photographed by Mayan Toledano. Lakeville, Pennsylvania, 2017.

I couldn't afford to pay for a car
service for Destiny, so I had to
pick her up at her house, and we
drove for two and a half hours.
It was quite awkward in the car,
but I was just trying my best to
make her feel comfortable around
us. We listened to music, talked,
and got to understand each other
better. I remember going to the
party store before the shoot
to buy blood capsules. I wanted
her to eat the capsules so there
would be blood coming out of her
mouth. But with a lot of these
things, she did it all on her own.
Twerking, showing her underwear,
and shooting a pistol with her
fingers. When I work with Destiny,
I'll always get something good
because she's a true artist and we
have a real connection.

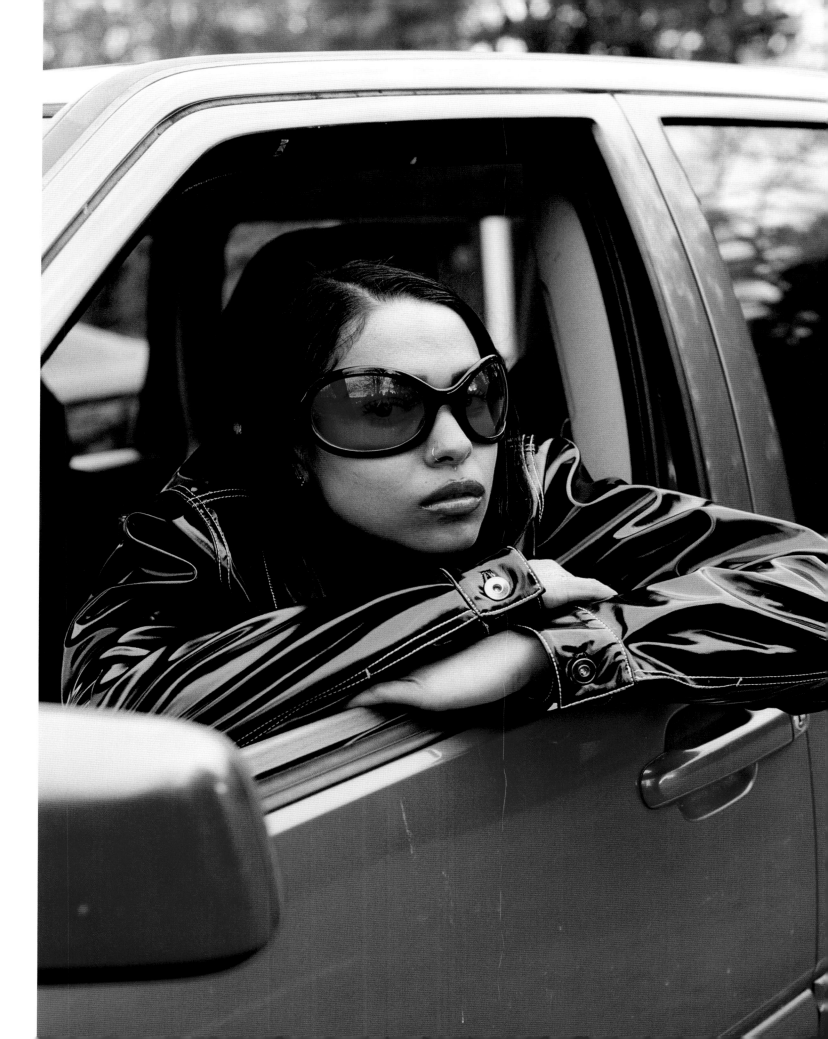

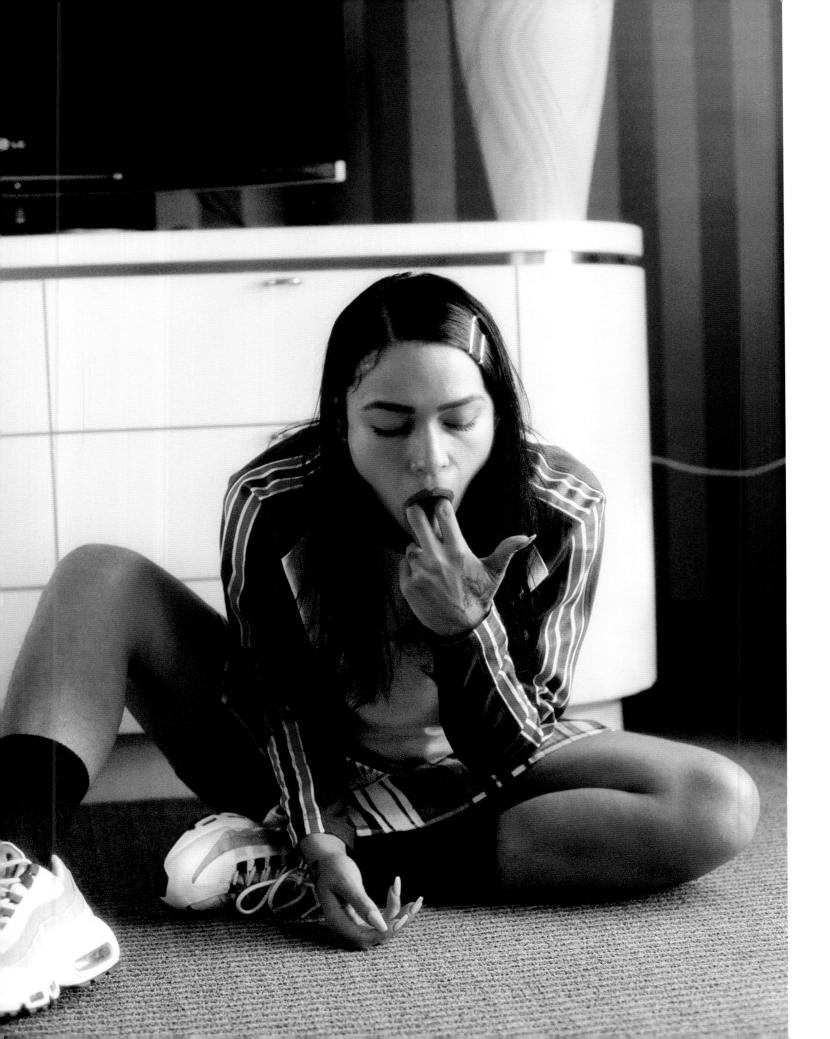

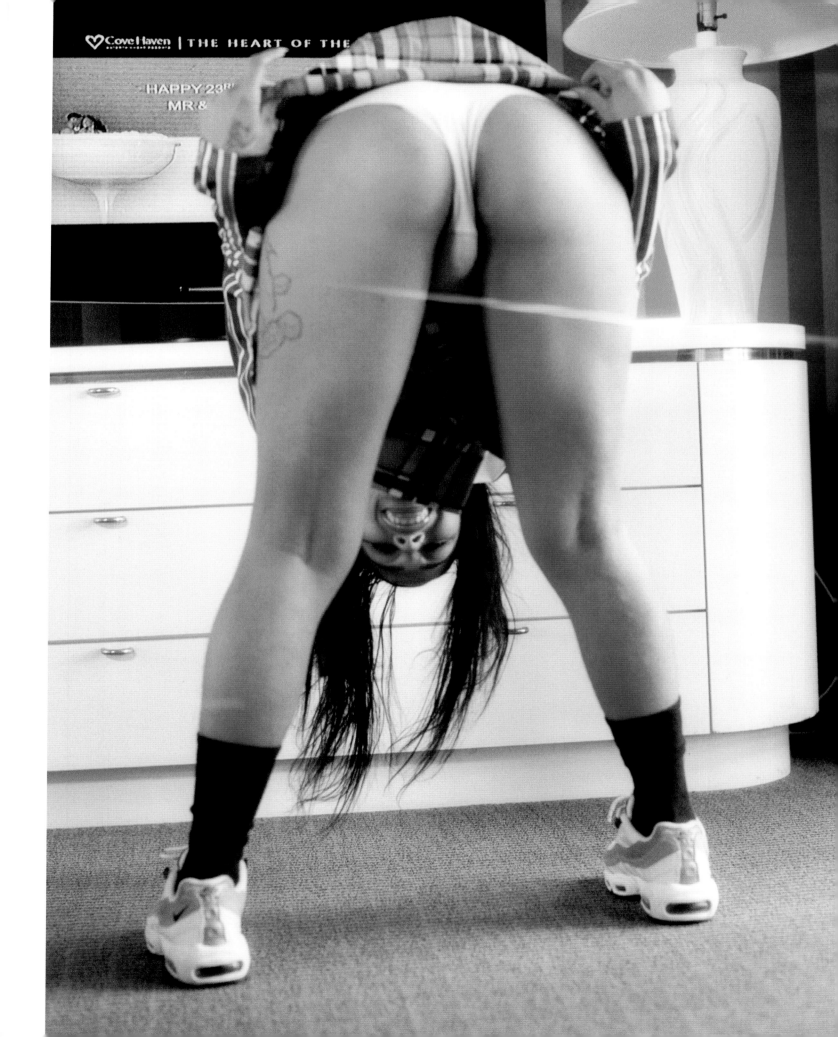

There's this classic Destiny story
that happens almost every time,
but this shoot was the first time
it happened: She pulled me into
the bathroom. She goes, "Can I
show you this trick I can do?"
I say yeah. She goes, "Look, my
breasts can lactate on command."
She squeezed her breast and breast
milk came out. Destiny gives so
much when you work with her. When
I got the film back, I was like,
damn, it's so good, it's so good,
these feel so real. It captured
everything I was trying to say
at the time. Because a lot of the
time, Destiny and I are trying to
say the same thing.

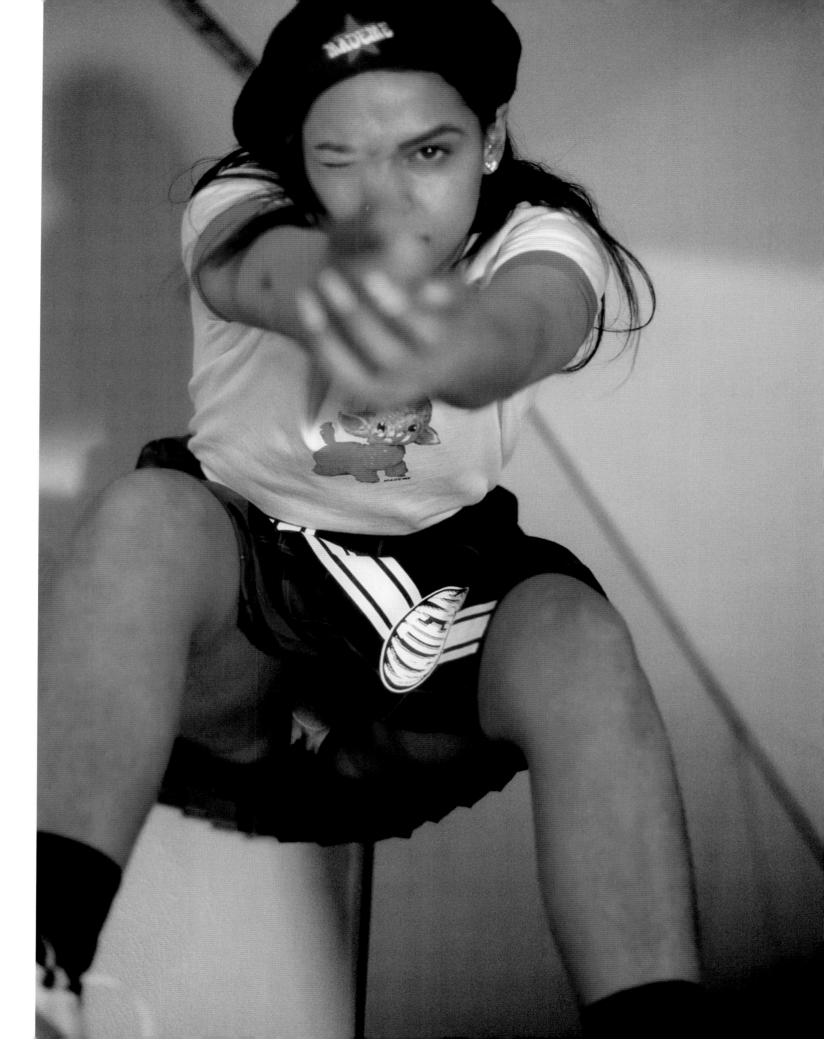

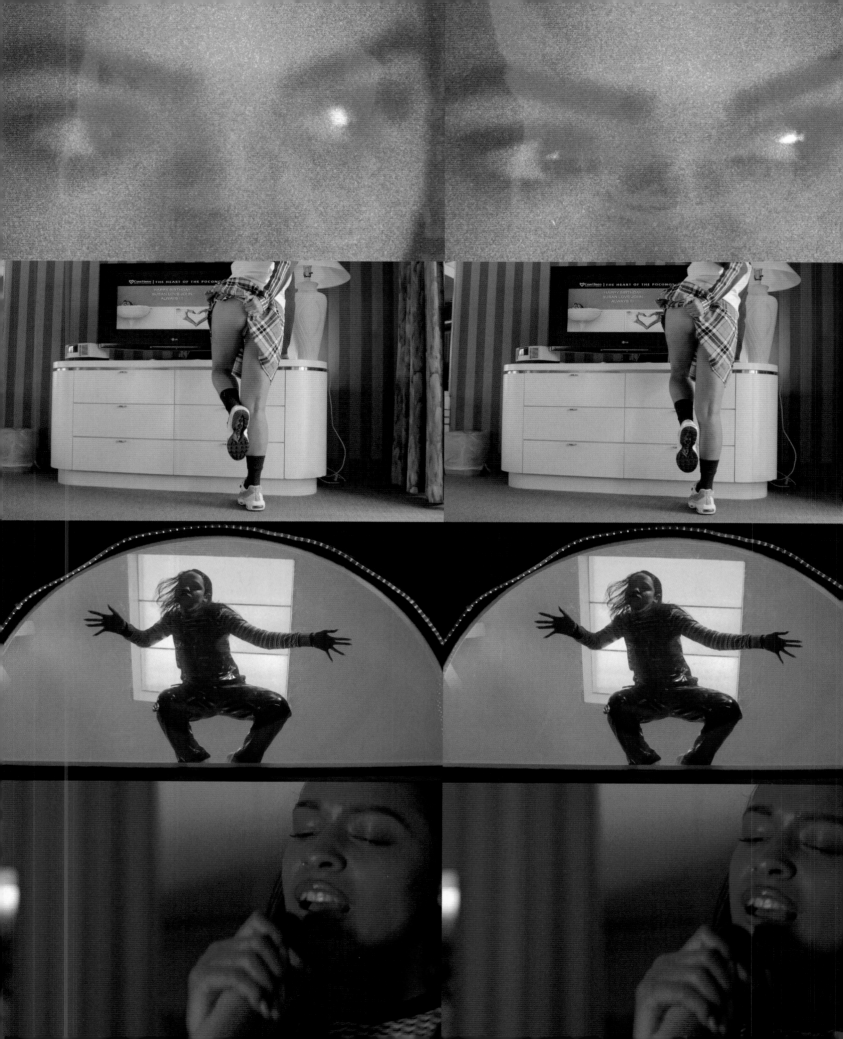

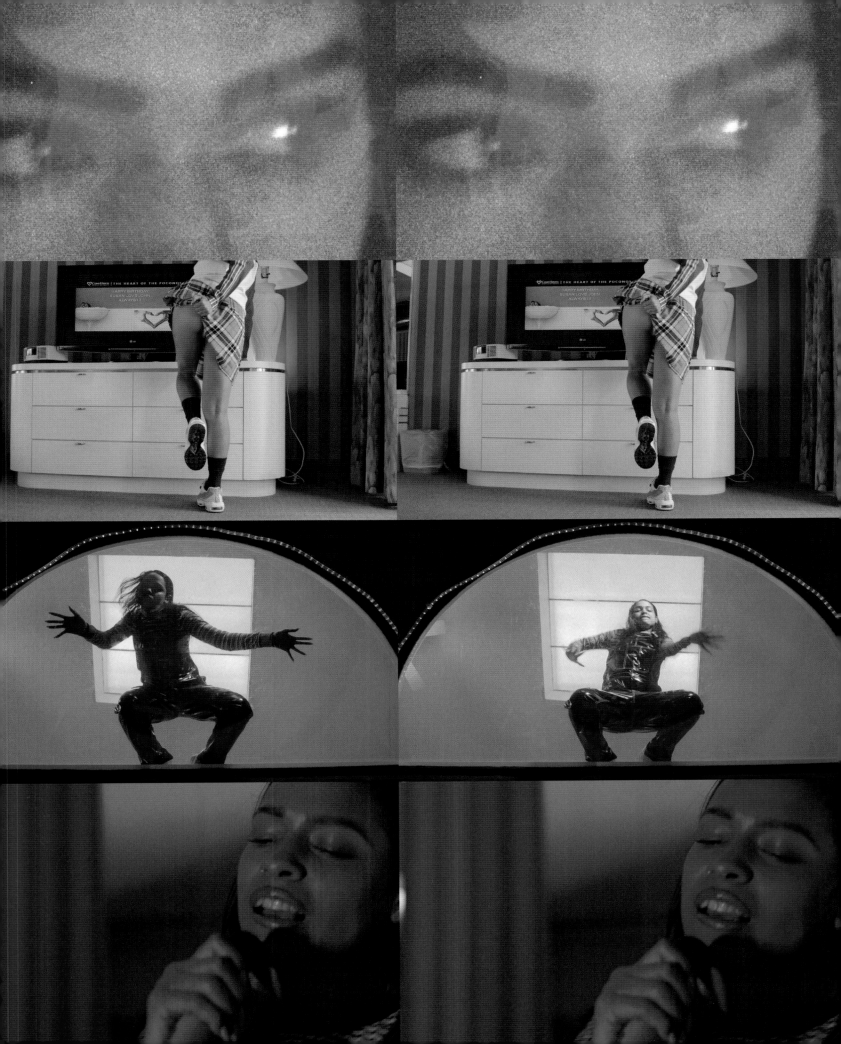

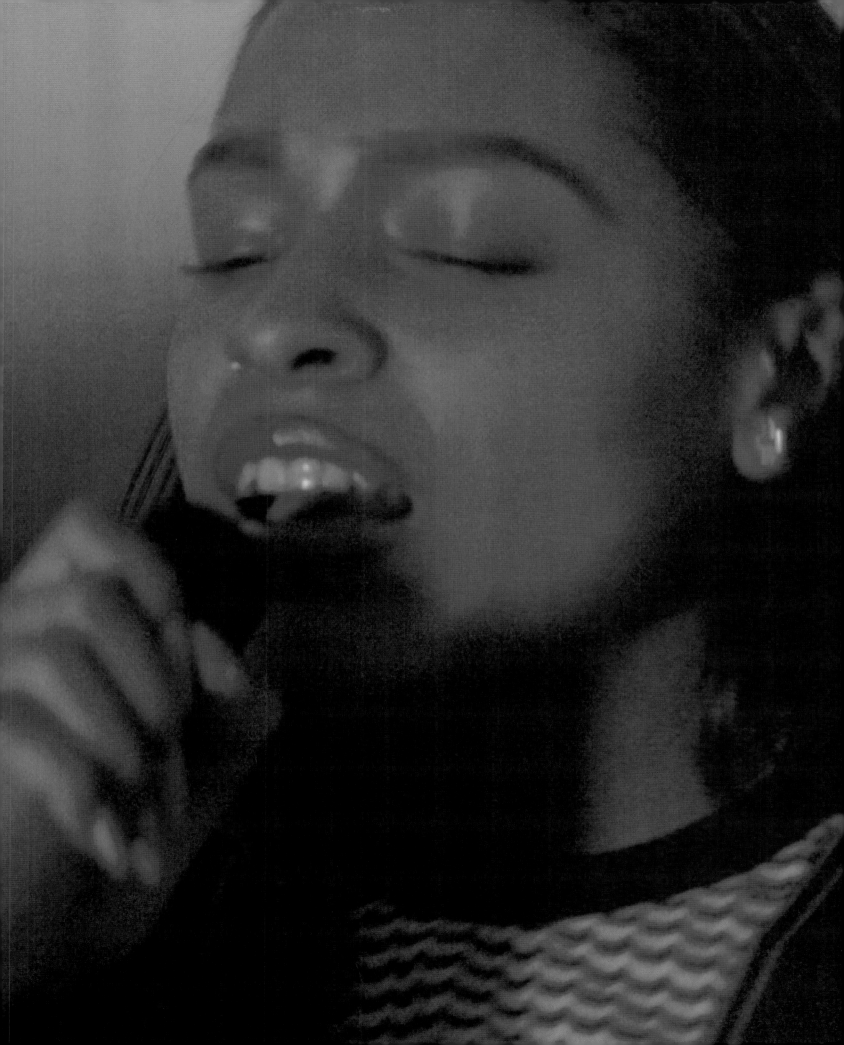

Every person who looks at this
photo goes, "I love this," and
then I always say it's the one I
love the least. It has nothing
to do with the image quality. I
love Akobi — it has nothing to
do with Akobi. It's more to do
with the fact that it's probably
the least-natural photo in this
book. It's staged; it feels
fabricated. We built an altar on
the beach. Who's she marrying on
the beach? I don't know.

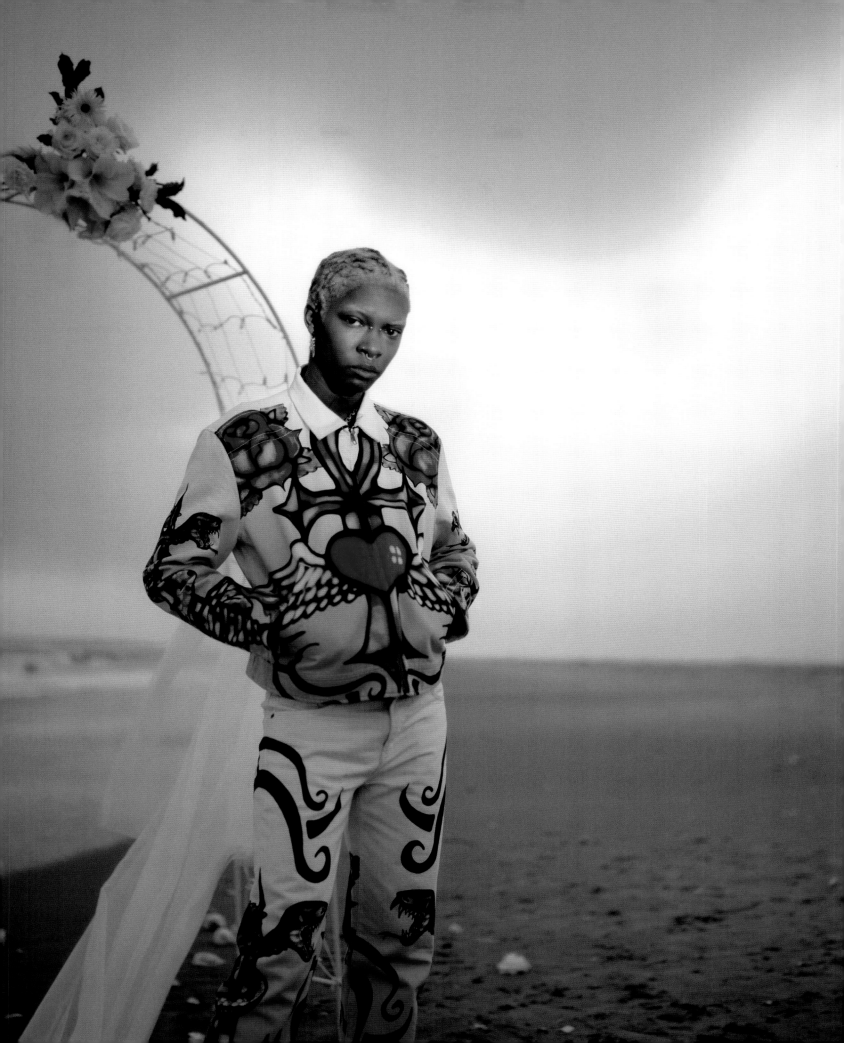

These are some of the best photos we've ever taken. Lola came three hours late or something. She got out of the car with a pillow and a toothbrush. It was like one p.m. and she had just woken up. We'd rented out this abandoned school, and there was a whole crew there. Mayan shot these photos and Zara Mirkin styled it. It was one of the first times I used a stylist; usually I do the styling myself.

Lola Leon photographed by Mayan Toledano. Brooklyn, New York, 2019.

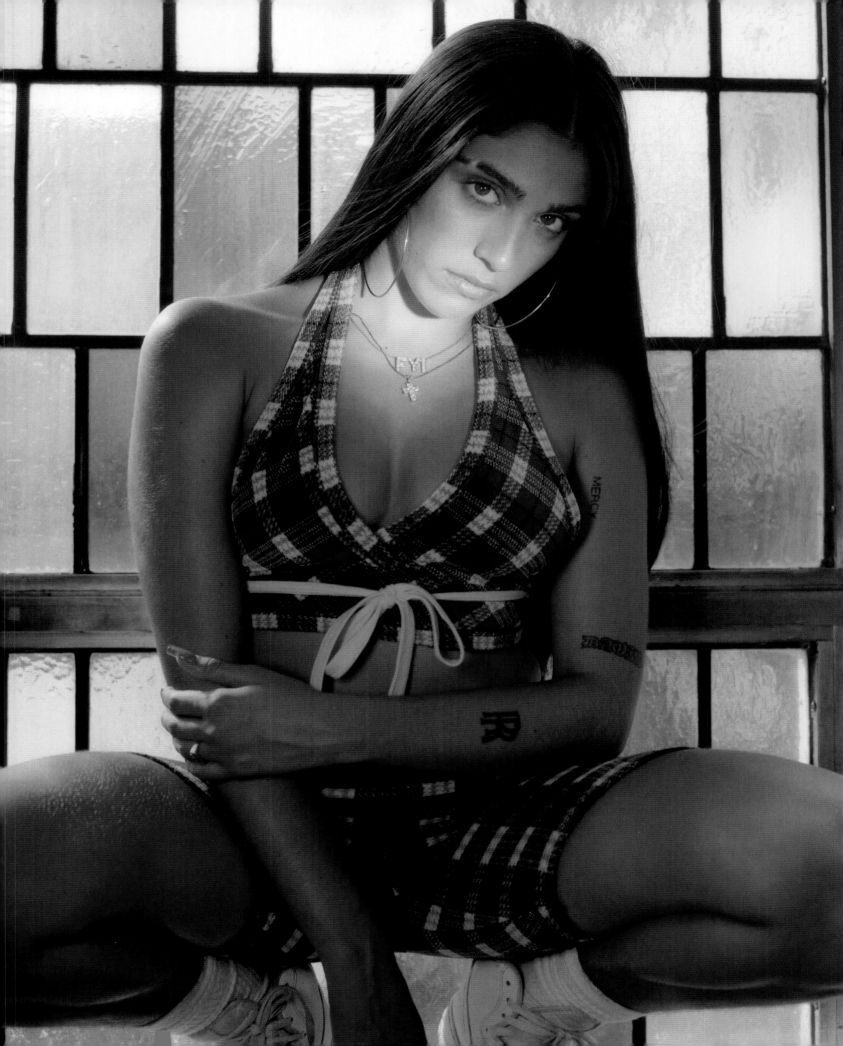

While we were waiting for Lola to
show up, we had time to rebuild
the school set. We brought in neon
curtains, mattresses, and bed
sheets and fabric. The school was
attached to a convent where the
nuns lived. I love how real they
came out, the hand tattoos, dirty
AF1's. My mom was very sick in the
ICU in Toronto, and I flew to NYC
that morning for the shoot. We did
the photos, and then that night I
got on a plane and went back to
Toronto to be with my mom.

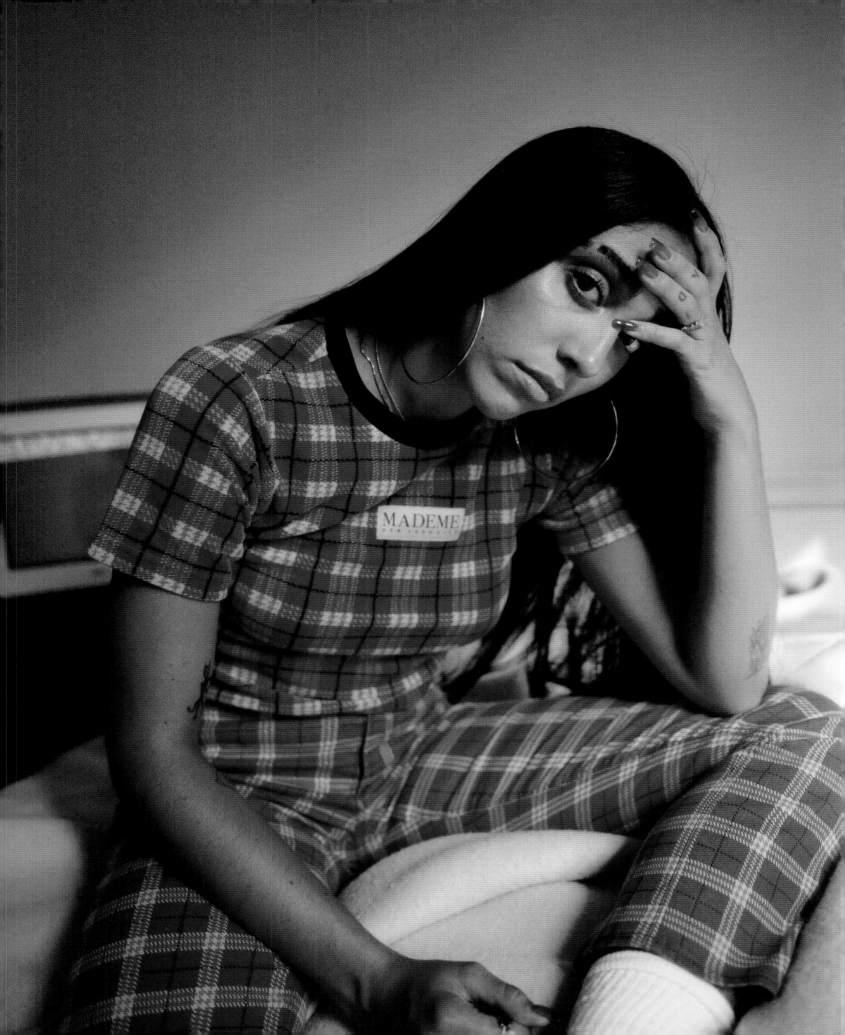

Kaila Chambers photographed by Manon Macasaet. New York, New York, 2016.

Manon took these photos maybe
eight years ago in her laundry
room. I love the green lighting.
The model's name is Kayla. I think
she's a video director now.

These are from the LeSportsac
collection I did. We shot with
Shaniqwa Jarvis, Coco Gordon Moore,
and Beatrice Domond. I remember
Beatrice had just moved from
Florida, and this was one of the
first photo shoots she ever did. We
also did a skate video with Emilio
from Hardbody. It was a little
out of character for MadeMe to do
a skate video, but with Emilio
and Beatrice involved, I figured
it couldn't go wrong. It was an
interesting new way to show bags.

Coco Gordon Moore and Beatrice Domond photographed by Shaniqwa Jarvis for MadeMe / LeSportsac,
New York, New York, 2018.

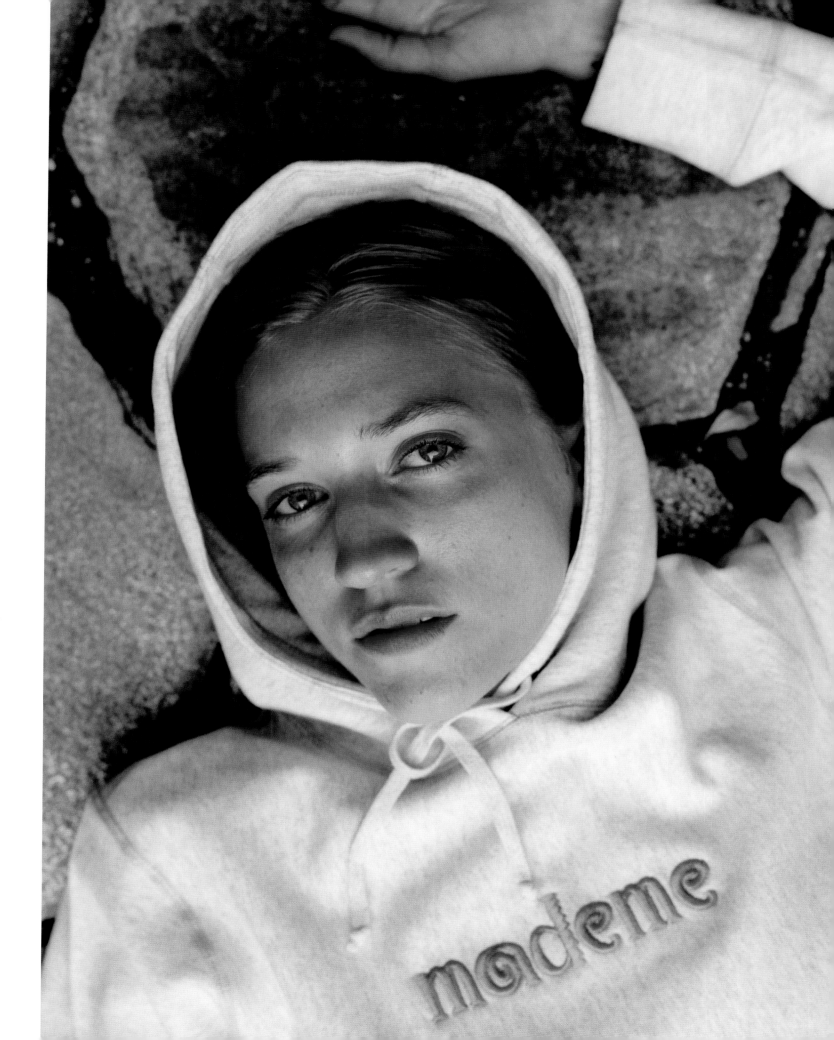

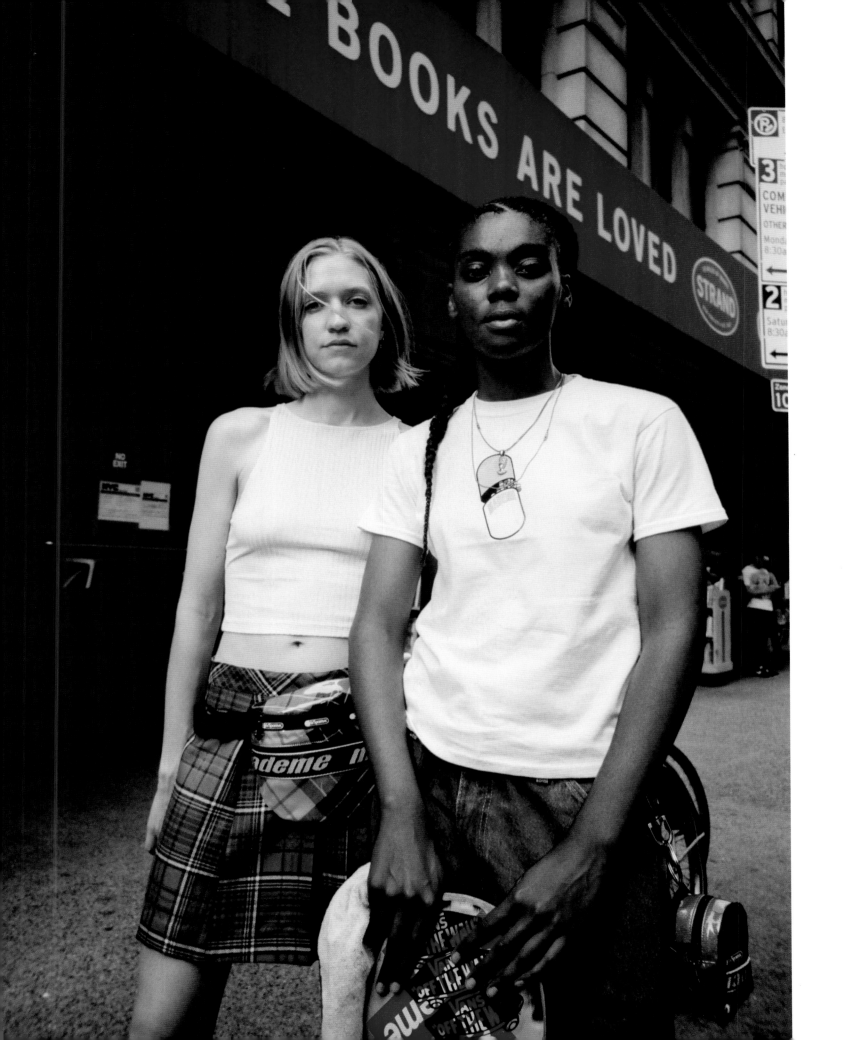

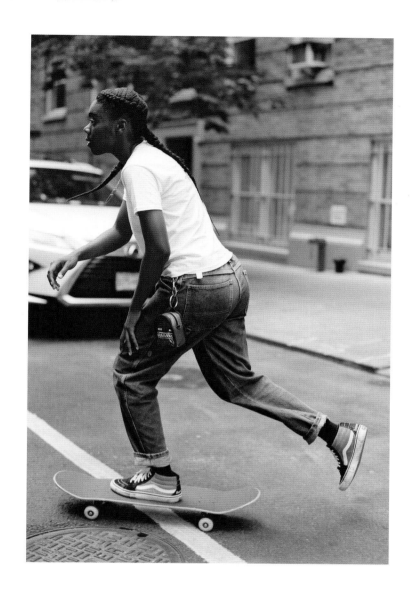

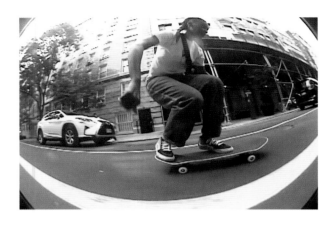 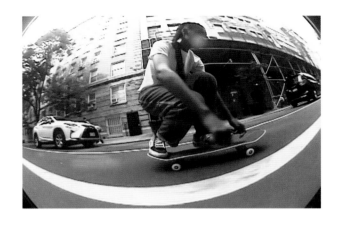
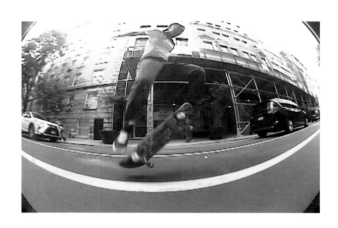 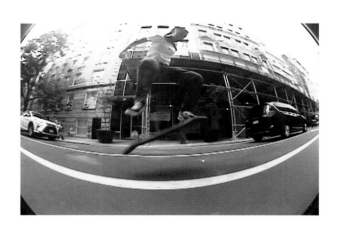
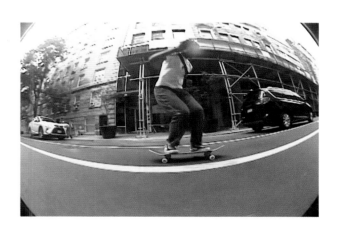 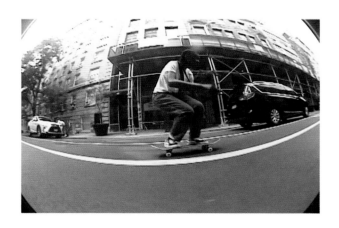

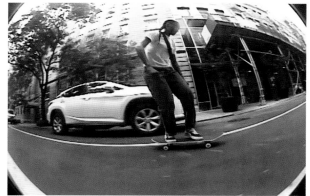
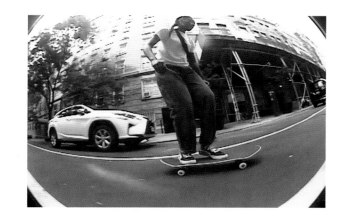

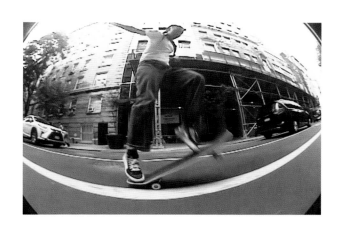
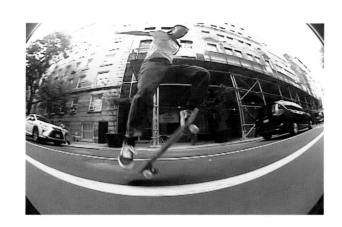

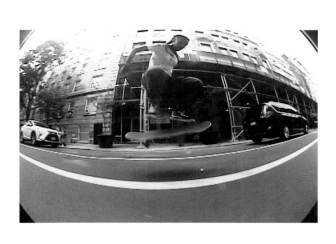
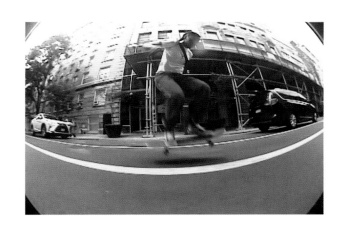

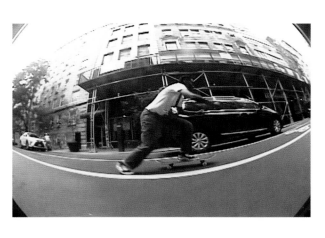
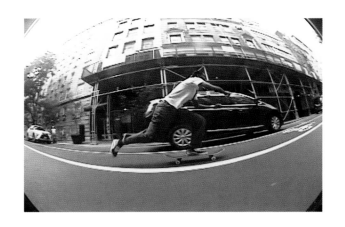

We all met at my apartment on
Tenth Street — everyone got ready
there and we just went outside
and shot. There's that one photo
of Coco where we caught her with
those biker dudes doing wheelies.
They just happened to be going by
and I was like, "Shaniqwa, quick,
quick! Take it!" It was a fun day.
Everyone got along really well.

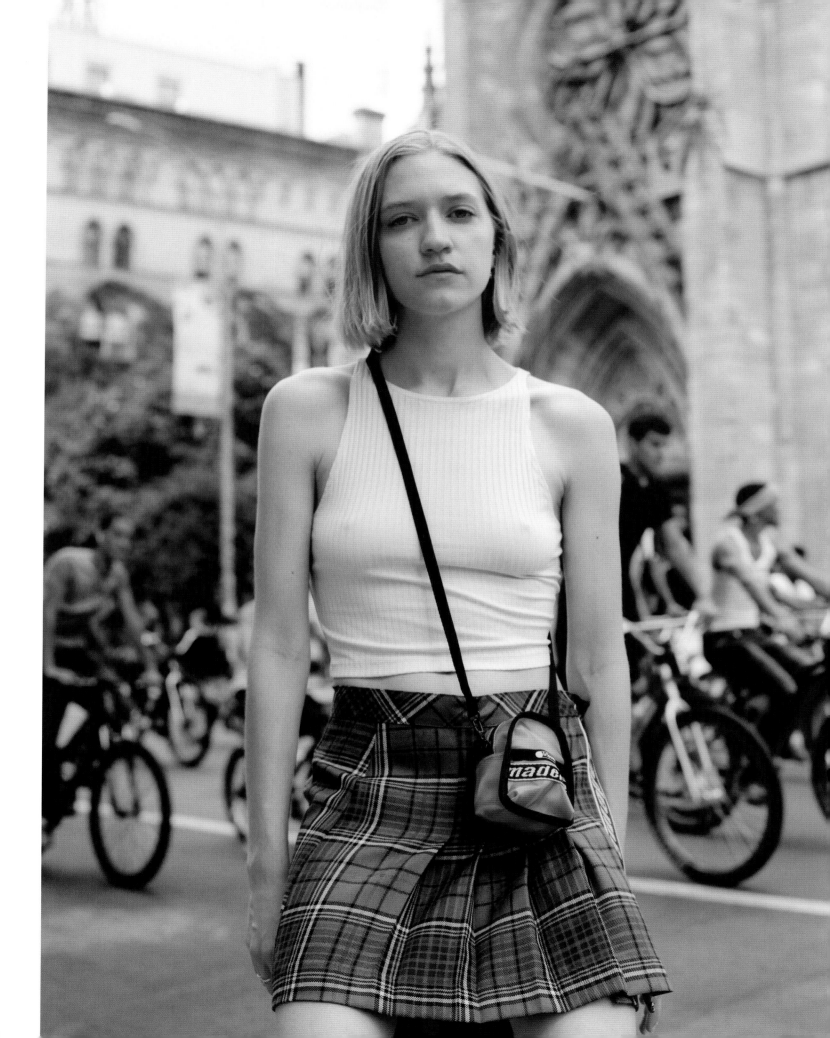

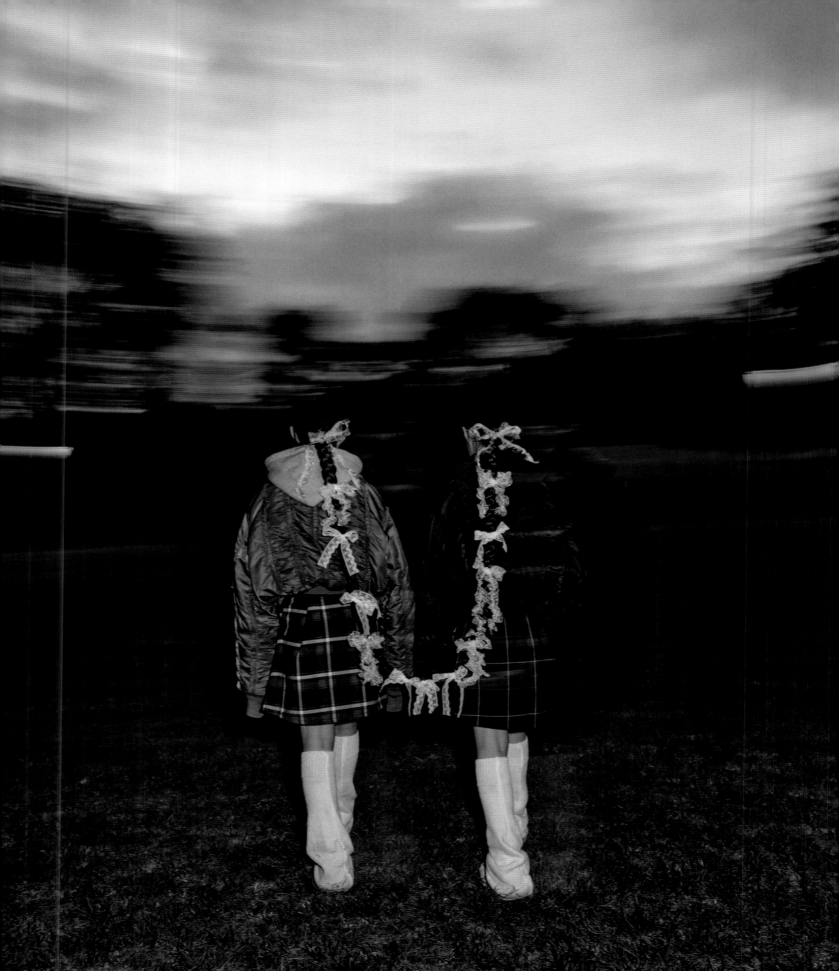

Bess Gsell and Sam Gsell photographed by Shaniqwa Jarvis for MadeMe / Alpha Industries.
New York, New York, 2023.

Shaniqwa Jarvis shot these in
2023. The coolest part is the
casting story about these twin
girls, Sam and Bess. In the summer
of 2023, I was walking down the
street with my daughter, and I saw
these two girls walk by. I grabbed
my daughter and told her we had
to go back to take their photo. My
daughter, who was five years old
at the time, was very confused.
I could only get pictures of the
back of them, their long hair
down to their ankles, because they
had passed us. I had this photo
in my phone for a long time. Then
when we were casting for this
Alpha Industries collaboration,
Shaniqwa and I were going back
and forth. We didn't want to
shoot any more influencers, yawn.
I remembered these twins, but
how could we find them with only
a photo of their backs? We put
it up on our Instagram stories
and hired the casting director
Chandler Kennedy, who tracked
them down. She found them because
they went to someone's boxing gym.
Their mom's name was on file, so
we emailed her; she turned out
to be an entertainment lawyer.
We asked if we could do a shoot
with her daughters. She said they
always get asked to do shoots
and they always decline. But they
wanted to do this one. They said
yes! Their mom came to the set. It
was a magical and beautiful day.

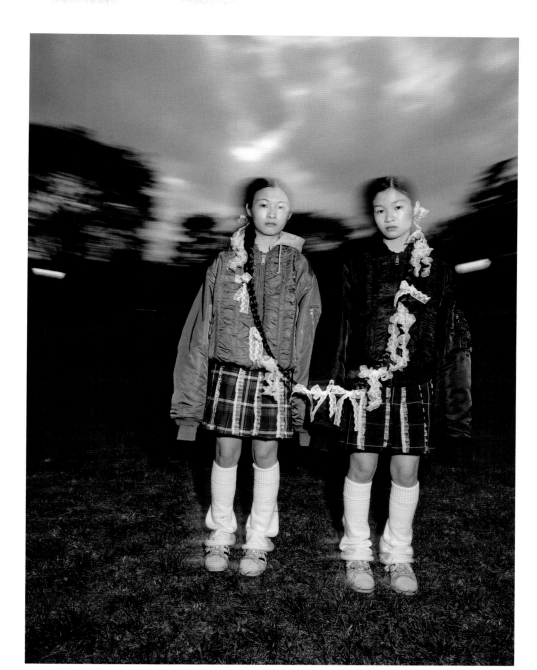

I've done a couple of Converse
collections, but this was the
first. I did a shoe collaboration
on a One Star, and they wanted me
to do clothing along with it. I
found it hard to do the clothing
but sunk into the '90s vibe with
baggy shorts, raver-feeling tees.
I shot Lola again for it, and we
built this huge set at Chelsea
Piers in a massive studio. At the
time, I asked my friend, "Does
this always happen? Do we always
get to build $50,000 sets and work
with Madonna's daughter?" Lola
had a security guard on set that
day; it was a different time.
The photograph with her armpit
hair went viral. *Vogue* posted
it on Instagram. It was one of
the first times she was seen
in a photo doing her own thing,
showing her armpit hair like her
mom. People really thought it was
controversial. Eye roll.

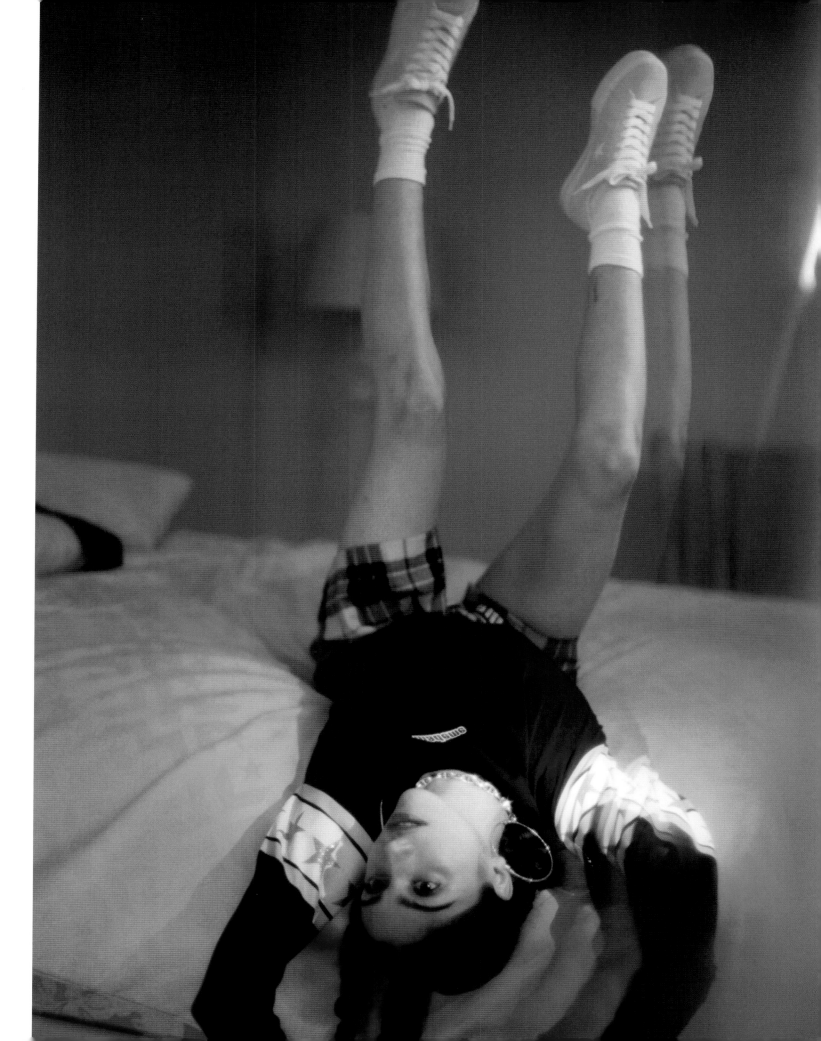

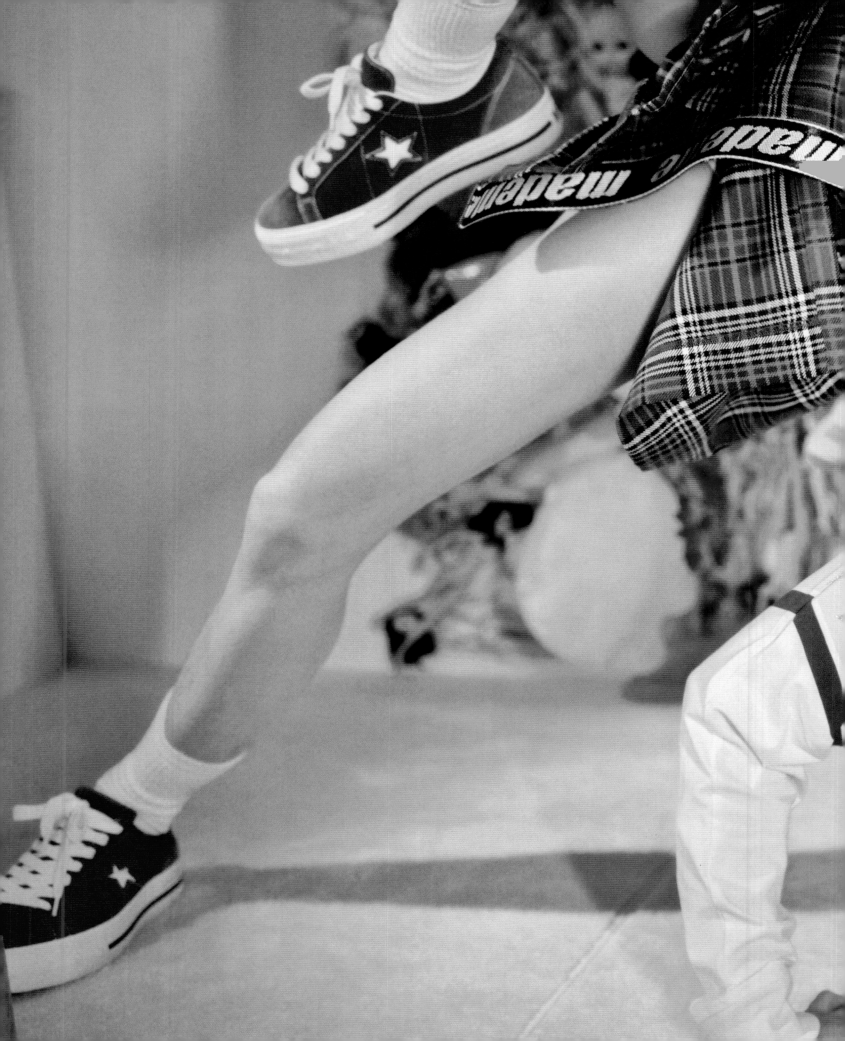

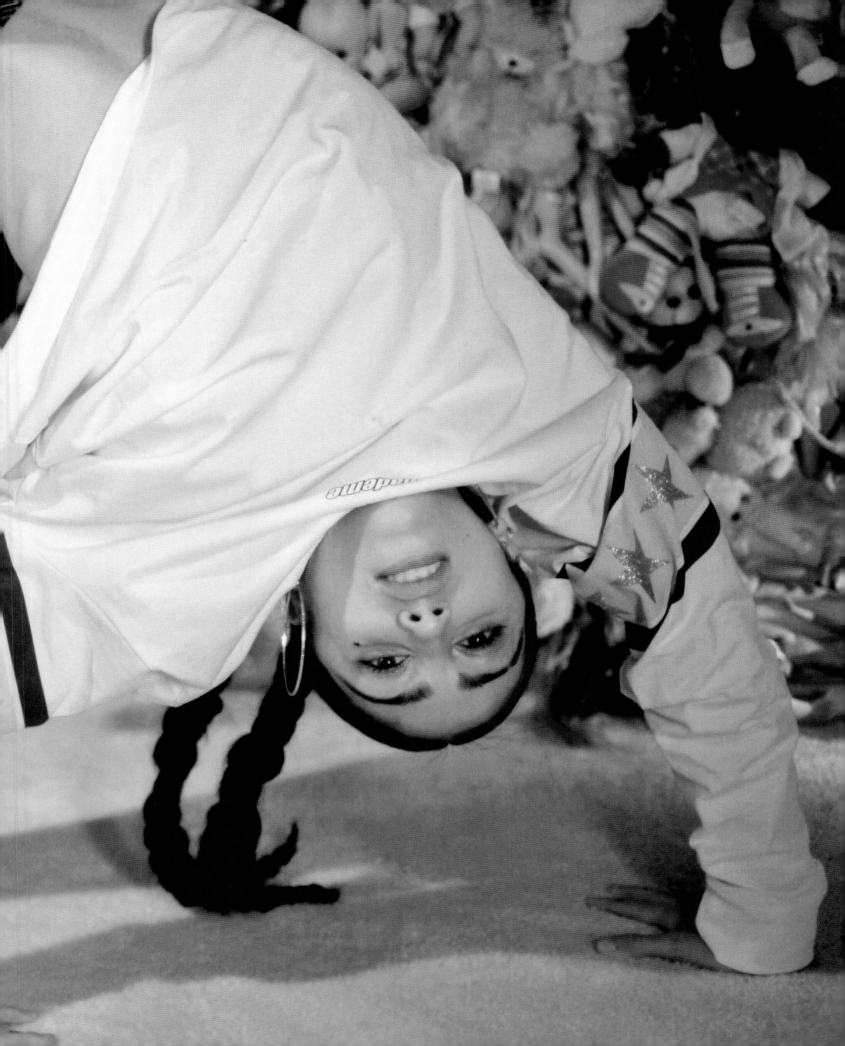

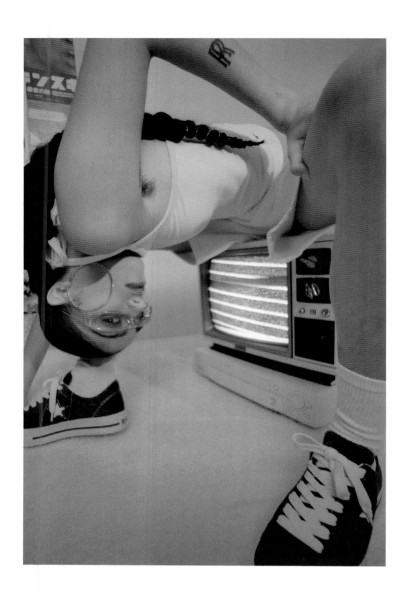

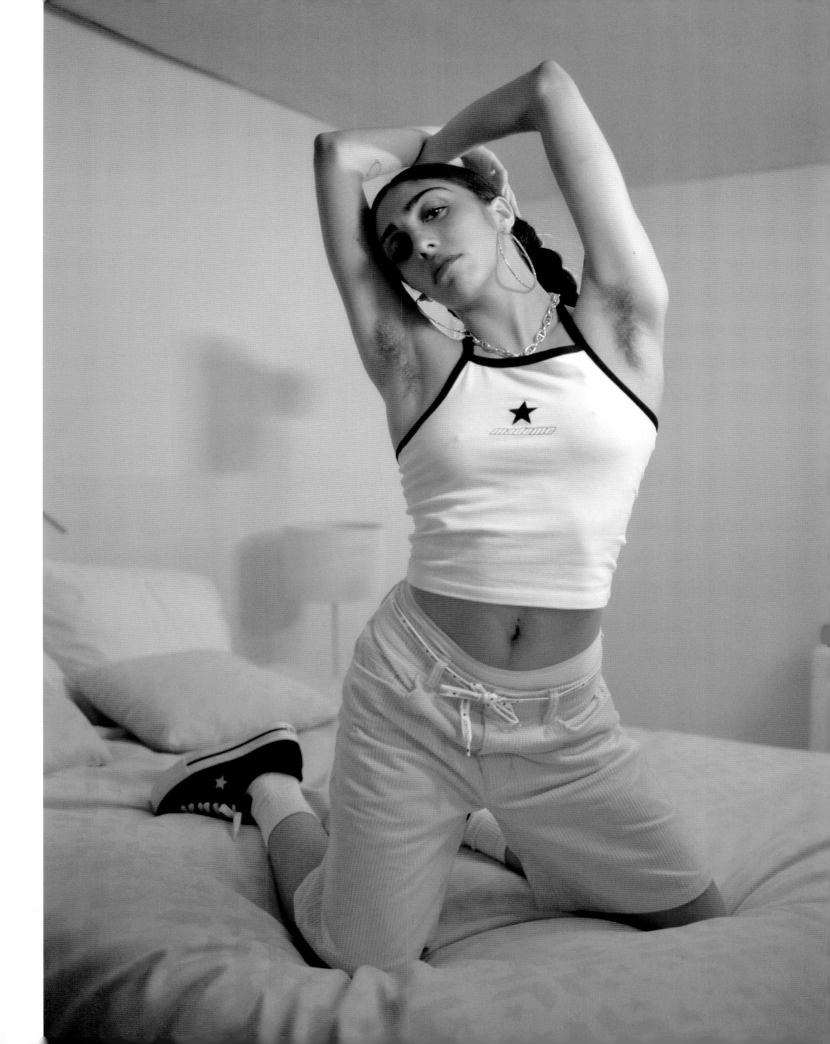

Cow Work Jacket and Wide-Leg Work Pant, Spring 2018.

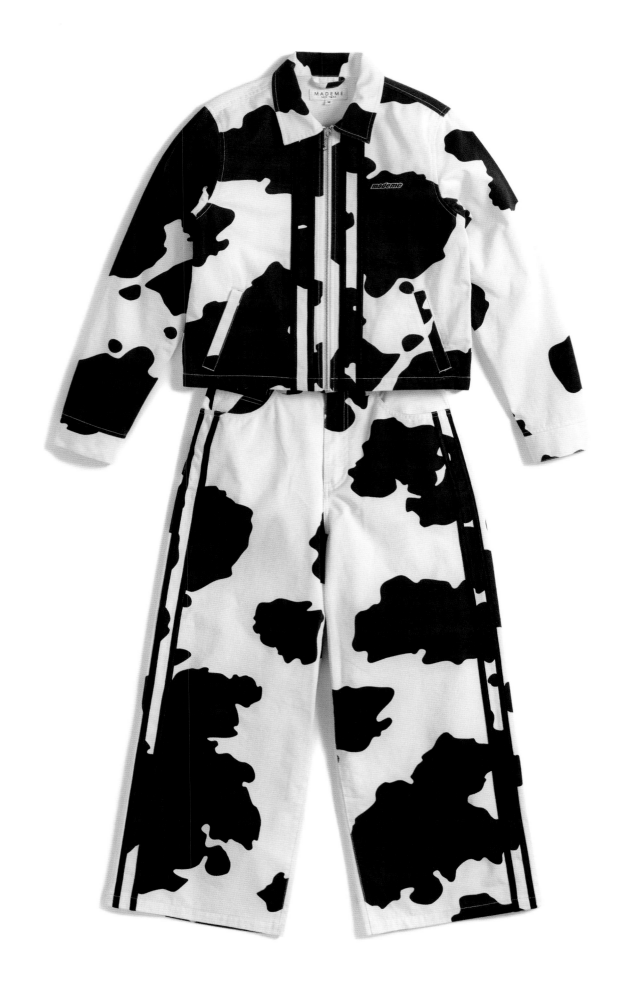

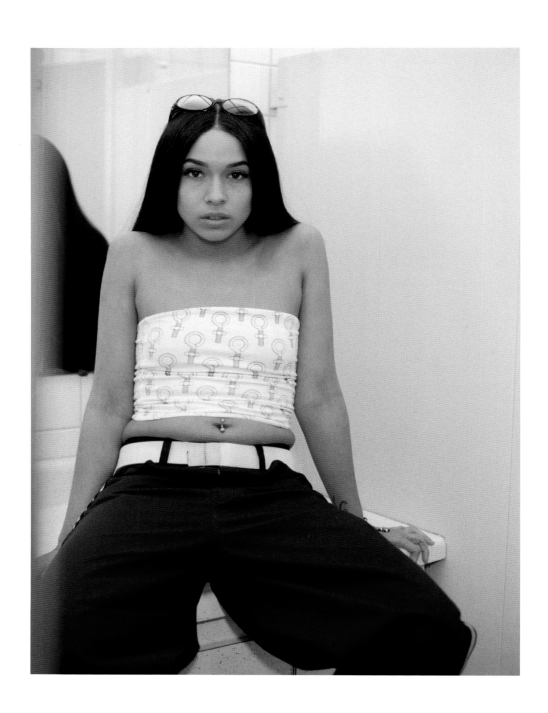

Princess Nokia photographed by Mayan Toledano. Brooklyn, New York, 2018.

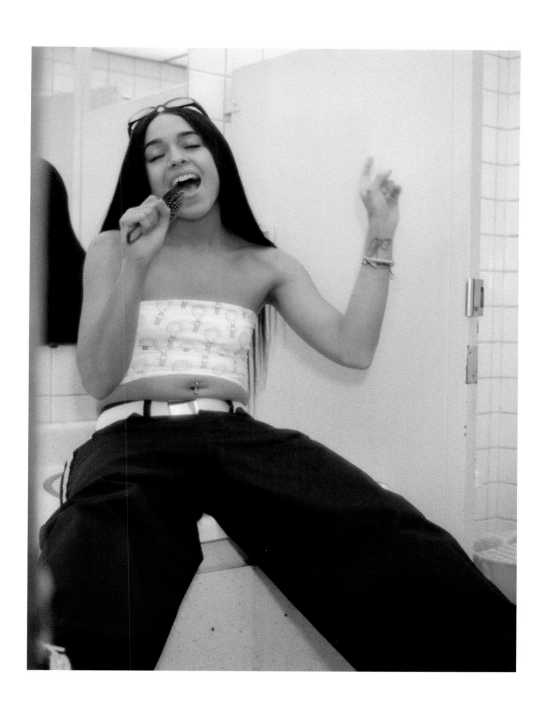

More of baby Destiny. Destiny will
always do something unprompted. I
love the ones where she's singing
into her hairbrush. Every girl on
the planet has sung into their
hairbrush, and Destiny knows that.

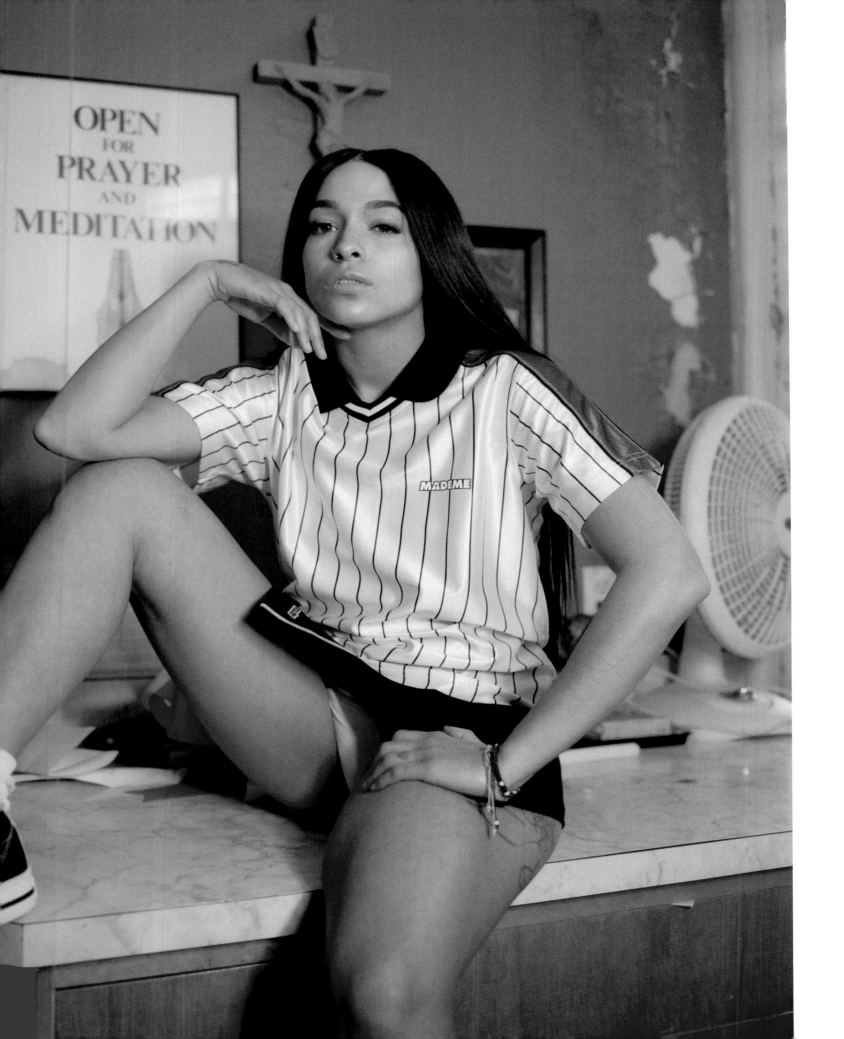

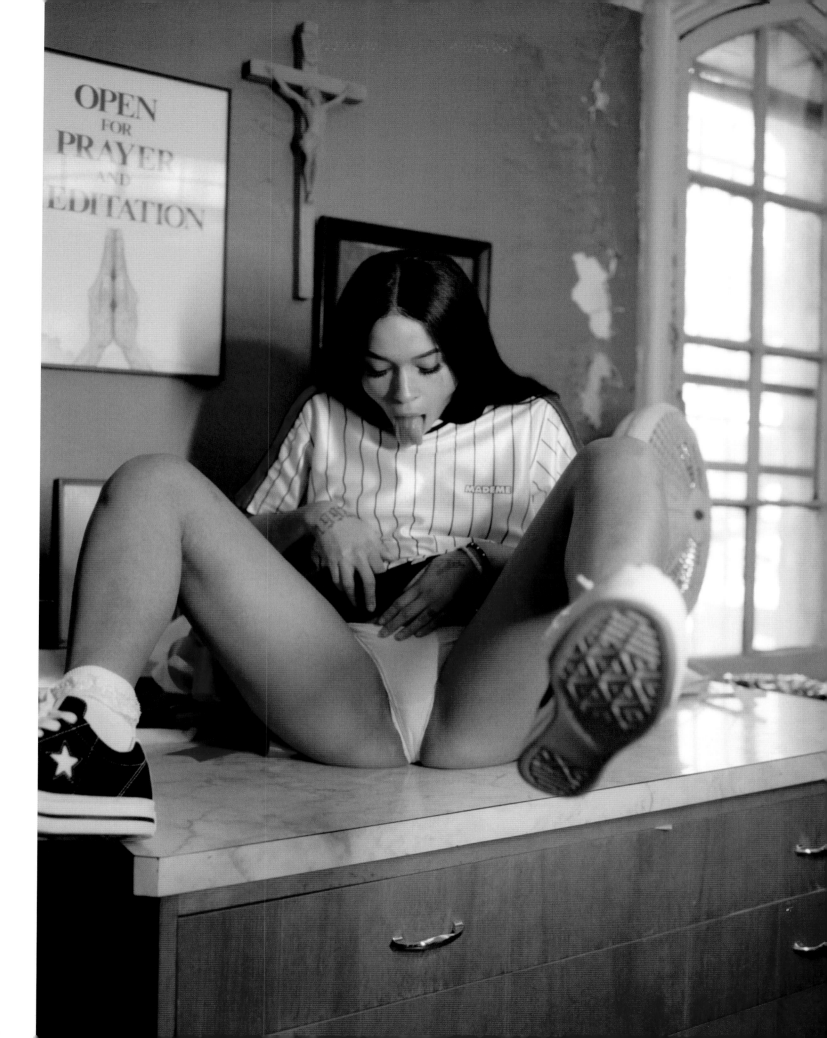

This shoot was at Ally Bo's house — this is his bedroom. He did the airbrush on that denim set, so I was like, "Why don't we go shoot at your house?" Easy.

Talya Louie photographed by Mayan Toledano. Brooklyn, New York, 2023.

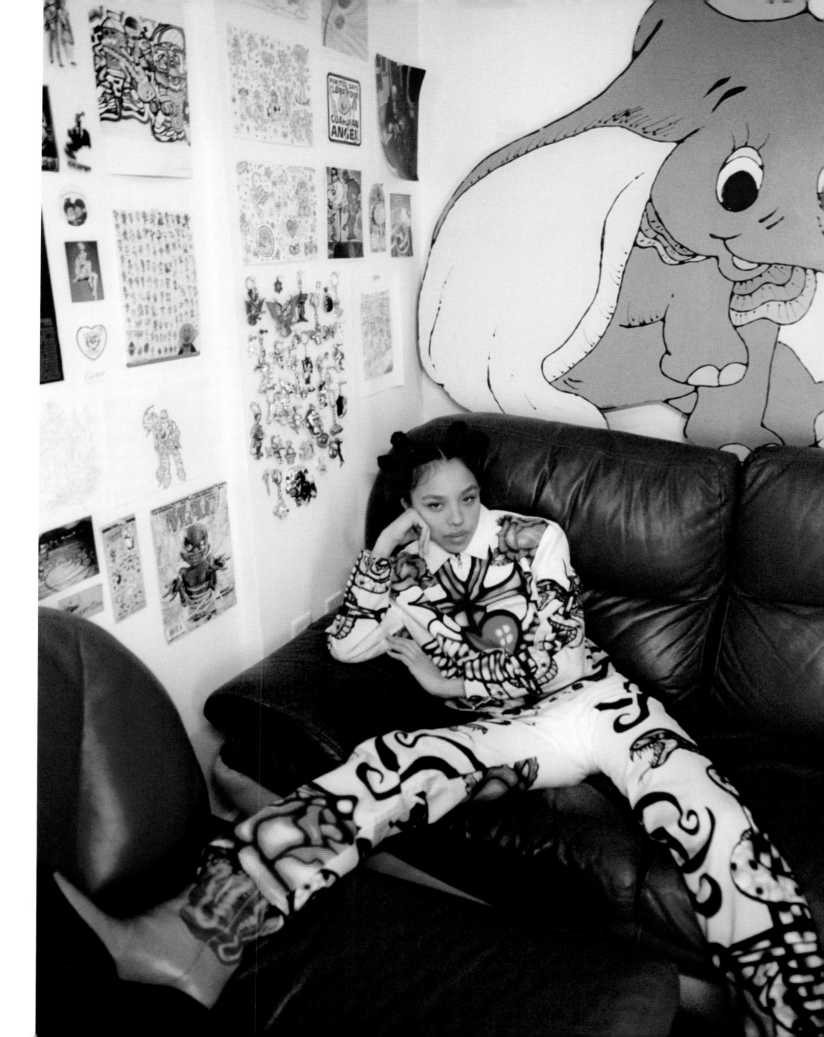

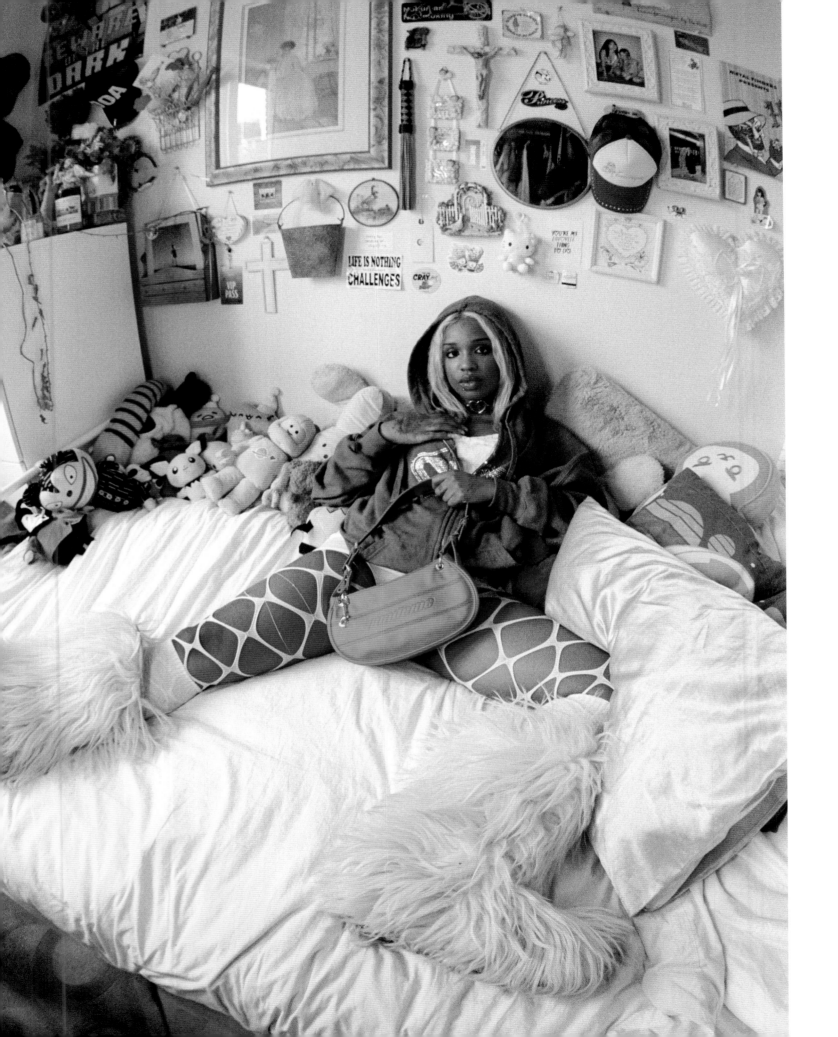

This is Clip. I find it hard to shoot somebody who's popular on the internet. She's popular, but she seemed interesting to me. She has such a kind, happy soul. I saw her on her Instagram, hanging out in this bedroom with her friend. I said, "I want to shoot you, but I want to shoot you in that bedroom you were in." She was down. It was her friend's house, so we went over, and her bedroom actually looked exactly like this.

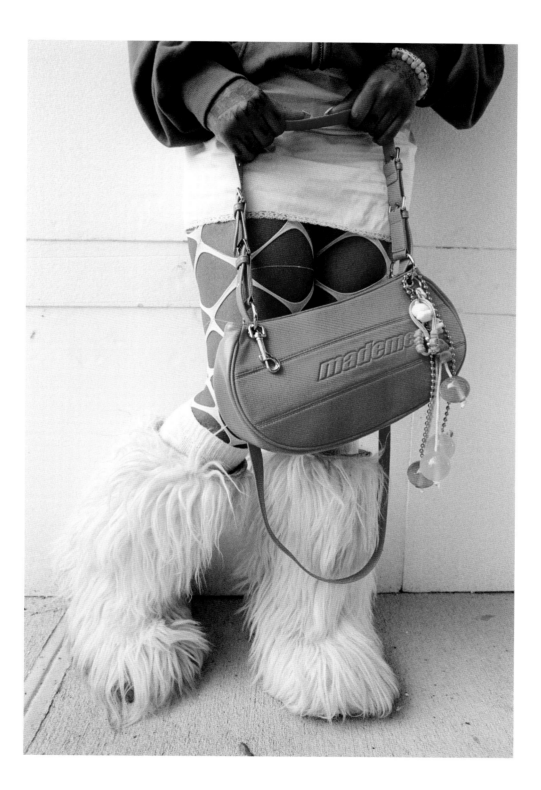

Clip photographed by Mayan Toledano. Brooklyn, New York, 2022.

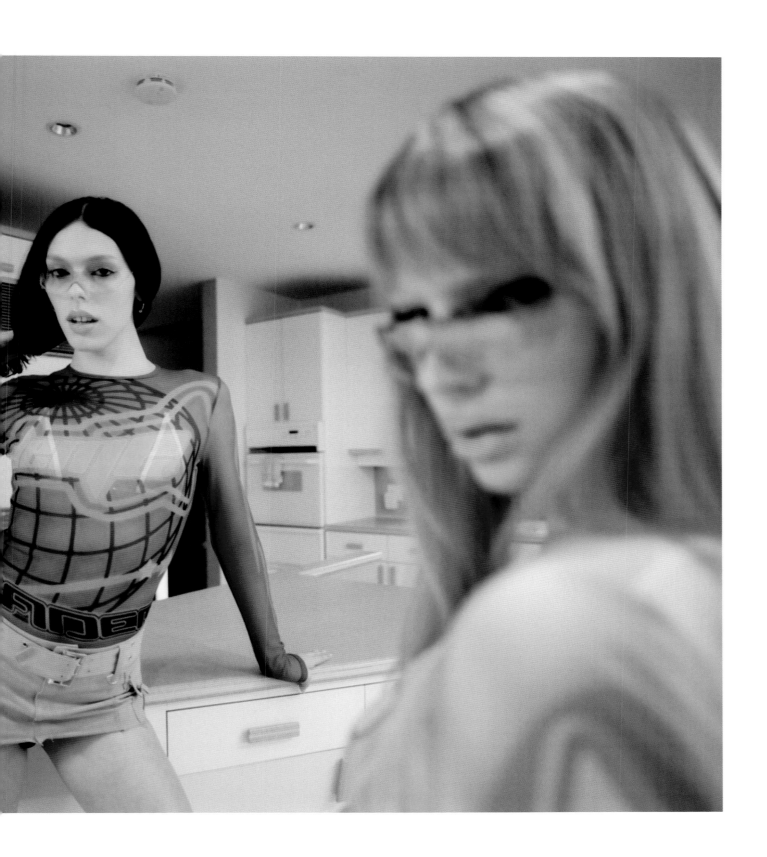

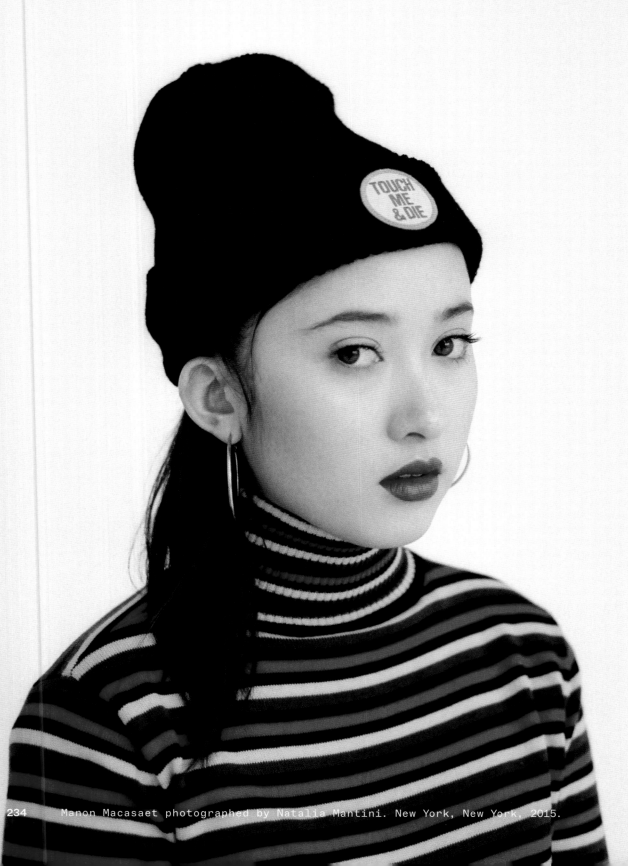

Manon Macasaet photographed by Natalia Mantini. New York, New York, 2015.

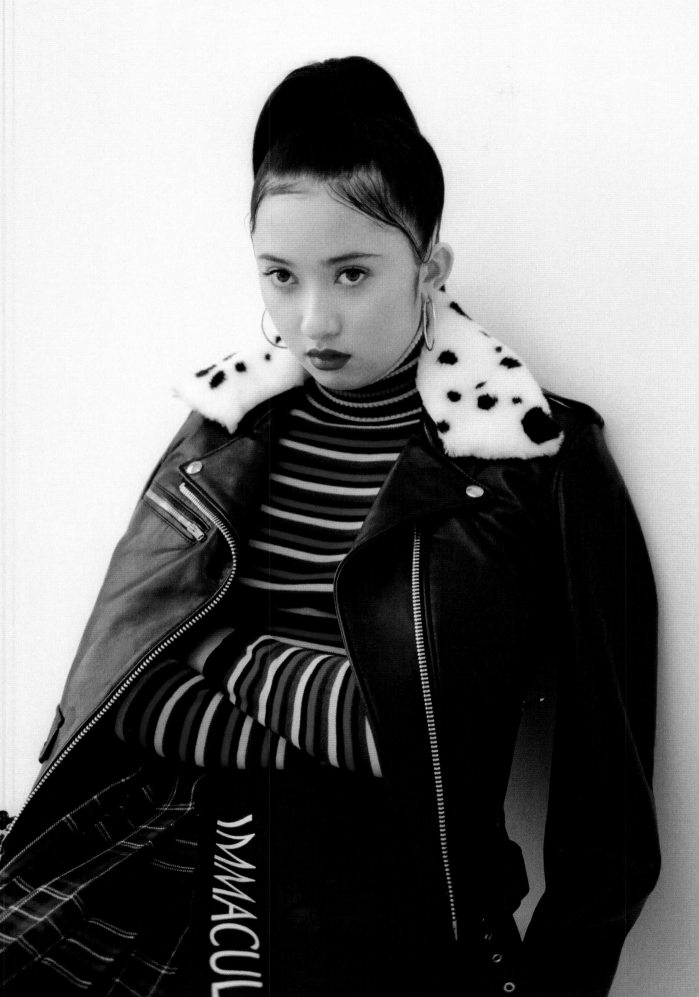

This is one of my first shoots,
must've been 2015. Natalia Mantini
shot these in the studio because
it was supposed to be a lookbook
shoot. Since then I've moved away
from doing things in the studio;
I don't like the feeling of it. I
wanted these in the book because
I like the mood they give. There's
Manon having an attitude, arms
crossed, a grumpy schoolgirl.

Ally Marzella photographed by Natalia Mantini. New York, New York, 2015.

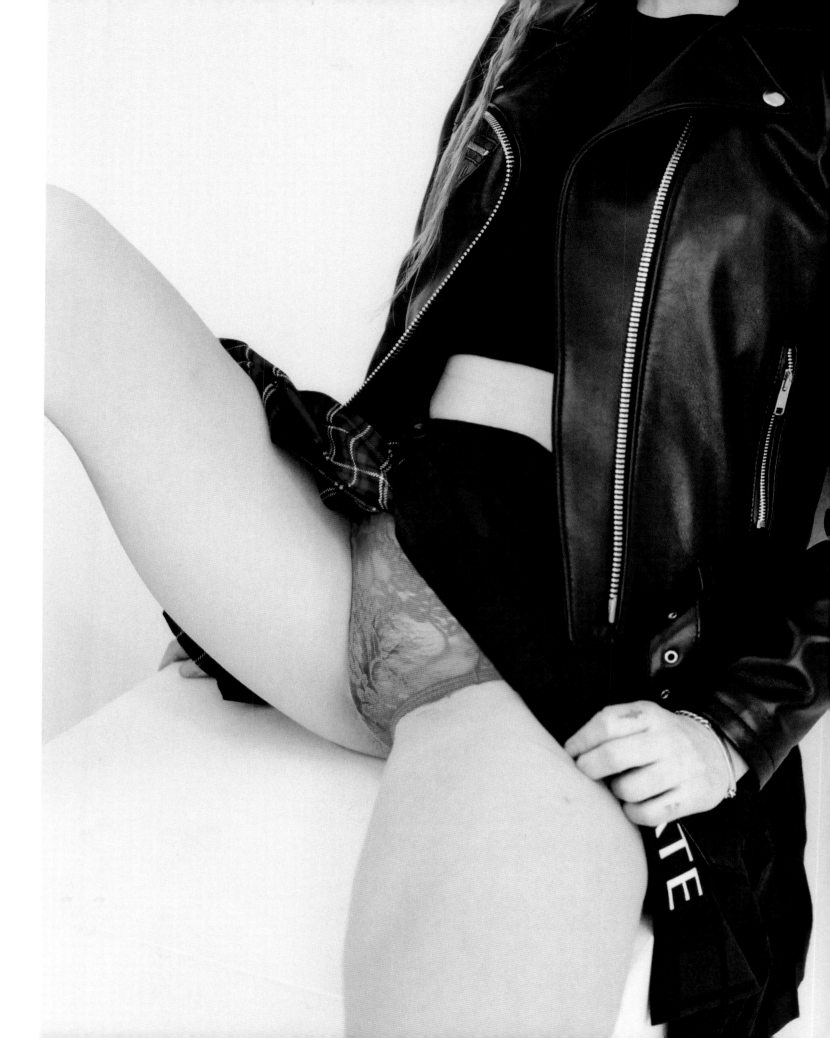

Drawings by Goldie Albino.

Acknowledgements

Wow, ok… that was hard! We did it, girls.

Thank you to Mayan Toledano, who's held my hand through many creative twists and turns. I am 10 feet taller than you, but your soul is 10 feet deeper than mine. Thank you.

To my wife, Nicole, and my daughters, Goldie and Violet: "just give Mommy 10 more minutes to finish this email." Thank you. I love you.

Su Barber, you were recommended to me by so many different people. "6 Degrees of Su Barber Theory." It was meant to be; you're a wise, talented, and very patient designer who fits right into the girlhood. Thank you.

To the indomitable Chioma Nnadi, Lola Leon, and Destiny Frasqueri, without whom I could never even dream of being a cool girl.

My favorite photographers Natalia Mantini, Petra Collins, Sam Puglia, Shaniqwa Jarvis, Moni Haworth, Erika Kamano, Alexis Gross, Ricky Saiz, Elvin Tavarez, Shoichi Aoki, Ben Rayner, Jason Rodgers, Milah Libin, Fish Zhang — I can never un-see the girl world you helped me see, and I never, ever want to.

A major thank you to the incredible MadeMe team: Zac Ching, Charlotte Crowninshield, Genevieve Brown, and Lia Schryver, all I have to say is, "UGH!! Can they not!?"

Thank you, Sam Adler and Lindsey Okubo, for listening and believing.

And, last but not least, thank you to the girls, without you we have nothing: Alana Derksen "Baby Head," Salem Mitchell, Akobi Williams, Omahyra Mota, Sateen, Coco Gordon Moore, Beatrice Domond, Charlotte Free, Lola Young, Amber and Jess Propper, Manon Macasaet, Mal Pugh (Swanson), Amandla Stenberg, Paloma Elsesser, Zara Mirkin, Sacha Alexander, Caroline Jayna, Ajani Russell, Efron Danzig, Sussi, Amanda Baez, Isabella Gianna Reed, Paige Kukuloff, Rylee Parsley, Clip, Blair Broll, Grey Hoffman, Ki Ukei, Cai Tanikawa Oglesby, Alia and Nadirah, Sam and Bess Gsell, Kaila Chambers, Karla and Sheila.

First published in the United
States of America in 2025 by Rizzoli
International Publications, Inc.
49 West 27th Street
New York, NY 10001
www.rizzoliusa.com

For Rizzoli:
Publisher: Charles Miers
Editor: Lindsey Okubo
Editorial Consultants: Meaghan McGovern,
 Ian Luna, and Joe Davidson
Production Managers: Barbara Sadick and
 Maria Pia Gramaglia
Production: Tim Biddick
Copy Editor: Mary Ellen Wilson
Proofreader: Angela Taormina

For MadeMe:
Photography Editor: Sam Adler
Project Coordination: Genevieve Brown
 and Zac Ching

ISBN: 978-0-8478-4482-1
Library of Congress Control Number: 2024945542

Printed in Hong Kong
2025 2026 2027 2028 / 10 9 8 7 6 5 4 3 2 1

Visit us online:
Instagram.com/RizzoliBooks
Facebook.com/RizzoliNewYork
X: @Rizzoli_Books
Youtube.com/user/RizzoliNY

MIX
Paper | Supporting
responsible forestry
FSC™ C023053

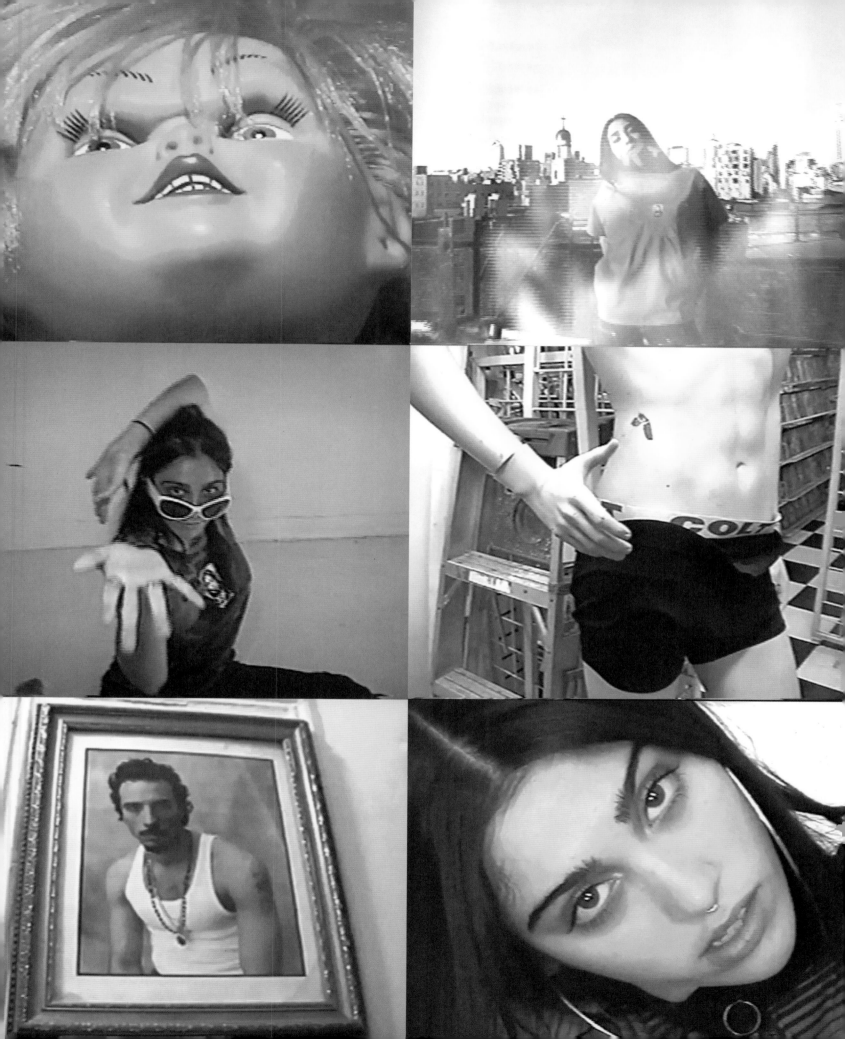

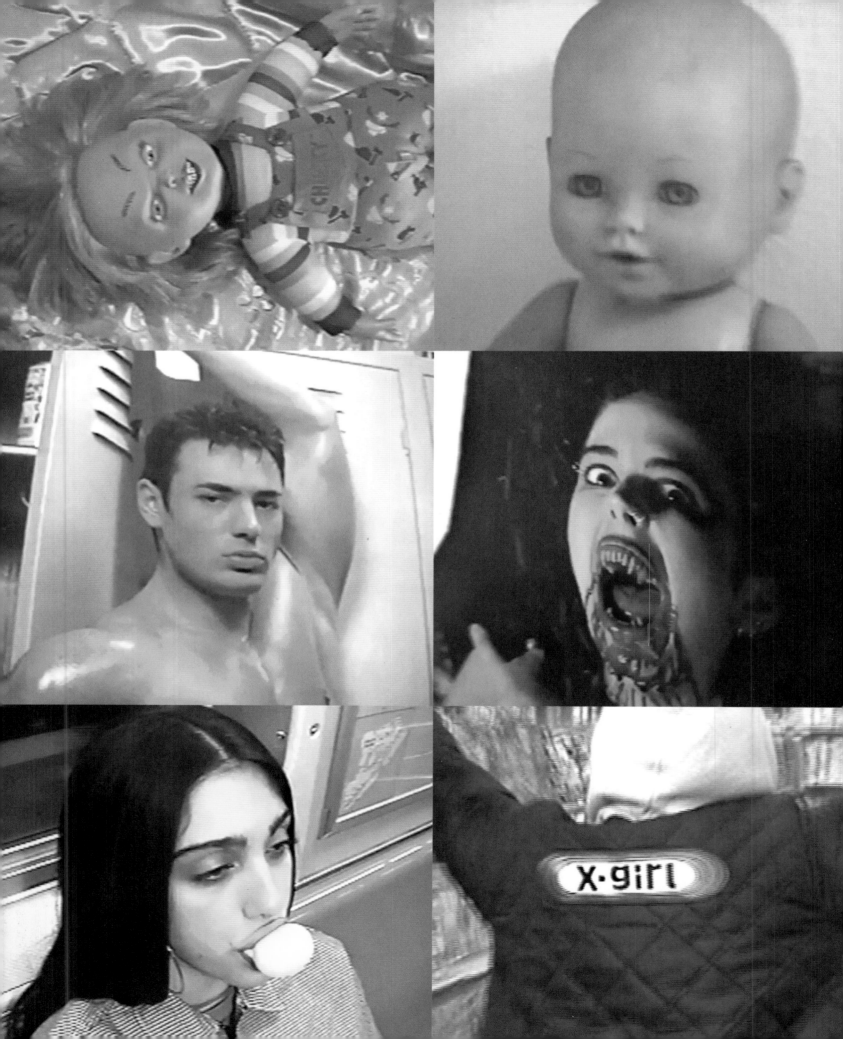